THE
AIRBRUSHING
BOOK

THE
AIRBRUSHING
BOOK

The handbook for all airbrush users

Roger W. Hicks

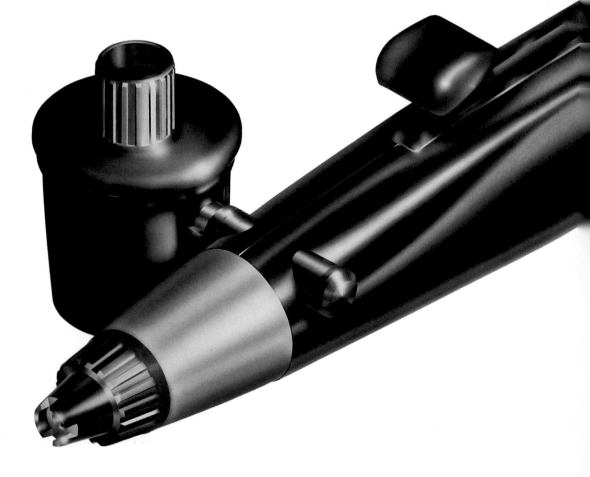

Produced in association with

A Kodak Company

BROADCAST BOOKS

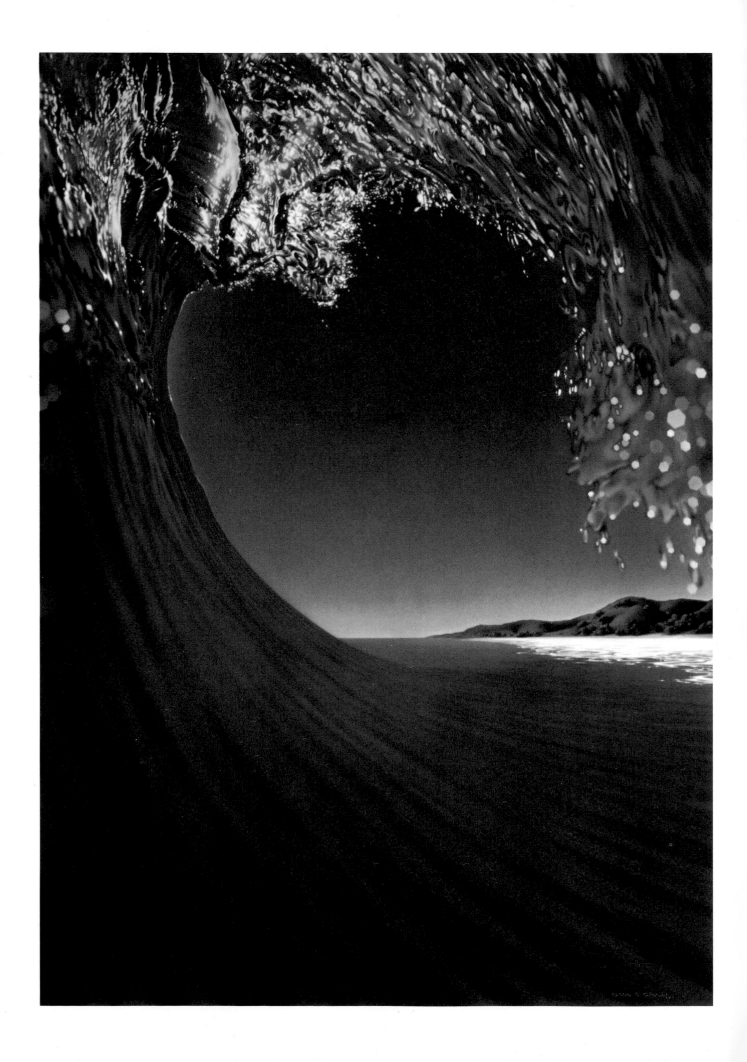

Contents

Wave Otto & Chris
Masking and freehand work have been combined in this skilled observation of a wave. The artists probably started with a photographic reference – lens reflections have been used as an integral part of the image.

Foreword

When I wrote *The Airbrush Book* with Christopher Hunt in 1979, I did so because there was a severe shortage of published information on the techniques of airbrushing. The need for this information has been demonstrated by worldwide sales of over 200,000 copies of my book in nine languages, and by the subsequent books from other publishers.

This is an important new book. It deals with an extremely innovative and versatile new airbrush – one which no airbrush artist should ignore. It also contains all the information you need to start airbrushing, as well as telling you where to find additional information on many related skills, from drawing to car customizing.

Using my first airbrush was an exhilarating but nerve-wracking experience. I was constantly discovering new applications, but I also discovered limitations. Gradually, the airbrush and I grew into each other. Then, I found that I needed two or three different models to cover the range of spray I had expected – and that for each, I needed time and practice to get into the 'feel'. I also found, as have many other airbrush artists, that cleaning, maintenance and repair occupied a great deal of my time and energy.

The Aztek design not only provides excellent control for experienced artists; it quickly gives confidence to beginners, and its versatility means that you can do everything from fine lines at slow speeds right through to a broad spray. The nature of the new design is such that running maintenance and repairs should be minimal, which will avoid the frustrations that have deterred so many people from working with the airbrush. I only wish it had been available when I started.

Seng-gye Tombs Curtis

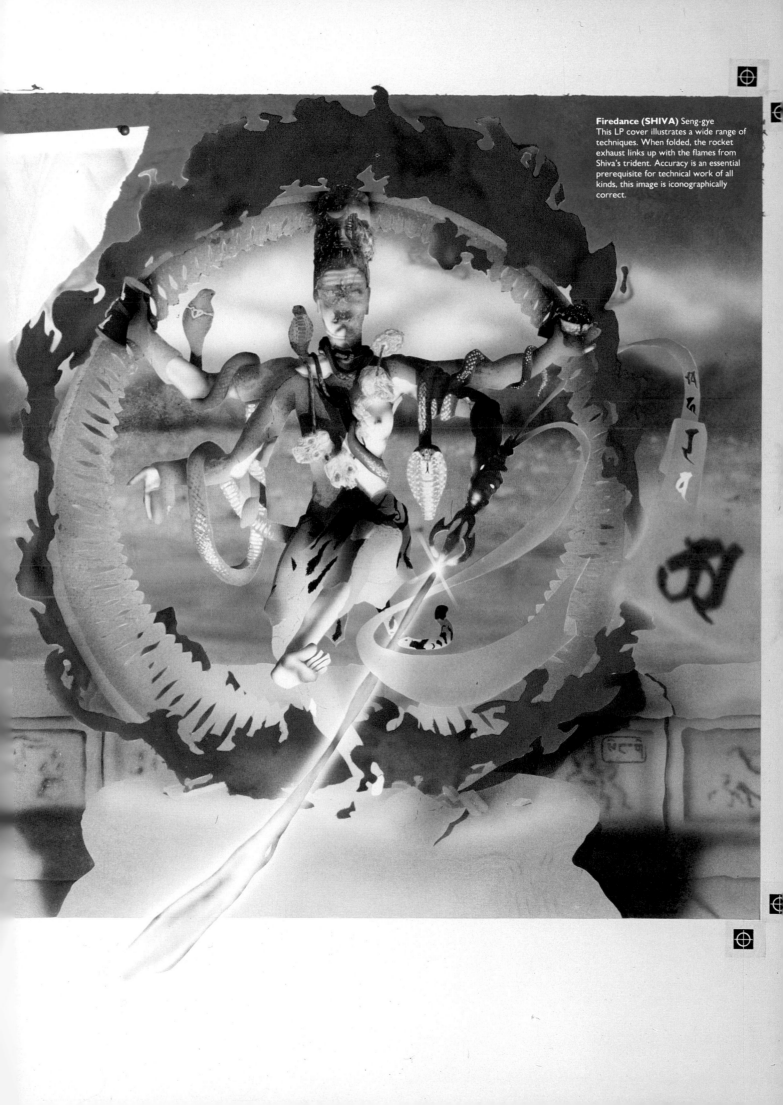

Firedance (SHIVA) Seng-gye
This LP cover illustrates a wide range of
techniques. When folded, the rocket
exhaust links up with the flames from
Shiva's trident. Accuracy is an essential
prerequisite for technical work of all
kinds, this image is iconographically
correct.

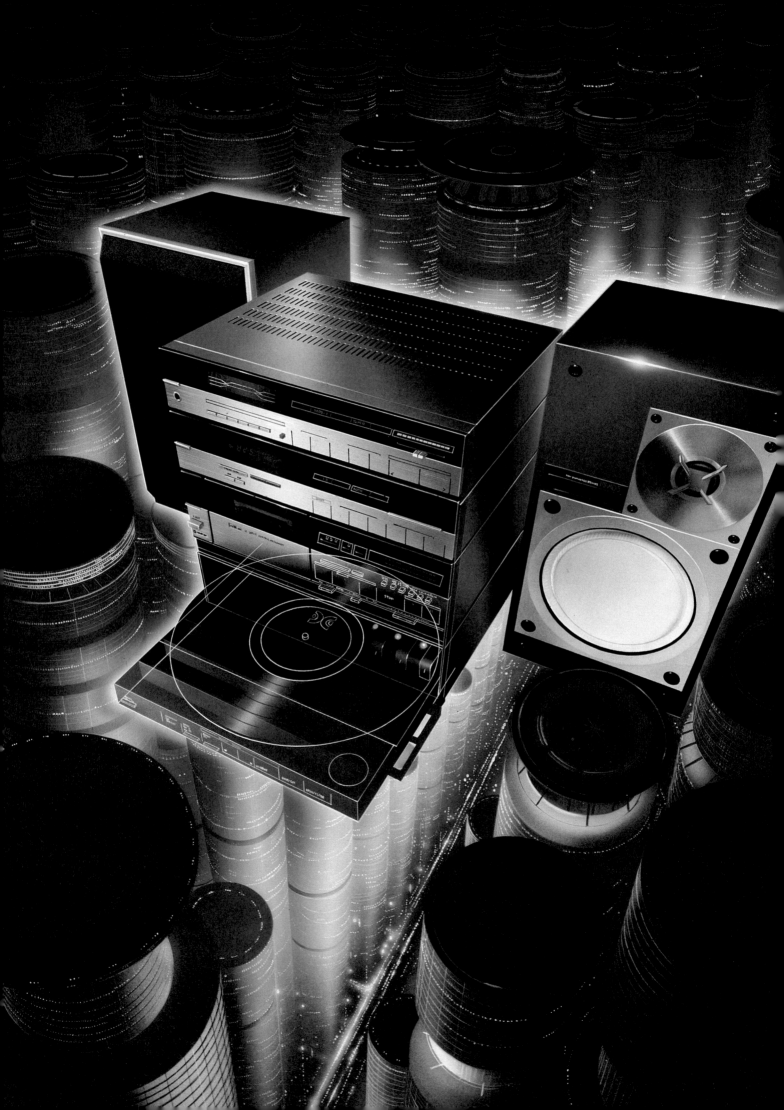

Chapter 1
The Aztek Airbrush

It has been predicted that by the year 2000, seventy-five per cent of us will be working at jobs which have not yet been invented.

This may sound like a strange prediction, and it may be an overstatement, but it gives a good idea of just how fast our world is changing. The electronic revolution and the microchip are commonplace examples, but even our diet is changing: we eat exotic fruits and vegetables, flown in from all over the globe or cultivated in totally new lands. Our cars are up to twice as fuel-efficient as they were in the 1960s, but the latest Porsche supercar can approach 200 mph. Everything is being re-invented, and new twists are being put on old ideas: who could have foreseen the market for computer video games, or autofocus cameras, or windsurfing boards?

One of the fascinating things about the late twentieth century, and the prospect of the twenty-first, is the vastly increased range of options it gives us – and not least, the options in our leisure life-style. We can pursue hitherto unimagined interests, many of them highly creative; and one of the new tools (or toys, if you like) for self-expression is a completely new design of airbrush.

Airbrushes are not new. The first model was invented in the 1890s by Charles Burdick, and since then, the airbrush has become a standard tool for illustrators, photographic re-touchers, model makers, car customizers, fine artists, and many others. The uses of a highly controllable miniature precision spraygun, which is essentially what an airbrush is, are so numerous that it is impossible to mention more than a few of them. Hollywood makeup artists spray latex with them, to create the wrinkles of age or the monstrosities of horror films. Confectioners use them to decorate wedding cakes. Fashion designers use them to decorate clothes, from kimonos to T-shirts; beauty salons use them to decorate nails. The list of possibilities is ever-expanding.

The vast majority of airbrush designs are, however, based to a greater or lesser extent on Burdick's original nineteenth-century design. The only major exception, until now, was the Paasche Turbo AB, which dates from 1903. Not until the 1980s was there a fundamental rethink of the airbrush. This is a book about this new airbrush, which is so radically different that it is fair to say that the airbrush has been re-invented.

The major differences are an enormously increased precision of control, achieved through a new kind of lever linkage which gives less friction and greater finger-movement; the ability to draw very fine lines, without having to move the hand very quickly; much greater reliability, achieved by the use of modern materials and a brilliantly simple air-valve; a far wider spray-range, from ultra-fine lines to broad areas, accomplished partly by nozzle design and partly by the addition of a revolutionary 'control roller'; and interchangeable nozzles, allowing quick and easy cleaning and color changes as well as the use of special nozzles for particular purposes. If you already use an airbrush, you cannot afford to ignore the new design. If you have never used an airbrush before, now is the time to start.

Work 'B' Ryo Ohshita
This piece of work demonstrates a wide range of illustrative skills combining technical accuracy with imaginative imagery. The halo effect is a variation of the controlled overspray technique used on page 75 for neon lettering.

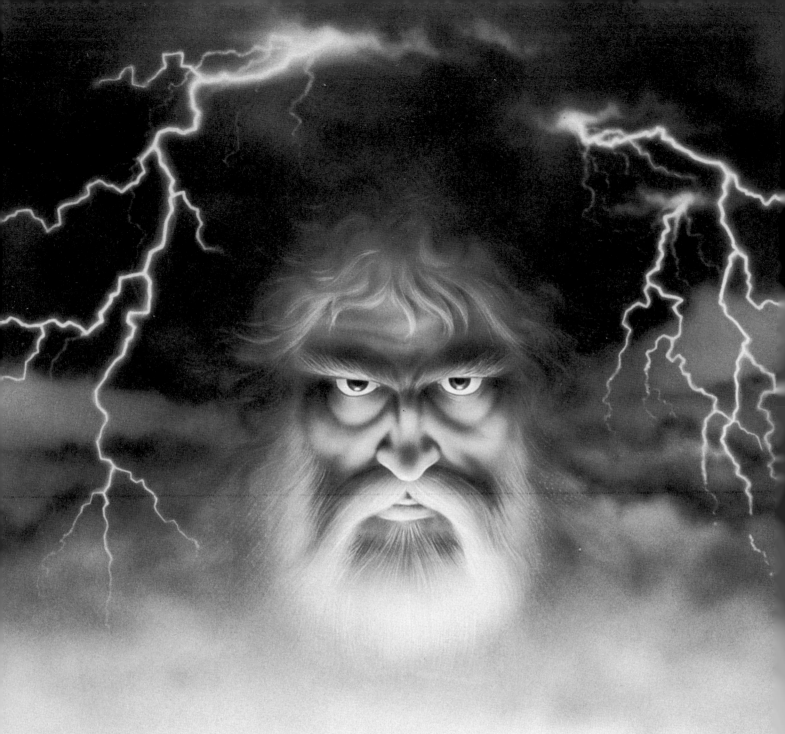

Airbrushes: Background

Most of our readers will have a fair general idea of what an airbrush is, and what it can do – and many, of course, will have a very good idea. Even so, it is worth running through a basic description of the main types.

As we have already said, airbrushes are highly-controllable miniature sprayguns. There have been hundreds of different models, but they can be divided in two major ways.

One distinction is between single-action brushes and double-action brushes. A single-action brush is akin in many ways to a simple spray-can: you push down on the control lever, and you get a spray which increases in pressure and volume as you press harder. It is much finer and more controllable than a spray-can, but the principle is the same.

A double-action brush is slightly trickier to master, but rather more versatile. The control lever or trigger can be pulled backwards as well as being pushed up and down. Pushing down controls the air supply, while pulling back controls the supply of paint or 'color'. This independent control allows you to control the *type* of spray, as well as the pressure and volume. Plenty of air, and not much color, gives a fine misty spray; plenty of color, and not much air, gives a coarser spray which eventually becomes a spatter.

Aztek brushes can be used either in double-action or fixed double-action mode, as will be described overleaf.

The other distinction is between gravity-feed brushes and suction-feed brushes. In a gravity-feed brush, as the name implies, the color is stored in a reservoir on top of the brush, and fed into the air supply by gravity. In a suction-feed brush, the color reservoir is usually on the side ('side-cup') but it can equally well be on the bottom (some brushes use a bottle), on

Deity Ray Mumford
The first airbrush artists, in the 1890s, used to work entirely freehand (Chapter 3). In this illustration, Ray Mumford has also used masking in the lightning (Chapter 4) and a knife to introduce the 'hairs' in the beard; there is no brushwork here at all.

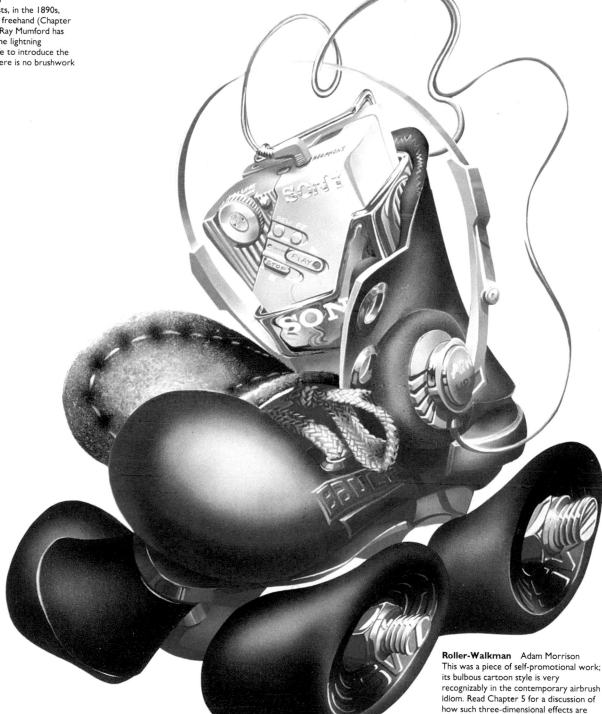

Roller-Walkman Adam Morrison
This was a piece of self-promotional work; its bulbous cartoon style is very recognizably in the contemporary airbrush idiom. Read Chapter 5 for a discussion of how such three-dimensional effects are obtained.

top, or even on the end of a flexible supply line ('line feed'). The Aztek design works on the suction principle, and has interchangeable cups of varying sizes which are attached to the side and a variety of nozzles. The side-cup version is illustrated throughout this book.

While the position of the cup is largely a matter of preference, it is worth noting that top-cup brushes normally have smaller color reservoirs, while side-cups often hold more. However, for those who prefer top or gravity fed brushes an adaptor has been produced for use with the Aztek design. For the ultimate in capacity, a line-feed is obviously desirable, and while the technical difficulties of making a reliable line-feed for most brushes are considerable, special high-suction nozzles and a line-feed reservoir would be technically feasible with the Aztek design.

With a single-action airbrush the lever only controls the supply of air. With a double-action (or independent double-action) airbrush the lever controls both air and paint flows separately. With a fixed double-action airbrush the lever controls both paint and air flow, but in a fixed relationship to each other. However, the Aztek airbrush offers double-action and fixed double-action modes with the same airbrush. For a full survey of earlier brush designs, including the Paasche AB Turbo which is neither suction-feed nor gravity-feed but works on a unique principle of its own, see *The Airbrush Book* by Seng-gye Tombs Curtis and Christopher Hunt, published by Macdonald Orbis.

Safety

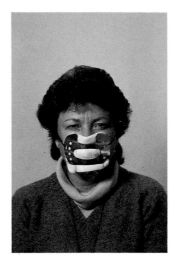

A simple face-mask keeps most of the moisture out of your lungs, and should be the least protection you wear when airbrushing indoors.

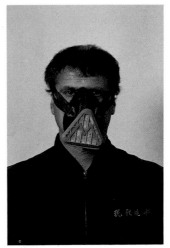

A respirator is much more effective, especially where toxic materials are being sprayed. Filtration is via a replaceable element of, for instance, activated charcoal. Various interchangeable filters using different materials are available for different purposes; see manufacturers instructions.

Before we go any further, it is worth taking a look at the question of safety and the airbrush. Sometimes, it seems that we are so safety-conscious nowadays that we give no one credit for common sense, but it is as well to make a few remarks about safety as early as possible in this book.

It is also worth noting that we cheerfully live every day with far greater dangers than airbrushing. An aerosol can of hairspray, for example, is potentially far more dangerous than any airbrush, being both inflammable when sprayed and liable to explode if overheated.

Compressed Air

'Compressed air can be dangerous'. This is a standard warning in all machine shops, where compressed air is used for cleaning and drying, but we are normally concerned with very much lower (and therefore less dangerous) pressures, typically 20–60 pounds per square inch (psi) or 1–4 bar. Gouache is normally sprayed at the lower end of the scale (up to 20–25 psi, 1.5 bar) while acrylics are often sprayed at higher pressures, but 30 psi (2 bar) is a good compromise setting until you develop your own preferences and techniques.

Even 60 psi is too high a pressure to spray near the skin – it can drive paint or ink particles deep into the pores, which can be particularly dangerous if you are using poisonous pigments (see pages 22–5) – but the real horror stories come with the considerably higher pressures which are found in machine shops, say 120 psi – 200 psi (8–15 bar), so there really is not much to worry about. In any case, it is unwise and unnecessary to go above about 60 psi/4 bar, and the brush is unlikely to function above about 75 psi/5 bar; the excess pressure will be vented automatically.

With low pressures (below 30 psi) you can actually press the airbrush against your skin without any significant risk, unless of course you are using poisonous pigments, but at higher pressures you should exercise ever-increasing care. For school use, 20–30 psi should be the maximum available.

Air Canisters and Air Receivers

If you are using pressurized canisters of gas (pages 26–7), do not leave them in direct sunlight. Putting them in warm water (not hot) can be useful to get a little more use out of a dying can, but applying any other form of heat can be extremely dangerous. Do not try to warm cold canisters in your hands; they can get so cold that your skin will stick to the metal, which is extremely painful.

If you are using a compressor with an air receiver, read the information about air cylinder corrosion on pages 26–7. Air receivers (also called air tanks or reservoirs) are covered more fully on the same page.

Safety Masks, Respirators and Spray Traps

To avoid inhaling particles of paint or medium, wear a simple 'smog mask' of the type illustrated. If you are working with toxic pigments or media, you will do better to wear a respirator, with an activated charcoal filter: the range of chemicals which an activated charcoal filter can absorb and neutralize is astonishing, though the filter element should be renewed periodically.

A more expensive solution, but one which is also much more convenient, is to buy a suction spray trap or 'mini booth' of the type illustrated; these are surprisingly efficient at removing airborne spray and are also useful for controlling overspray (see below).

Flammable Solvents and Media

Although the dangers of using highly-flammable 'thinners' are clear, a much less obvious danger is that even comparatively low-flammability oils can form an explosive mixture with air if they are sufficiently finely divided. Use flammable solvents or

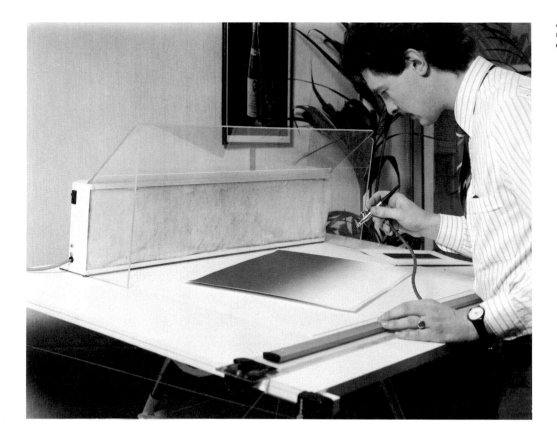

A spray-booth, like this one from Sim-Air, removes any overspray and protects your equipment and lungs from drifting spray.

media only out of doors, or at least, make sure that your studio is very well ventilated and that the windows and doors are wide open: ideally, fit (and use) an extractor fan.

Cleaning Solvents

Whether you use domestic solvents such as alcohol for cleaning the brush, or proprietary cleaners, ALWAYS be careful where you spray the brush to clean it out. Some organic solvents are dangerous to health as well as inflammable; some proprietary cleaners are extremely alkaline and could conceivably cause blindness if sprayed in the eyes, though Aztek's own cleaner is both safer and more effective than most.

When cleaning the brush, spray onto a wet cloth or paper towel, or into water. If you do spray or splash your eyes, wash them out with plenty of water and seek medical attention if necessary.

Used Blades

In order to cut masks (see pages 50–1), you will need razor-sharp blades. Disposing of these so that neither household members nor garbage-disposal men are injured is not easy. Some people replace them in the original packing, but one of the safest ways to dispose of them is to put them inside old 35 mm film canisters, and tape on the lid when the canister is full of blades. Others drop them into empty beer or soft-drink cans, stamping the can flat (with heavy boots!) afterwards.

Overspray

This is not really a major safety consideration unless poisonous particles settle on your food (and it can happen!), but it can lead to considerable distress and disharmony. If you are spraying large areas, or if you are spraying for a long time, paint can drift surprising distances and settle on all sorts of surfaces. This was particularly relevant when taking photographs for the present book, where camera lenses had to be protected with clear glass filters to guard against overspray. Also, don't wear an expensive watch when you are airbrushing.

Most manufacturers publish tables giving the toxicity and permanence of their paints; toxic pigments (pages 22–5) are still used today, either because they give colors which are otherwise unobtainable or because they are more permanent than less toxic pigments. Often, toxicity and permanence ratings are given in the manufacturers' catalogs; where they are not, the manufacturer will usually supply the information on request. In many countries, they are legally obliged to do so; in Britain, for example, the Health and Safety at Work Act could well be invoked, especially in a commercial studio. Daler-Rowney products, for example, comply to EEC and USA safety standards and warning information is contained on product packaging and in their catalogue; performance data is treated in the same way.

The First Session

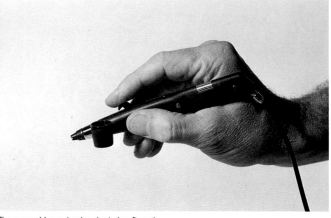

The control lever (under the index finger) is the primary control on any airbrush. The paint-cup is mounted on the left here; you can put it on the right if you prefer. The control roller is the bright part towards the rear of the brush.

When you first pick up the airbrush, you will see that there are two obvious controls, the lever and the roller. The lever will be familiar to anyone who has used an airbrush before; the roller is something new, and even experienced users of older designs of airbrush sometimes have difficulty in working out what it is for. We shall come back to this later.

Whether you are familiar with airbrushes or not, try operating the lever even before you connect the brush to an air supply. First, turn the roller as far as it will go in the direction of the arrow. Then try the action of the lever. Move it up and down, and pull it back. Practice combining the two movements.

Next, turn the roller as far as it will go the other way, and try it again. You will notice a marked difference in the 'feel' of the brush: there is a much easier movement at the beginning of the travel when the roller is set to one extreme, so that you have a sort of 'first pressure' and 'second pressure', as on a rifle trigger. This may feel a little strange at first, especially if you are already used to other airbrushes.

In use, you will rarely set the roller to either extreme; the brush usually feels better if you back off half a turn, but this is a matter of personal preference. Also, do not force the roller; it moves fairly freely, and resistance indicates that it has reached

the end of its travel. Ordinary finger-pressure cannot damage it, but do not use pliers or anything like that to turn the roller.

Now, turn the roller back in the direction of the arrow, close to the limit of its travel: you are ready to try using the brush. You are probably going to get through a lot of paper, together with a fair amount of ink. Unless you have a compressor, there is a good chance that you will also get through at least a full can of propellant (page 26–27).

The paper need not be of the best quality, but unless it is of reasonable quality, you run the risk of ink soaking through and ruining the sheet underneath: you may also get a certain amount of spreading if you use too much ink and let it soak in, but one of the intriguing things about the airbrush is that if you use it properly you will not saturate the paper, even if it is of the very cheapest kind. Printer's offcuts are ideal, but you might also consider wallpaper lining, newsprint (sold as packing paper for moving house) and torn-off sheets of photographic background paper (such as Colorama). Or, of course, you can buy a pad.

For ink, look for a modern drawing ink without shellac: Shellac will not harm the airbrush, but it needs to be flushed out with alcohol or methylated spirit or it can build up inside the brush. Blue ink is probably a better choice than black, because it

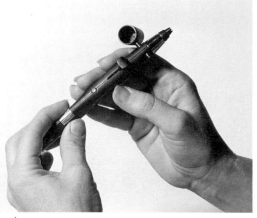

The interchangeable nozzles are exchanged in the same way as the tips on a drawing pen. Screw them fairly tight, but use only finger pressure; anything more will result in damage.

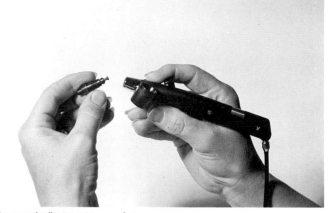

The control roller is a unique new feature of the Aztek brush. You do not necessarily have to turn the brush round to operate it; the photograph was taken this way for the sake of clarity.

gives you a better idea of how both color density and color intensity build up as you increase the spray power, or as you spray the same area a number of times. Use one of the smaller cups, 1 cc or 2.5 cc. You can see the work more easily, and besides, you will get a better idea of how fast you use up ink. There is also less ink to spill if your hand slips and you don't have a lid on the paint-cup!

As for propellant, you can use gas canisters, compressed air, or a compressor, as described on page 26–27. If you are using gas canisters, you may find it useful to have two, swapping them over periodically as they chill in use. If you have a regulator, set it to 30 psi/2 bar.

Exactly how you hold the brush is a matter of personal preference, but some people find it easier to put their index finger right over the lever, with the tip resting on the body of the airbrush. That way, the first joint of the index finger actually rests on the trigger, which most people find gives better control. It may sound awkward, but you should try it, especially for fine-line work or if you have long fingers.

Play the air-jet on your finger or (better still) the back of your hand, which is very sensitive to variations in air pressure. DO

NOT press the tip of the brush hard against your skin, for the reasons already described.

Put some ink in the cup – about half-full will be fine – replace the paint-cup lid and put the lid on to prevent spillage. Spray at the paper. Try all the effects you can. For a broad spray, you will need plenty of air and color, which means pulling the lever full back and pressing it well down, with the airbrush 10–12 in/ 25–30cm from the paper. Now experiment with other roller settings, and with different finger-pressures. Try to draw even lines, try spraying flat areas of tone, and try drawing with the brush; both writing and drawing are likely to prove more difficult than you expect, until you get the hang of the brush.

You will encounter all sorts of problems (see page 36). One is an involuntary jerk of surprise when the spray actually starts, which means that your first attempts are likely to be pretty wavery. Another is 'spidering', where you are holding the brush too close to the paper and not moving it fast enough. But all of these show that you are learning what the brush can do, and (with any luck) they will inspire you to try to approach the subject in a more systematic manner.

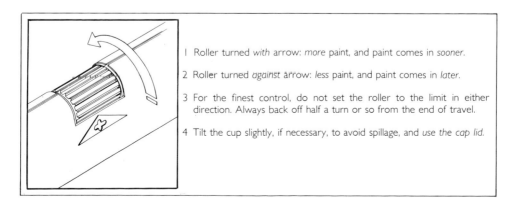

1 Roller turned *with* arrow: *more* paint, and paint comes in *sooner*.

2 Roller turned *against* arrow: *less* paint, and paint comes in *later*.

3 For the finest control, do not set the roller to the limit in either direction. Always back off half a turn or so from the end of travel.

4 Tilt the cup slightly, if necessary, to avoid spillage, and *use the cap lid.*

Mastering the Controls

Gas!
Gas!, inspired by the poets of the 1914–
1918 war, is an even simpler illustration of
the way in which an airbrush can be used
in conjunction with other media to create
unique effects.

After an enjoyable first session, spraying everything in sight (preferably not the cat, the children, the wallpaper or other sensitive targets), you are likely to realise that a rational, controlled approach to learning the controls could be useful. This is what we are concerned with here. You will need the same sort of materials as before.

First, concentrate on the up-and-down movement of the lever. Set the roller fully forward (ie turn it as far as it will go in the direction of the arrow), and then back off a half-turn or so, as described on the previous page. Then, just press the lever *down*. The spray starts just after the lever starts its travel.

This is straightforward fixed double-action airbrushing, as described on pages 10–11: basically, you are using the airbrush as a highly sophisticated spray-gun. For many applications, such as touching up scratches on a car or painting a child's toy, this is all you need. You can control the pressure and volume of the spray by up-and-down finger pressure alone, and you can vary the width of the line by the distance at which you hold the airbrush from the paper.

We can, however, pre-set the point at which the spray starts. If you turn the roller a little – try a whole turn, or even two turns – you will find that the initial movement of the lever produces just air, and that the color does not come in until it has travelled a bit further. There are several reasons why you might want to do this, but one of the most noticeable effects is that you can draw finer lines this way.

Turn the roller a little further, and the color will come in still later. If you turn the roller as far as it will go, you will get only air, no matter how hard you press down on the lever, unless you also pull back. As the roller nears the end of its travel, you will find that you can draw incredibly fine lines, just by pushing down. You will also find that the tip of the airbrush will almost be touching the paper; it should never actually touch, as this could mar the ground when you start working in earnest.

Once you have tried a wide range of experiments in this fixed double-action mode, you can try pulling the lever back as well. Now, you are using the brush in true double-action mode, just like any other high-quality airbrush. Ultimately, double-action gives you more control, because you can go from a very fine line to a very broad one. As we have already said, this is a little trickier than fixed double-action, not least because you have to coordinate two separate movements: up-and-down and back-and-forth. Even so, what you have learned from fixed double-action use will smooth the way.

When you are using the brush in double-action mode, you become aware of other advantages of the setting roller. One is that you can set the whole lever action to suit your particular preferences: some people like to have the color come in early, some prefer to have it come in late. You can choose. Another is that you can set the range across which you want to work: fine-to-medium with the roller at one extreme, medium-to-broad at the other, with whatever intermediate settings you like. And if you like to use air from the brush to dry off your work, or to blow debris out of the way, you can set the roller so that your initial pressure gives you air but no color, as already described, while leaving plenty of control in the rest of the range.

Because the roller is a unique new feature, it does take some getting used to. In fact, several people who tried out prototype brushes never even used the roller, and they still reckoned that the new design was vastly more controllable and versatile than others – and they are right. But an understanding of what the roller does is invaluable, if you want to get the very best out of your brush.

Cartoon Toby Glover

If you are already familiar with other media, you may find it easiest to begin by mixing airbrushing with more familiar techniques. Toby Glover used pen-and-ink cartoon techniques which he had already mastered together with simple 'flat' spraying and more interpretational freehand work.

The Aztek Airbrush System

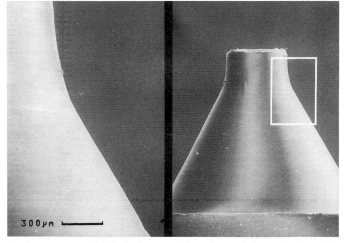

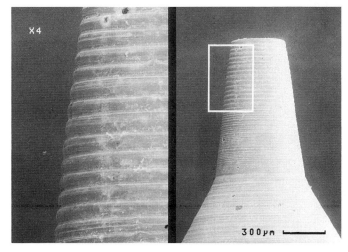

An electron micrograph of the Aztek nozzle design shows the incredibly high degree of precision to which the parts are injection-molded. Compare the plastic Aztek nozzle (left) with the brass nozzle made by another manufacturer (right).

The surface finish that can be achieved by injection-molding is superior to the finish achieved with metal components. This is a major factor in increasing the efficiency of the fluid dynamics of the nozzle.

'System' design is a relatively recent innovation. One of the best-known examples is cameras, where you can begin with a single camera body and then go on to add interchangeable lenses, motor drives, special viewfinders, and so forth. The first 'system' camera was the Leica, originated in about 1930, and revised in 1953/4 – and cameras made in 1954 will still accept lenses made in 1988!

The Aztek brush is the beginning of a 'system' which has not really existed in airbrushes before. Interchangeable paint-cups are not new (though few other designs allow you to fit the cup either on the left or the right, to suit your personal preferences), but the standardised series 3000 interchangeable nozzle/needle units produced by Aztek are as revolutionary as standardized interchangeable lenses were in 1930, and there is also a very high degree of cross-compatibility between different brushes.

Of course, the basic 'building brick' of the system – the airbrush itself – has to be very well thought out, the streamlined design with its rear-entry air line, which allows it to be laid down on the edge of a table or other flat surface is an example of the thought which has gone into the Aztek 3000-S – the side cup airbrush. This may seem like a trivial point, but many airbrush artists in the past have been driven to devise the most extraordinary range of supports and brackets to hang their airbrushes on when they want to put them down. Again, the rear-entry airline can be draped over the arm, which keeps it well clear of the work.

Taking the paint cups first, there are obvious advantages in being able to swop cups if you want to swop colors. Also, there are advantages in being able to fit the paint cup on either the right or the left hand side of the 3000-S.

You can also fit larger or smaller Series 3000 cups: three sizes of cup are available for the 3000-S as well as the gravity fed cup. The nominal capacities are 1 cc, 2.5 cc and 8 cc, and all share the same push-fitting. The gravity fed cup is 2.5 cc. Spare cups of all three sizes are available. It is not possible to fit two paint cups simultaneously, one either side, on the side-cup brush.

There is even an alternative to the cup, for fine-line work or where you are changing colors frequently. The feeder-funnel accepts a few drops of color from a teat pipette, and takes them into the internal reservoir of the brush.

The patented interchangeable nozzle/needle unit is really revolutionary. On all high-quality airbrushes, it is usual to be able to remove and replace both the nozzle itself and the needle, but needle changing is normally a tricky operation which carries a high risk of bending (and thereby writing off) the needle. On the Aztek design, the needle and nozzle form a single unit, rather like the interchangeable points on high-quality drawing pens, and they are changed in exactly the same way: they screw in and out with finger-pressure only. For convenience, Aztek calls them 'nozzles', but they do in fact incorporate the needle as well.

Electronic equipment advertisement
Phil Evans
This advertisement by Phil Evans was one
of the first pieces of commercial art to be
produced with the new airbrush.

Interchangeable nozzles bring three very great advantages. The first is cleaning: a dirty nozzle can simply be unscrewed and dropped into a bottle of cleaning solvent to soak, and replaced with another one. There is more information on cleaning and maintenance on pages 152 and 153.

The second is that specialized nozzles can be fitted for particular applications: the initial Series 3000 line-up included a standard nozzle, a fine-line nozzle, a high-flow nozzle, and a spatter nozzle.

The third is that the broader, stronger Aztek needle and the high-technology nozzle both last far longer than conventional designs, so you are unlikely to need to change them because of wear. In the unlikely event that you have to remove the Aztek needle unit you no longer have to do so with the finesse of a bomb-disposal expert in order to avoid damage. You can touch the tip with your finger without causing any damage; it is a straightforward in-and-out operation.

All nozzle units are fully interchangeable across all models of Aztek airbrushes, which brings us back to cross-compatibility. At the time of writing, interchangeable paint-cups, nozzles and a brush-rest were the only 'accesories' in production, but others were on the drawing board or existed in prototype form. All Series 3000 accessories have been designed for easy addition to the airbrush. Not only does this mean that you should be able to borrow a friend's brush (or his spare nozzle, at least!); it also means that if you are familiar with one Aztek brush, you will be familiar with them all.

Technical Information

The information on this page is intended mainly for experienced airbrushers and for people who want to know how the airbrush actually works. You do not need to go through it if you just want to use the brush, but if you do read it, you may find that it helps your understanding of what you are doing. It will also explain the differences between the new design and previous types of airbrush.

The cutaway drawing shows how different the Aztek design is from previous designs. The air valve is the block in the centre of the airbrush; the needle/nozzle assembly, with the paint feed from either side, is clearly visible. When you press the lever down, it first opens the air valve and then (according to the roller setting) feeds color in as well. Pulling it back supplies additional color by moving the needle. As the needle moves back, the air passing the aperture of the color cup sucks color into the airstream, and the mixture sprays out of the nozzle.

The nozzle is unique in that it is injection-molded in a synthetic resin which is in many ways tougher than steel, and a good deal tougher than the soft brass which is normally used in airbrushes. Development was not easy, but the net result is that every nozzle is identical to every other nozzle of the same type. This removes the need to 'tune' airbrushes when you change nozzles or needles; you just change the tips with the same confidence that you would change the tips on a drawing-pen.

These are not the only advantages of the injection-molded nozzle: others include corrosion resistance, abrasion resistance, and elasticity.

Corrosion resistance is obviously far greater than for any metal. Of course, you should never leave color in the brush, because it can set and cake; but if you do, at least you have a good chance of being able to clean it out again. With a conventional metal nozzle, there is a good chance that you would write off at least the nozzle, and possibly the whole brush; almost certainly, you would be looking at a major overhaul. Cleaning the Aztek brush is described on pages 152 and 153.

Abrasion resistance is also greatly improved when compared with metal nozzles. If you are spraying a pigment-based paint, the individual particles may be as abrasive as sandpaper. Continued spraying through a metal nozzle can actually wear it away, resulting in coarse, inaccurate spray and the need for a new nozzle. The inherent slipperiness of plastics, on the other hand, means that wear on the plastic nozzle will be negligible.

Both of the previous advantages are related to the elasticity of the nozzle. Of course, 'elasticity' has to be understood in relative terms. The nozzle is not rubbery, but it has more 'yield' than a metal nozzle, which pays off in two ways. Oversize particles of pigment are less likely to score or dent the inside of the nozzle if they are trapped between it and the needle, and moving particles simply bounce off instead of leaving a scratch. What is more, the nozzle is to a certain extent self-cleaning, because it can yield slightly as the needle is pushed home; and if you drop it or bang it it will not dent like a metal nozzle.

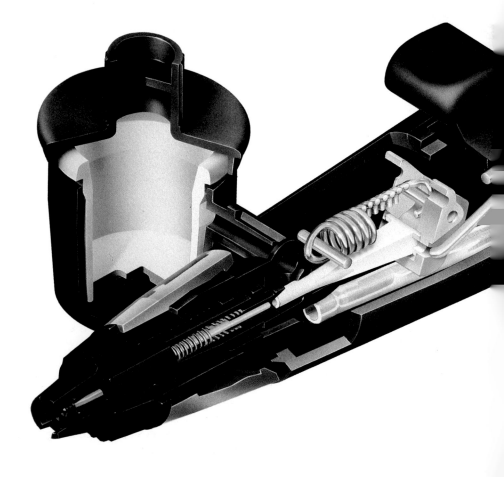

The nozzle/needle relationship is also unique. Perhaps surprisingly, the design of almost all previous airbrushes has been empirical, which in the final analysis is a polite way of saying 'by trial and error'. In the new design, the fluid dynamics of the air/color mixture have been carefully calculated to produce a brush which is considerably more reliable and less prone to color build-up on the needle. Unlike other airbrushes you will not draw paint through the body of the Aztek brush when you remove the nozzle/needle unit; the mechanism section is automatically blocked off as the unit is removed. If there are any build-ups, they can be removed without fear of damaging the stainless steel needle, which has a steeper taper and is much thicker and stronger than most designs. What will really amaze experienced airbrush users is that you can drop the needle on the floor (though we do not recommend this, and you should not rely on it), and then put it back into the airbrush, undamaged.

Isometric cutaway drawing of Aztek side-cup airbrush drawn by Adam Morrison airbrushed by Ray Mumford.

The air/color lever is 'fully floating'. This means that although you are working against a spring, the pressure that is required to move the lever up and down or back and forth remains almost constant; you are not fighting against ever-increasing spring pressure as you press or pull. The patented 'bicycle-crank' design also means that vertical movement is two or three times as great as on most designs, while horizontal movement is 50–100 per cent greater. Obviously, this translates into much greater sensitivity and control.

The linkage between the lever and the needle is, as can be seen from the cutaway drawing above, based on a circle with two stirrup linkages. During the first part of the lever's travel, where you need the finest possible control, a given movement of the lever causes a small movement of the needle. By the time the lever is (say) half-way back, however, the same movement of the lever will cause a considerably greater movement of the needle. This continuously progressive movement is exactly what is needed in airbrushing.

Paint will not get into the airbrush in normal use.

The synthetic resin body is lighter and stronger than conventional designs, and is ergonomically designed to sit comfortably in the hand. Experienced users will find that the grip is a little wider than they are used to (though new users usually find this more comfortable than older designs), and the balance is slightly different because of the lighter weight.

Blue figure Jens Holt
If you work in monochrome, you will get fairly similar effects whether you use dyes or pigments. Once the dimension of color is introduced, however, you need to know rather more about the medium in which you are working. (AA)

Chapter 2
Color, Propellants and Grounds

So far, we have referred to 'inks', 'paints' and 'gas' without looking at them too closely. In this chapter, we look at your options: what you can spray through the airbrush, what you use as a propellant, the grounds you spray onto and the other materials you may use.

Color

'Color' is a generic term for anything you can spray through an airbrush, including clear varnishes and resists. Normally, though, 'color' consists of two things: a medium and a dye or pigment.

The medium is the liquid which carries the dye or pigment. The most familiar medium is water but some inks are based on alcohols or other organic solvents, and in 'oil' paints, the traditional medium was linseed oil, though other oils were sometimes used. More modern alternatives to oils include acrylic media and alkyds: both of the latter are effectively plastics which 'cure' and become insoluble when they dry, though acrylic medium is water-soluble when wet and alkyds are alcohol-based. Further information on media is given in Chapter 8.

Dyes actually dissolve in the medium, and cannot therefore settle out; furthermore, the medium may be diluted repeatedly, simply weakening the color at each stage. Most modern inks are based on dyes; so are some (but not all) food colorings. Less obvious examples include wood, fabric, and leather dyes, all of which can be applied with the airbrush.

True paints, on the other hand, are based on pigments. These do not dissolve, but are suspended in the medium – which is why thicker media, such as oils, are often used. Pigments are solid colors. Ochres, for example, are earths; lamp-black, as its name suggests, is carbon or soot; vermilion is made from cinnabar; ultramarine was traditionally made from ground-up lapis lazuli; and there have been some truly wonderful recipes, such as 'mummy black' which was made from Egyptian mummies (honestly!) and Indian Yellow a yellow pigment which was made from earth which had been urinated upon by cows that had been eating mangoes!

Pure pigments produce clearly defined colors, and have known degrees of permanence, as described on page 12. It is worth knowing that if a tube of paint is labelled 'hue' (as in 'Vermilion hue' instead of 'Vermilion') it is not a pure pigment, but is mixed from a number of pigments to give the same color, though it will not always look the same in different lights and it may have a different permanence rating. It may also respond differently when it is mixed with other colors, including white, and it may appear different in photographs or in photomechanical reproduction. When buying paints, this is important; tints are normally significantly cheaper than pure pigments. For example, Rowney's Georgian Watercolours are less expensive than the Artist Watercolour range.

Many pigments have been successfully synthesized and some modern pigments are greatly superior to the materials they have (mostly) superseded; titanium white, for example, is brighter and less liable to oxidation than the old white lead, (Flake White), though some people still prefer the older pigment.

Traditionally, pigments were sold in lump or coarse-ground powder form and had to be ground by the artist before being mixed with the medium. Nowadays, traditional 'artists' colormen' who sell such pigments are increasingly hard to find, and even if you can find them, the colors will normally be ready-ground. This is just as well, as grinding is tedious, tiring, messy work and it would probably be impossible for most people to grind the pigment sufficiently finely to go through an airbrush. As a general rule, you should use only paints recommended for airbrush use, as others may have larger pigment particles which are unsuitable for airbrushing.

Some pigments are extremely toxic and should only be used with great care. It is always a good idea to wear a mask and with the more toxic pigments such as White Lead or Vermilion you should consider a respirator.

The obvious difference between pigments and dyes is that whereas pigments overlay one another and can (if applied thickly enough) completely obliterate underpainting, dyes are transparent. This means that mistakes made with dyes are a good deal harder to disguise! Some paints are hard to classify; among water-colors, for example, most are pigments, but they are so finely divided as to be effectively transparent. It is also possible to color a white pigmented paint with dye.

Clear varnishes require little explanation, though different

In order to avoid blockages, it is almost essential to strain pigment-based paints before putting them in the airbrush. Most people don't, but sooner or later they pay the penalty in clogged nozzles. If you are using a dye or ink with crusty bits, it is a good idea to strain this too. Thin pigment-based paints to the consistency of milk or (at the thickest) thin cream and strain them through a nylon tea-strainer; for lumpy ink, use an old handkerchief. The advantage of the 'tea-strainer test' is that anything which is too thick to flow through a tea-strainer will also be too thick to go through an airbrush.

media require different varnishes (ask your art supplier), and most modern synthetic varnishes are much less prone to discolor than most older formulae. Varnish is normally applied primarily for protection, but with oils (page 104) they also serve the useful function of giving all colors the same reflectivity; an unvarnished oil painting can be a hotch-potch of shiny and dull patches.

'Resists' are varnishes or coatings which are laid to *stop* the action of a plating or etching bath; the bath acts on the exposed metal, but not on the area that is covered by the resist. There is more information on this, and on glass-etching, on pages 146–7.

Daler-Rowney Color and the Aztek 3000-S

Daler-Rowney Cryla Flow is an artist quality acrylic which may be let down with water to a suitable viscosity for airbrush work, a ratio of approximately 2:1 color to water is recommended. This is a good start point but artists will need to modify this for their needs and the different colors in the range, which amount to 45 in tubes and jars ranging from 60cc to 2.25 Litre capacity. Periodic cleaning may be required (whether color changes are being made or not) to prevent build up of acrylic paint through drying in the reservoir of the nozzle. For gloss finish utilize Gloss Medium in place of some or all of the water referred to above. This medium will also speed up drying time.

Another Acrylic offered by Daler-Rowney is System 3 which is available in 22 colors and comes in 250cc squeezy pots for easy dispensing. This product is produced with economy in

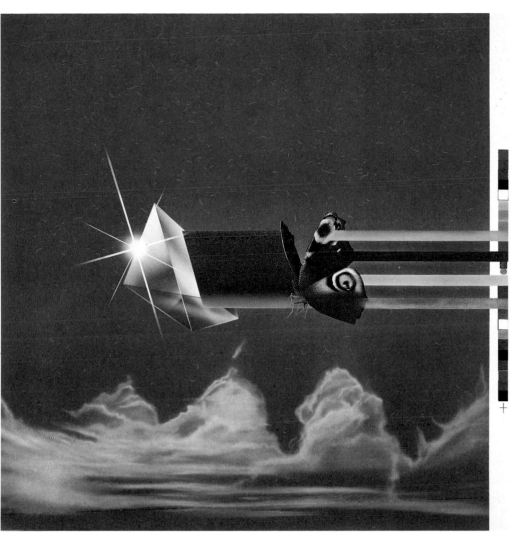

Woman Keiichi Morakami
This colorful image illustrates the illusion of a variety of textural effects from soft skin, produced by freehand spraying, to the crispness of the fan and the gloss of the eyelids and lips, where masking would have been used to create the required definition and highlighting. The spattered background is in complete contrast to the fine spray of the subjects, adding an impression of depth. (ICA)

The Reproduction Jon Rogers
The use of vibrant colors in this piece is an integral part of the way in which the artist expresses his ideas. The rainbow has been created by the soft blending of rays of color. These can be contrasted to the hard masked edges of the prism underneath. The necessity of a pre-planned sequence is clearly demonstrated by this picture: the butterfly and prism

were probably sprayed first; the rainbow and stripes second; then the completed sections would have been protected by masking and the sky filled in; clouds would have been added freehand in opaque white; and finally, the farkle on the prism would have been sprayed rather than knifed (the arms would be masked and then the centre is sprayed freehand).

mind and the formulation is particularly suitable for educational establishments. The mixing ratio is 1:1 color to water, but again this is a starting point and more water can be added dependent on application, and color selected. (Gloss Medium can be used in same manner as for Cryla Flow).

Rowney Designers Gouache and Poster Colors may also be used in the Aztek 3000-S and are less likely to build-up or clogging than Acrylics when diluted sufficiently, as resoluble binders are employed. Designers Gouache utilizes artists quality pigments and both ranges are available in a variety of sizes from 14cc to 500cc. Dilution recommendations are much more variable than for acrylics, but start with 5 color: 4 water and add more water as required.

A new product from Daler-Rowney is Opaque Airbrush Color. This is a pigmented color with alkali soluble acrylic as a binder, which can be used directly from the bottle without letting down with water. It is easier to clean than other acrylics and hardened paint can be redissolved with an alkaline solution

and particularly Daler-Rowney airbrush cleaner. There are 30 colors in the range packed in 30ml bottles with droppers to facilitate filling of even the smallest of airbrush cups.

Rowney Kandahar ink is a transparent dye (except black and white which is pigmented) and this too can be used directly with the Aztek airbrush. The colors give a brilliant and transparent effect and come in 14cc and 28cc bottles. Any color which has dried should be removed with methylated spirits, but initially clean equipment with water after use.

Finally, as a ground, Daler Truline Board is recommended. This is a 1750 micron board in 21×15″ and 31×21″ sizes. Its features are: a very smooth, high white surface, giving the optimum degree of obsorbency plus the durability needed for most erasure and masking techniques.

Daler-Rowney products are available from all good art stores worldwide. In case of difficulty, write to Daler-Rowney Ltd, P.O. Box 10, Bracknell, Berkshire, England.

Propellants

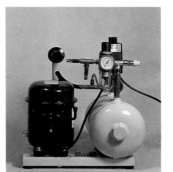
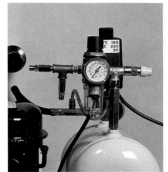

'Tinned wind' requires a minimal initial outlay, but running costs are high; if you do much airbrushing, you will do better to buy a compressor. Always buy the largest size of can that you can get, because they are proportionately much better value.

Small compressors like this are good value for the occasional user, but the noise can be irritating after a while, and you are likely to notice pulsing in very fine lines. Of course, you can always switch to 'tinned wind' for fine work, and use the compressor for less critical spraying or use a longer lead.

A larger compressor, with an air receiver (reservoir) and regulator, is far and away the most desirable option if you plan on doing much airbrushing. Many can handle two or more brushes; ask when you buy.

A regulator is essential if you want to use different media at optimum pressures, without guesswork, and a moisture trap (the glass bowl in this picture) is also extremely useful. It needs to be emptied occasionally.

Although the generic term for propellant is 'air', there are two major alternatives. For the occasional user, cans of pressurized gas are worth considering. This 'tinned wind' is an expensive proposition if you intend to do much airbrushing, but it does have its uses. You have to keep the can upright, or you will get liquid propellant coming down the line, and pressure can drop quite dramatically towards the end of the can's life, particularly because of the pressure drop caused by the cooling of the gas as it expands. Ideally, you need to use two cans, swapping between them as they cool; you may also wish to stand the can in warm (NOT hot) water, to extend the life between 'freeze-ups' and to get a bit more life as the can begins to empty. DO NOT put the can in front of a fire (including a fan heater) or in very hot water.

The other major alternative to air is carbon dioxide, in the same kind of cylinder that is used to pressurize keg beer. The 10 lb and 20 lb sizes (say 5 kg and 10 kg) are convenient and reasonably economical; you normally hire the cylinder, against a deposit, instead of paying for it outright. Because the pressure in the cylinder is so high (about 600 psi/40 bar), you need a more sophisticated regulator (see below) than the kind of simple tap which is sufficient on tinned wind, and once again the cylinder must be used upright or you run the risk of liquid CO_2 coming down the line.

If you are going to use compressed air, you are faced with two possibilities. One is to buy a large air cylinder, and rely on your friendly neighborhood diving school or someone else with a compressor to fill it up for you. You need high pressure, too: most garage compressors only run to 200 psi, and you need anything up to ten times that for reasonable life between refills.

These cylinders are surprisingly expensive, and you may wear out your welcome unless the compressor owner is a friend of yours, but this is still a relatively economical way to get your air. All air receivers should be checked regularly by a competent safety inspector for corrosion, which is a legal requirement in many countries. This is not mere bureaucracy: a big, corroded receiver can go off like a grenade. Aluminum cylinders, such as those used for skin-diving, are much less prone to corrosion; get one of these if you can. You can save money by buying second-hand, but in view of the dangers of corroded cylinders, this may not be wise.

For the ultimate in convenience, as well as for economy in the long run, you will need your own compressor. In the Good Old Days of airbrushing, some people used to charge their own cylinders with a foot-pump. This is still perfectly feasible, but it is surprisingly hard work, and a good footpump/receiver outfit would cost more than a modestly priced compressor.

The very smallest, cheapest compressors are not really to be recommended: they burn out if they are used for long periods (some motors have a working life of as little as twenty or thirty hours of continuous running), and the air supply is 'lumpy' with detectable pressure variations. They also make an irritating and distracting noise, the note of which varies with the spraying pressure. Small compressors are run continuously, connected directly to the airbrush.

It is a much better idea to use a bigger compressor, with an air receiver. The receiver stores air, which means that the compressor does not have to run continuously, and also allows a much more even air-flow. It is usual to run the receiver at anything up to 200–250 psi (14–16 bar), though there is no particular need to run it at more than 100–120 psi (7–8 bar); you then govern the pressure reaching the airbrush with a regulator, as described below. When the pressure in the receiver reaches a pre-set level, the compressor stops; when it drops below another pre-set level, the compressor starts again.

Second-hand compressors are not particularly expensive (though new ones are), and almost any piston compressor will deliver the kind of pressure needed to operate an airbrush.

One approach that is most emphatically *not* worth using, though it is still touted in some books, is to pump up an old car tyre (on the wheel) with a foot pump and then use that as an air-source. The pressure is low, and falls rapidly; the air is often moist, and contains dirt; and all in all, it is more trouble than it is worth.

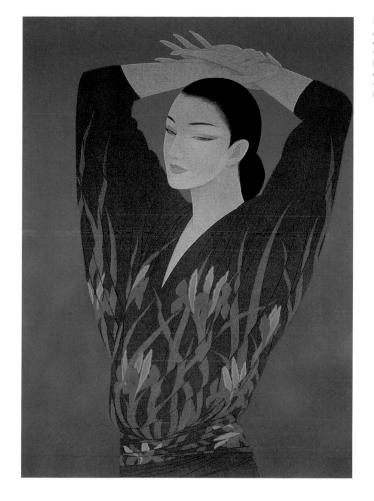

Iris Ichiro Tsuruta
Although this is a very skilled example, out of focus tones can easily be created with an airbrush and make an excellent background for other work. This effect can be produced either by masking out the already airbrushed/painted figure or by adding the figure to the background.

Pressure valves, filters and dampers

A typical operating pressure for an airbrush is about 30 psi (2 bar), but other pressures are often used, as described in the 'box'. In order to cut the pressure in your reservoir to this level, you need a valve which can be screwed up or down to regulate (or even cut off) the air flow. More sophisticated valves include pressure gauges and blow-off valves (in case the pressure in the receiver gets too high), and these are worth considering if you are doing a lot of airbrushing; otherwise, you have to do it by guesswork and 'feel', which can be difficult until you have some experience in airbrush use.

Some airbrushes can be damaged if the air pressure is too high, but the Aztek brush can be used perfectly smoothly and satisfactorily up to about 70–80 psi (5 bar), after which point the air safety valve begins to operate and vents the excess pressure. This venting is controlled, and will not damage the brush; reducing the pressure restores normal operation. At the other end of the scale, the standard nozzle can be induced to operate at as little as 7–8 psi (0.5 bar), but it is barely usable at this pressure.

It is well worth having a filter on the supply side of your compressor, to trap both water and oil. Both can cause 'fish-eyes', an infuriating blob of color which looks just like a fish eye on a uniform field. Water will cause fish-eyes in oil media, and oil will cause them in water-based media. Equally, blobs of miscible media are not much use either!

As already suggested, a problem with some compressor/airbrush combinations is that the pumping action of the compressor shows up as 'pulsing' at the airbrush; at worst, a fine line may come out as a series of dots. You can reduce this effect in two ways. One is to use an extra-long hose, and the other is to use an air receiver between the compressor and the airbrush. A six-foot (two-metre) hose should even out all but the lumpiest air delivery; a receiver of 50–100 cubic inches (say 1–2 litres) will be even more efficient.

Different media require different pressures, and the pressure required will also depend on the nozzle. With the General Purpose and all other Aztek nozzles the following pressures are good starting-points for different media:

Gouache	20 psi	1.5 bar
Ink	30 psi	2.0 bar
Acrylics	up to 60 psi	4.0 bar

Grounds

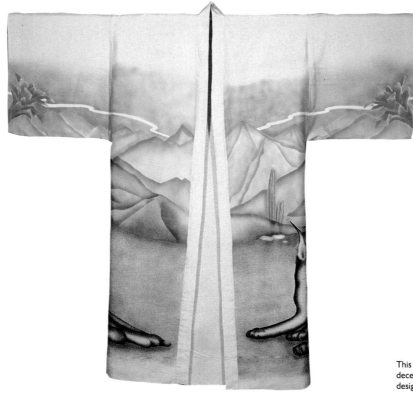

This silk kimono by Sue Saunders was deceptively difficult to paint; carrying the design around a garment so that it hangs naturally is not easy.

Grounds are simply the surfaces you spray on to: paper, illustration board, canvas, metal, glass, various plastics, and even cake frosting are all grounds. Some grounds are chosen for utility, such as paper; some are forced upon us, such as the metal of a car-panel; and others survive purely on tradition, such as canvas. Canvas is actually a pretty poor ground for oil painting, because traditional oils attack it and rot it, but the force of tradition is such that it still survives. A number of modern plastics would be superior! Some manufacturers are, however, combining traditional and modern methods. Daler canvases and panels are mostly acrylic primed and all are double primed.

Some media adhere to some grounds better than others, and the precise mechanism of bonding varies. In the ideal case, chemical bonding occurs between the ground and the medium. Usually, you require a 'tooth' or slight roughening of the surface, and with material such as glass you will often get better adhesion if you etch the surface first. In other cases, the ground has to be covered with some form of primer in order to make it accept the medium, and you have to choose your media carefully. An obvious example of this is in car customizing: it would be difficult to spray inks onto bright metal.

Also, there is a difference between what might be called 'continuous' and 'discontinuous' media. Some media, such as acrylics and alkyds, form a continuous skin over the surface of the ground, so that even if there are areas where adhesion is less than perfect, the medium can 'carry' the defect. Other media, such as gouache, form no such skin and will fail to adhere to any area where the ground is not properly prepared, or where it deteriorates afterwards. However, it is possible to mix an acrylizing medium with gouache so that it can be applied to substances such as acetate.

In practice, you can make almost any ground accept almost any medium, provided you are prepared to prime it properly. There are, however, two less obvious problems. One is when the medium attacks the ground (or vice versa), and the other is when you have to use brittle primers or paints on a flexible ground, in which case you run the risk of your work simply popping off. The main grounds and preparations are given on this page and overleaf.

Acetate

This transparent film is often used in the production of animated films as the vehicle for individual images or animation cells. It is also useful for overlays or when you wish to build up layers of color or tone. Some technical artists work solely on acetate because it removes the need to trace line images onto the ground.

Canvas

Canvas accepts oils, acrylics and alkyds, but requires careful preparation for traditional oils.

The traditional approach to priming was to stretch the canvas and then to use rabbit glue to size it. Next, it was covered with repeated layers of gesso (whiting plus rabbit glue), working in alternate layers, running the brush in one direction for each layer – first horizontally, then vertically, then horizontally again, giving plenty of drying time in between, until the surface is smooth and flat. The gesso acts as a barrier between the paint and the canvas. Daler-Rowney supply the necessary materials and a booklet entitled *An Introduction to Egg Tempera Painting* which explains in great detail how to prepare a traditional gesso panel.

Nowadays, you can buy ready-stretched and even ready-primed canvas, and proprietary acrylic gessoes are quicker and easier than older methods. If you use a well-diluted acrylic gesso, you can actually soak it into the canvas and coat each rot-prone fibre of linen or cotton with a thin layer of plastic, which will make the canvas vastly more durable.

Although some people paint straight onto canvas with acrylics, others prefer to prime it first. Only with alkyds (see page 104) can you paint straight onto unprimed canvas with total confidence.

Alternatively, there are synthetic canvases, but many painters feel that they do not accept paint well and they are not widely available.

Acrylic canvas primer can also be applied to almost any other surface, including wood, metal, and so forth, but it will not always stick very well; acid etching of glass and metal is advisable (see page 146). Acrylic medium or 'acrylizer' (without color) will stick to virtually any clean surface. Hardboard Panier, which is made of white titanium pigment bound in an oil-modified alkyd resin, is suitable as a base for oils and alkyds.

Canvas Board
'Canvas board' is used to describe two quite different materials. One is a form of illustration board (see below) impressed with a canvas-like pattern, and the other is a form of stiff board covered in canvas, usually sold ready-primed. The former can be treated like any other type of illustration board, and the latter can be treated like 'real' canvas.

Fabric
The difficulty with fabrics lies in finding the right dye which can be used on dry fabric. There are constant advances in dye technology, so the only practical approach is to discuss matters with craft shops. There are many different brands of fabric dyes, formulated for different fabrics: cotton dyes are unlikely to work at all on nylon, for example. Some of these dyes are highly specialized and only available in certain shops, so it is worth asking at the best craft shop in your area. You will soon find out which one that is!

Rubberized fabric paints will stick to almost anything, but the texture is not to everyone's liking.

Frosting
Sugar frosting or icing is normally only used with food colors, for obvious reasons; the medium is usually alcohol (brandy, vodka, etc) but water is also theoretically possible. The disadvantage of water is that it is slower-drying and can dissolve fine detail or etch the surface of the icing. See pages 140 and 141.

Glass
Getting anything to stick to glass, at least for any length of time, is not easy. Winsor & Newton's excellent 'Vitrina' range no longer seems to be available, though there are other makes of glass paint including Mameri and Lefranc & Bourgeois. Automotive paints also adhere reasonably well to glass. If you want to use oils, alkyds or acrylics it is as well to have the glass sand-blasted or etched with hydrofluoric acid.

Hardboard: see Masonite

Icing: see Frosting

Illustration Board

There are many grades of illustration board, but they are *not* the same thing as cardboard, which has far less abrasion resistance, is much likelier to 'pick up' when you remove masking film (pages 50–1), and quickly discolors.

Most illustration boards are heavily loaded with china clay, which gives a very smooth surface and allows you to work at high pressures, as there is no danger of paper fibres lifting. Illustration board is normally used with the same media as paper (see below).

Masonite

Known as hardboard in the United Kingdom, this accepts most media but is usually very acid, which leads to rapid discoloration of paints and disintegration of the ground. Swedish steam-pressed hardboard is vastly more durable and acid-free than the usual chemical-pressed variety, and it is possible to get pH-neutral forms of hardboard which are at least as good a ground as canvas. You will, however, need a good builders' merchant to know which is which.

You can paint directly onto either side, with or without priming; the main advantages of priming are that it gives you a lighter color to work on, and that it protects the board if you are using traditional oils.

Metal

Many media will stick to bare, clean metal: automotive paints are the obvious example, but you can also use oils, acrylics and alkyds. Acrylics and alkyds will adhere better, especially if there is any danger of the panel flexing.

The important thing in preparation is scrupulous de-greasing, and acid-etch priming is also a good idea. See pages 112–13.

Paper

Available in an immense range of weights, surfaces and qualities, most of which will accept almost any medium.

The best papers are known as 'rag' papers, because they are made from cotton or linen rags, which have much longer fibres than the wood in 'pulp' papers (see below). Rag papers are more durable and resistant to attack from media than fibre papers, but no paper can stand up to oil paints. Hand-made rag papers, the finest (and most expensive) papers available, are enormously strong and usually have quite a rough surface, as they are sold 'unpressed'. Pressed rag papers, smoothed between rollers, can be very smooth indeed; banknotes are printed on pressed rag paper.

Pulp papers are made from wood pulp, and are considerably cheaper than rag papers. Unlike most rag papers, wood pulp papers are often loaded with china clay to give a smooth surface; this book is printed on such a paper.

See also pages 102–3, *Watercolor*, for more details on stretching watercolour paper, and for watercolour in fine art.

Photographic Film

Large sheets of graphic arts film may seem an unconventional ground, but some brands apparently accept gouache very well – and, of course, you can transfer the original image to the base photographically, with a PMT machine. Draw the design so that it will reproduce in *very* fine lines which will not be visible in the final artwork. A particularly interesting possibility with gouache on film is that you can wash off overspray with water, and it is also possible to attack the paint physically with steel wool, fine wire brushes, etc, to create texture effects. You can, if you wish,
paint on both sides of a film which has a gelatine anti-curl layer on the other side from the emulsion.

Plaster

Plaster can be worked wet (fresco) or dry. One of the most exciting possibilities in airbrushing is the potential (if you could work fast enough) to complete a complete fresco at one go, instead of working in sections as you would with normal techniques. The medium is actually the plaster itself; the pigment is mixed with water and worked directly onto the wet plaster, so the medium and the pigment are actually applied separately – and classical fresco artists would sometimes use two or more layers of very thin fresco. It is a hair-raising medium, in that the only remedy for errors is replastering, and there are very few plasterers who can prepare plaster suitable for fresco painting anyway – but we would love to hear from anyone who has tried to use an airbrush for fresco painting.

Very little adheres reliably to dry plaster, because of its frequently dusty surface, and oil paints will fairly jump off the ground after a few years. Acrylics and (especially) alkyds are a better bet, and automobile paints are probably best of all. For maximum grip, prepare the plaster with 'acrylizer' (acrylic medium).

Plastic

With plastics, there are three possibilities. One is that the medium will dissolve the ground; the second is that there will be a good bond; and the third is that the medium will not stick. The only way to find out is by experiment, but methyl methacrylate, sold as Lucite in the United States or Perspex in the UK, is a good ground; so is acetate sheet. Both are extremely stable, both dimensionally and from the point of view of rot-resistance. Oils are good media, but acrylics and alkyds are better; there are also some transparent colors formulated especially for acetates, which are used in film animation.

To test an unknown ground with a given medium, put a little paint on a piece of scrap material and leave it to dry. When it is dry, try to scrape it off. Sometimes, you will find that color has actually migrated into the plastic, indicating an excellent bond.

Stone

A great deal depends on the kind of stone you want to paint. Limestones, sandstones and similar sedimentary rocks are prone to crumbling, and a good coat of the kind of stone-paint made for house decorating will help hold them together, especially if you are planning on using oils. The same is true to a lesser extent of metamorphic rocks such as marble, though few people would want to cover up marble in any case. With igneous rocks such as granite, the only reason for preparing the surface is to get a lighter, uniform surface on which to paint.

Fine-textured porous sedimentary rocks will accept watercolors and inks as well as oils, alkyds and acrylics (including automobile paints); it is normally difficult or impossible to prepare igneous and metamorphic rocks to accept watercolors or inks, unless you prime them in some way first.

Wood

Wood was the standard ground for art before canvas came into use, and in many ways it is still superior: it is just more expensive, and heavier. The wood must be well seasoned to avoid warping and cracking, and it is normally coated with gesso in the same way as canvas, both to protect it from the oils and to provide a light, uniform-colored ground.

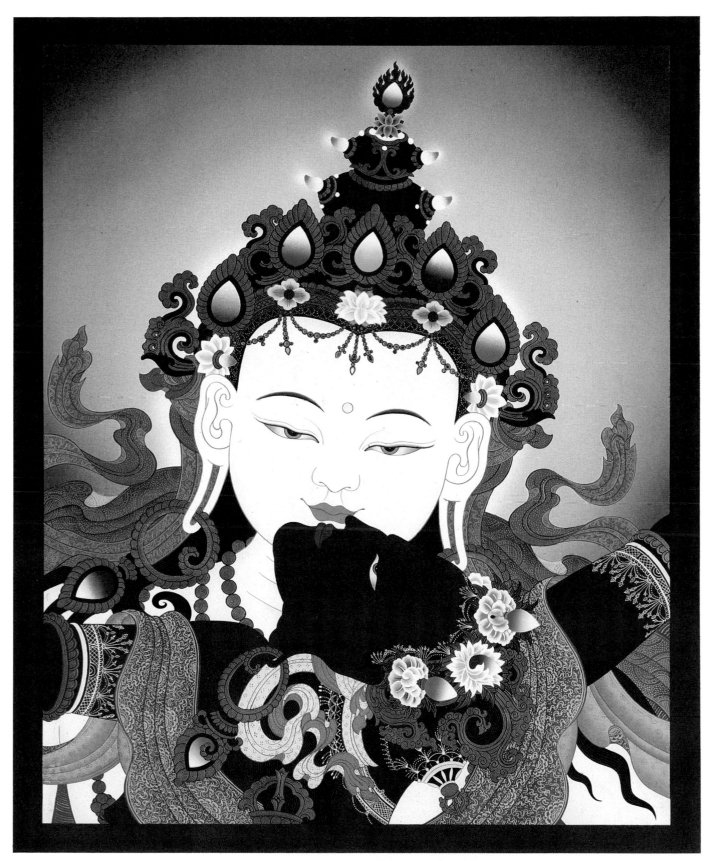

rDorje Sems.dpa Robert Beer
Robert Beer paints traditional Tibetan-style *Thangkas* (devotional paintings) using an airbrush. This representation of rDorje Sems.dpa (Vajrasattva) of the Drukpa Kagyud school is done on illustration board which is heavily loaded with china-clay. The original is only about 12 x 16 in (30 x 40 cm). Most illustrators choose this type of board because the surface will not be damaged and paper fibers will not lift when high pressure is used. With other types of board or paper the fibers lift and a texture is created by the spray. This can, however, be used to create special effects.

Equipment – Glossary and Checklist

The additional equipment and supplies below are rated on a star basis. Three stars means that the item is essential, or near-essential, except perhaps for a few specialist applications. Two-star equipment is highly desirable, while one star is frankly luxurious. No stars indicate mainly historical or highly specialized use.

Acetate sheet**
Stiff sheet used for making loose masks – see page 48. Can be cut with a scalpel or, where the utmost precision is not important, with a hot-wire cutter such as the Air Nouveau Stencil Burner.

Brushes***
The airbrush is used alone only rarely. Often, detailed work is added with conventional sable brushes. The best brushes you can afford are usually a wise investment.

For photographic and other fine retouching, use *squirrel* brushes (not sable) and pull out the long central hair. Squirrel brushes are slightly stiffer than sable.

Compasses**
A 'system' design is best, as it enables you to use extension arms; a pencil; a drawing pen (see below); or even a scalpel blade. Some manufacturers sell purpose-made blade-holders, and others sell blades which will fit in place of the lead in a compass-holder. It is sometimes possible to put Swann-Morton or X-Acto blades (see below) into a drawing pen (ruling pen) attachment, but it may not function too well at its original purpose afterwards.

Cutting Mat***
A plastic cutting mat, available from art and graphics supply shops, has no 'grain' to turn the blade of your scalpel when you are cutting and blunts scalpels less quickly than other cutting surfaces. It is essential if you are cutting stencils or loose masks. The plastic 'heals' or flows back together in time, so that old cuts do not turn your blade when you are cutting. Translucent versions are available which can be used over a light-box, which is useful (for example) when you are transferring a design using tracing paper.

Drawing board**/Drafting table*
Used with a T-square (see below), a simple drawing board makes technical drawing very much easier. If you can afford it, a proper drafting table with parallel motion is a dream. If you aspire to technical illustrations of the type shown on pages 134–7, a first-class drafting table is effectively essential.

Ellipse guides**
Plastic ellipse guides make it very much easier to draw reliable ellipses; they are available in a wide range of sizes. You can also use them as spraying masks, but it is advisable to keep your spraying ellipses and your drawing ellipses separate.

Ellipsograph*
An ellipsograph is a rather complicated mechanical device which allows you to choose the major and minor axes of an ellipse and to draw it with absolute accuracy. You would need to have a specialized need for one of these before considering buying it.

Erasers***
Kneadable or 'putty' erasers will not mark the surface of illustration board, and can be molded to a point for fine work. Firm or 'stick' erasers (the sort familiar from school) are easier to use but can mar the board surface.

Partially erased areas accept color in a slightly different way from untouched sections, so if you want to spray after using an eraser, it is as well to use it over the *whole* surface, very lightly if necessary.

For some purposes, 'clutch erasers' (which work on the same principle as clutch pencils) are invaluable; you can even sharpen them with a pencil-sharpener.

Fine-Line Tape
In office supply shops, you can buy narrow tape – down to 1 mm, about 1/25 in or less – which is used in drafting and artwork preparation. It makes excellent ultra-narrow masking tape.

Flexible Rulers
Often known as 'Flexicurves', after the leading trade name, these are invaluable for drawing curved lines. DO NOT attempt to bend them 'against' the plane in which they bend readily, or they will break.

French curves**
These curious-looking drawing aids are considerably more useful than they look, and (like the ellipse guides) they can be used as spraying masks as well as for pencil drawing. Once again, it is best to keep your drawing curves separate from your spraying curves.

Frisket
'Frisket' is now used as a generic term for 'masking film' (see below), but its original meaning was *home-made* masking film. If you paint liquid masking (see below) onto glass, let it dry, and then peel it off, you will have a frisket. This is so much work, and the product is so inferior to proprietary film, that it is hard to see why anyone would bother nowadays.

Grant Projectors and PMT Machines*
Both 'Grant' and 'PMT' are trade names, but both are used generically. A Grant projector is a sort of camera obscura which allows you to enlarge or reduce artwork, and make tracings to size; a PMT machine is a similar sort of thing, but it can also be used to make photographic copies. Both of these are examples of the kind of professional tools which make life much quicker and easier, but both are prohibitively expensive for the amateur – though occasionally, you may be lucky and find a cheap secondhand one.

Hair dryers**
Domestic hair dryers are often used to accelerate drying. Use the lowest heat setting, and take care not to 'cook' the masking film onto the ground. Air bubbles in the masking film will expand as they are heated; give them time to cool down before pressing them out.

Kitchen Rolls/Tissues***
White kitchen rolls are perfect for mopping up, drying up and checking color (colored paper masks any residual color if you are spraying water to check that the gun is clean). Tissues are used mainly in cleaning the brush.

Knives, Scalpels and X-Actos***
'Knife' is the generic term, used professionally, but it covers a range of tools. Britons tend to prefer the Swann Morton scalpel; Americans mostly use the X-Acto cutting knife. Either way, the secret of good cutting is to keep a good stock of interchangeable blades, and to put in new ones frequently.

Masking film***
Low-tack masking film is the standard material for airbrush contact masking (see page 50), but you can also use the thicker, stickier films used for book covering if you are working on coarse surfaces such as pottery or even canvas.

Masking film is available in glossy finish, or with a matt surface which accepts various drawing media.

Masking fluid
Some people still use liquid masking, instead of film. Masking fluids are evil-smelling, have to be worked fairly quickly before they dry out, and tend to pull the hairs out of the brushes that are used to apply them, as well as drying irremovably onto the brush. A useful tip is to soap the hairs of the brush before you start, but even that will only alleviate the problem; it will not solve it. They can, however, be useful on awkward three-dimensional grounds, as in car customising, and Robert Beer (see pages 31 and 93) vastly prefers liquid to film.

Life in the Jungle Susumu Matsushita
Soft or freehand spraying has been used
to create these cartoon figures (JCA).

Masking tape***

Most commercial studios use masking tape in enormous quantities, for anything and everything. You should not, however, leave it in place too long or it may be difficult to remove. Some people prefer Scotch Tape or Sellotape, because it is transparent, but you should only use this on masking film or on other surfaces where you are sure you can remove it without marring the ground. Double-sided adhesive tapes are often ferociously adhesive, and can lift grounds.

Pencils***

Soft pencils are used mostly for preliminary sketching; for final drawing, rather harder pencils are used, and for drawing under transparent inks (pages 22–5), very hard pencils are required. Charcoal pencils are useful when you are using oil-based paints, as the line will not migrate through the paint in the way that graphite pencils do.

'Non-photo blue' pencils have a blue lead which will not 'read' when line negatives are being made from artwork; they can be very useful for marking up instructions to the platemaker or printer, but obviously they are irrelevant for color work.

Proportional Dividers*

Although these are surprisingly expensive, they can be extremely useful for scaling illustrations, especially when you are using a scaling grid. They look like double-ended dividers, and the position of the pivot can be moved, so that (for example) one unit on

one end corresponds to four units on the other. Look for them second-hand in navigational shops; they are often used in chart-reading.

Rapidograph*

'Rapidograph' is a trade-name for a type of drawing pen made by Koh-i-Noor, but it has come to be used generically. Similar pens are made by Rotring and also by Pentel; the Pentel has the advantage of replaceable, disposable inserts. Rapidographs have several advantages over conventional ruling pens (see below). Not only do they have a fair-sized ink reservoir, which removes the need for frequent refilling: they are also much easier to use freehand than ruling pens. Some people draw straight onto masking film using a Rapidograph.

Ruler***

You will usually need at least two rulers, or at least, a ruler and a straight-edge. A transparent plastic ruler is invaluable when drawing, and a metal ruler or straight-edge is useful for cutting a straight line with a scalpel. See also *Scaling Ruler*, below.

Ruling Pen

The old-fashioned ruling pen is less convenient in some ways than a Rapidograph (see above) but apart from being cheaper it has several other advantages. First, it will accept virtually any medium that you can use in the airbrush. Second, it is easier to clean. Third, you can vary the line width simply by

screwing the points closer together or further apart. Fourth, you can usually fit a ruling pen to a pair of 'system' compasses, while a Rapidograph needs a special adapter.

Scaling Ruler*

A useful tool is a ruler scaled in reduced-size 'inches' or 'centimetres'. Typical scales are 1/2, 1/3, 1/4 and 1/12, so a twelve-inch ruler is scaled 1–24, 1–36, 1–48 and 1–144: a 30 cm rule would be scaled 1–60, 1–90, 1–120 and 1–360. Other rules have 1:250 and 1:500 scales, primarily for map-drawing. The advantages when making scale drawings are obvious: for a 1/3 scale drawing, for example, you measure the original with a regular ruler, then make your drawing using the 1/3 size 'inches'.

Set Squares**

Ideally, you need a 45° square, a 30°/60° square, and an adjustable square. For professional use, big is beautiful: the miserable, undersized things sold in school geometry sets are more trouble than they are worth.

Teat pipettes***

Or, to use their less glamorous name, eye-droppers. These are almost certainly the easiest way to load any airbrush, though some people prefer to carry the paint on a brush and wipe it into the reservoir. Alternatively, disposable syringes (without the needle) are pretty good.

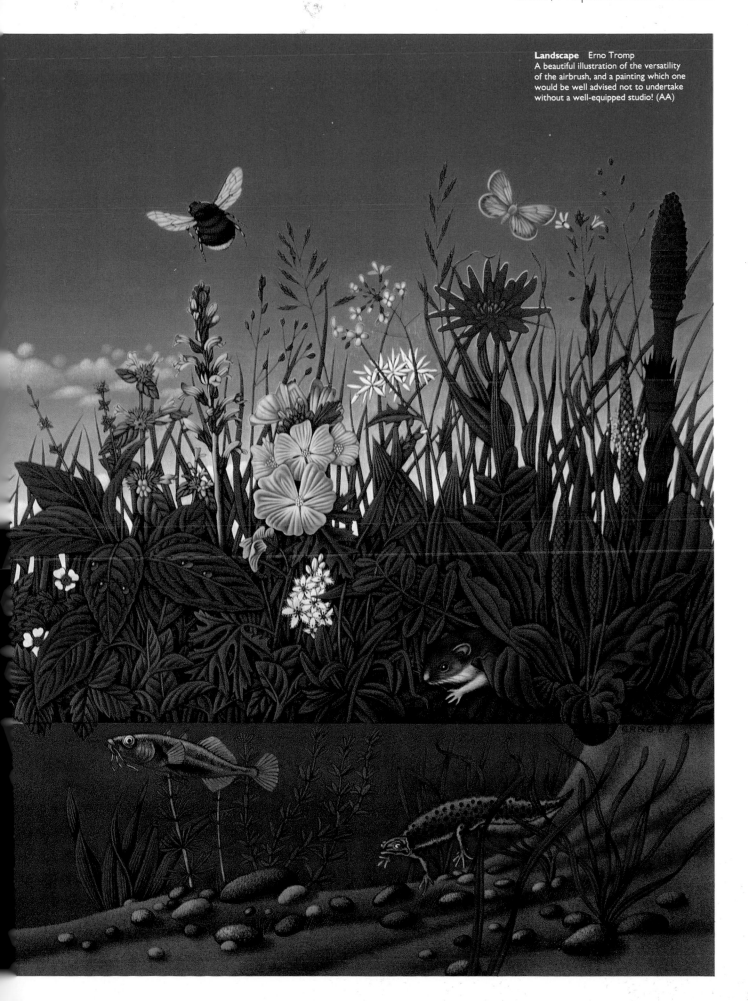

Landscape Erno Tromp
A beautiful illustration of the versatility
of the airbrush, and a painting which one
would be well advised not to undertake
without a well-equipped studio! (AA)

Chapter 3
Freehand Airbrushing

Anyone who buys both a book and an airbrush at the same time, and who then reads the book *before* playing with the airbrush, must be possessed of an exceptionally calm turn of mind. The airbrush is a fascinating tool, and most people will probably want to give it a test-drive before they settle down to reading the book.

Unless you are unusually gifted, however, you will soon find that you need to know more about the airbrush in order to get the most out of it. If you *are* unusually gifted, you will probably come to the same conclusion even faster. This is where the book comes in useful.

The airbrush can be used in much the same way as a conventional brush, which is known as freehand airbrushing, or in conjunction with masking as described in the next chapter. For maximum versatility, you will need to use both techniques, but learning freehand airbrushing comes first.

Airbrushes, even the most sophisticated airbrushes, are sprayguns. It is therefore impossible to get the same kind of 'hard edge' effects that you can with a conventional brush unless you do use some form of masking. You can, however, do three kinds of work completely freehand.

The simplest is 'blowing in' color. Whether you are creating a background for a painting, or retouching a motor-car, you can do this freehand and either without masking or with the very simplest masking – just newspaper and masking tape to protect areas you don't want sprayed. This is described more fully on pages 50–1.

A considerably more advanced kind of airbrushing is freehand painting on the large scale. Perhaps the best-known exponents of this technique are the graffiti artists who decorate city streets and subways. Some of them are just vandals and defacers, but even if you don't like graffiti, you have to admit that some of these fly-by-night painters are artists of no mean skill. They work mostly with spray-cans, which are much less controllable and versatile than airbrushes, but the results can be quite impressive. If you want to emulate these effects, which could be very effective in car customizing for example, you can do so with any airbrush that is capable of producing a reasonably wide spray.

The most difficult type of freehand airbrushing is fully detailed painting. For this, you need an airbrush that is capable both of broad-scale work and of fine detail; for obvious reasons, those who favor freehand airbrushing usually tend to work BIG, and a canvas three feet by five feet (or 1 m x 1.5 m) is regarded as small. This can make tremendous demands on the range and versatility of the airbrush, and the fine-line-to-broad-spray capability of the new design is invaluable to fine artists.

Even if you only ever want to use masks, freehand exercises are well worth trying from time to time, just to learn what the airbrush can do and to master the discipline. Not only is there an interesting quality to freehand work; there are also many occasions when you will need to add freehand detailing inside a mask.

Portrait Talia Fisher
Talia Fisher produces freehand portraits reminiscent of the old movie-house portraits of stars. She works mostly in monochrome, but an example of her color work appears on page 92.

Line Drawing

Lines & line faults
Reading from top to bottom, this shows
Insufficient air (spatter)
Poor finger-lever control
Working too close to the ground
(spidering)
Too much ink (spidering)

A good, methodical beginning to the serious study of the airbrush is simply to practice drawing lines using paper and ink. The better the quality of the paper, the better the quality of the work can be, but for the very earliest exercises you might as well continue to use the same sort of thing as we suggested earlier, newsprint, lining wallpaper, old computer printouts or printers' offcuts.

The most basic exercise is predictably the straight line. Experiment with different settings of the roller, and with different combinations of ink (downwards pressure) and air (backwards movement). Also, try working at different distances: for the very finest lines, the brush will actually be touching the paper surface.

If you find that it helps, use a ruler or straight-edge to guide your hand; this not only helps to keep the line straight, but also helps to keep the distance between the brush and the paper constant. This technique is shown on pages 58–9. The nozzle has a small step on it which you can use to run along the ruler:

support the ruler itself on a couple of books to get a fixed distance from the paper. Start with a distance of about 4–6 in (10–15 cm), and work inwards. Work as slowly as you can; this gives you a much better idea of the capabilities of the brush.

You will soon discover that too much ink and not enough air causes spattering, but 'spidering' is more complex. Even with the correct ink/air mix, you can get spidering if you are holding the brush at too low an angle to the paper, or if you are moving the brush too slowly, but a great deal also depends on atomization and drying rates: a finely-atomized, fast-drying spray on absorbent paper is obviously far less prone to spidering than coarsely-atomized wet spray on shiny paper. Also, the closer you work to the paper, the less air and ink you will need and the greater is the risk of 'spidering'.

Unless your finger pressure is absolutely steady, you will also find that the line wavers in thickness. All of these possible errors are shown here, along with examples of correctly drawn lines at different distances.

When you are satisfied with the straight line, or when your patience runs out, practice your signature again and then try a curlicue; this is the kind of ornament used by the scribes of old to embellish their manuscripts.

Begin by trying to draw an absolutely consistent series of loops: keep both the loop size and the spray width even, and just work down the page. This is more difficult than it looks.

Once you are confident that you can draw consistent loops, and you have tried signing your name again, you can try the curlicue itself. Begin by trying to keep the line thickness constant as you reduce the loop size and then try to reduce the line thickness along with the loop size. Now try signing your name again . . .

By this time you will have found out two more truths about drawing lines with an airbrush. The first is that it is difficult to end a line cleanly without a blob, and the second is that you often get spatter at the beginning of a line. The cure for both these problems is the same: as you approach the end of a line,

gradually release pressure on the lever rather than letting go sharply. At the end of the line, this will result in an abrupt tapering-off rather than a blob, and it will also ensure that you clean out those few drops of ink which would otherwise cause spattering when you begin the next line. Another problem, when you have finally mastered the fine line, is the temptation to lift (or even jerk) the brush away without cutting off the air/ color supply: this will result in a sudden widening of the line before it vanishes altogether. On the other hand, going *controllably* from a fine line to a broad one is a skill to practice.

You should by now have had enough of lines, though you will need to keep practicing if you are to become really proficient. If you are stopping for the day, CLEAN THE AIRBRUSH by emptying out the cup and running water (preferably followed with a cleaning solvent such as alcohol or methylated spirit) through it; otherwise, read on.

Even curlicue (far left)
Practice even curlicues like this until you are confident that you can work reliably at different distances and air/color combinations

Increasing curlicue (left)
In contrast with the advice given in the text, this curlicue was *begun* very small and then expanded steadily. Which way around you prefer to work is a personal matter.

Airbrushing (right)
Like the two curlicues on this page, this demonstration was done by the inventor of the airbrush, Jan Ilott. Some people suspect that two brushes were used, one for 'air' and one for 'BRUSHING', but if you look closely you will see that it would be almost impossible to form such a join.

Tone and Shading

Producing an even area of tone – the effect that painters call a 'flat wash' – is one of the most obvious applications of any spray-gun, but it is much easier to achieve if you know how. Also, a great deal depends on whether you are applying several coats of the same tone, or spraying lightly to create an overlay.

To begin with, it is probably best to practice using paper and ink again, though the techniques are exactly the same if you are painting a car door with enamels, or an iced cake with food dyes.

Creating a solid tone, using several coats, is much easier than creating an even, faint overlay; if you have mastered the overlay, you simply repeat the same technique again and again until you have built up the depth of color you want. *This is the only way to get a smooth, deep color.* If you try to cut corners by using fewer, thicker coats of paint you will only get runs, and 'orange-peel' effects if you are using enamels. This is as important to the car customizer as it is to the watercolor painter.

The basic technique is *always* to spray beyond the area which you need to cover. The reason for this is that as you reverse the

direction of movement of the brush, you will inevitably double the spray thickness at that point. This causes local areas of higher color density, and if you are working close to the limits of coat thickness, doubling the amount of color on the ground may well lead to runs or dribbles as well.

If you are working on paper, you need to continue the movement of the brush beyond the edges before reversing the movement; if you are working on, say, an automobile panel you may need to use newspaper and masking tape to protect areas you do not want sprayed. Most people find it easiest to work at a distance of about 8–12 in (20–30 cm), though you may prefer to come in a little closer or to move out a little further. Rather than spraying 'square-on', you will almost certainly find it easier to spray at a slight angle; if you are spraying a vertical or near-vertical surface, angle the brush down slightly. Note 'slight' and 'slightly': steep angles can lead to problems, especially spidering. Also, use the lid on the paint-cup to avoid spillage!

Although this is the easiest way to get an even tone, experienced airbrush artists will find that they can vary the color

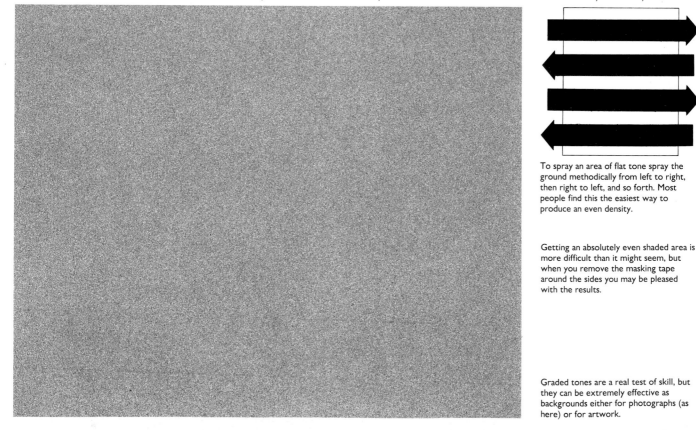

To spray an area of flat tone spray the ground methodically from left to right, then right to left, and so forth. Most people find this the easiest way to produce an even density.

Getting an absolutely even shaded area is more difficult than it might seem, but when you remove the masking tape around the sides you may be pleased with the results.

Graded tones are a real test of skill, but they can be extremely effective as backgrounds either for photographs (as here) or for artwork.

as they reach the edge of the paper; constant small adjustments to the vertical pressure are very easy with the new design, because of the sensitivity and suppleness of the control. This makes limited-area tones (without masking) much easier.

On the previous page, we mentioned spattering. Normally, this is a nuisance, but if you can learn to control it, you will have a whole new technique literally at your fingertips; a controlled fine spatter is useful for rendering surfaces as diverse as concrete and rough-cast metal, depending on color and scale. One of the easiest ways to achieve it is to reduce the air pressure at source, by turning down the regulator.

Graded Tones

Once you are content with the quality of your flat tones, you can try a graded tone, or as artists say, a 'fading wash'. Use exactly the same technique as for the flat tone, but gradually reduce the paint supply with each successive pass as you move down the paper. To build density, as with a flat tone, repeat the exercise. Creating a graded tone is easier described than done,

but with practice a perfectly graded tone from deep color to white can be produced. If you look at advertisements, you will find that this is a popular background for 'pack shots' which show photographs of the product; it can also be a very effective background for various kinds of artwork.

'Soft Edge' Areas

For some applications, you may wish to create an area of tone which fades towards the edges. This is considerably more difficult than a regular 'wash', because you need to taper off the air and color as you approach the edge of the field, and then to feed it in again as you start the next line. This is awkward enough when you are dealing with a square or a rectangle, but if you are trying to paint an area of a particular shape, it becomes *really* difficult. Masking (page 44) is likely to be much easier, though the effect will be different.

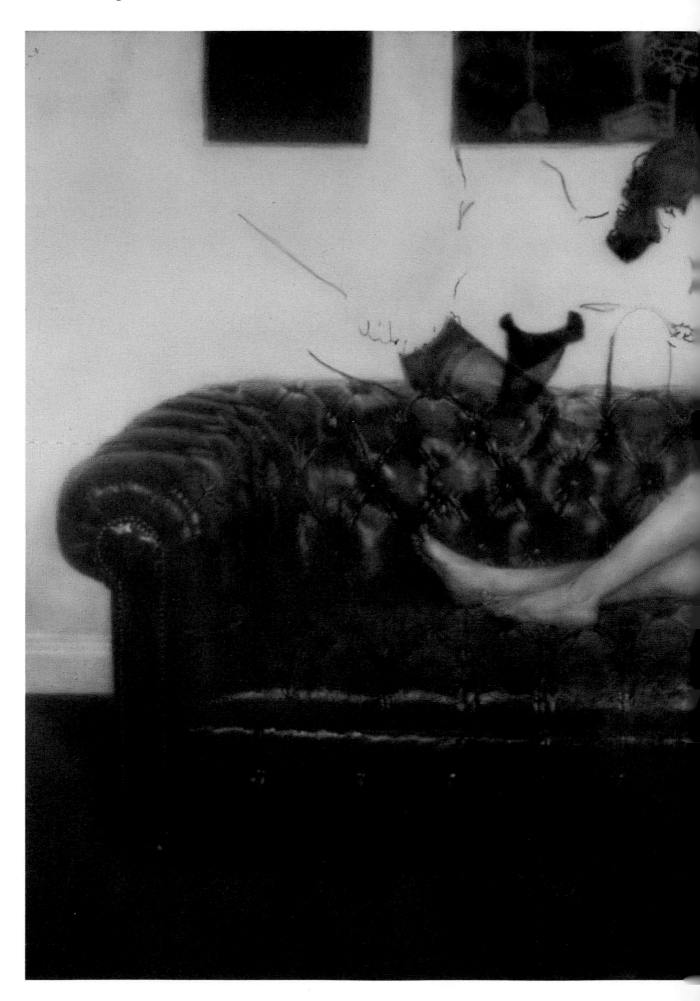

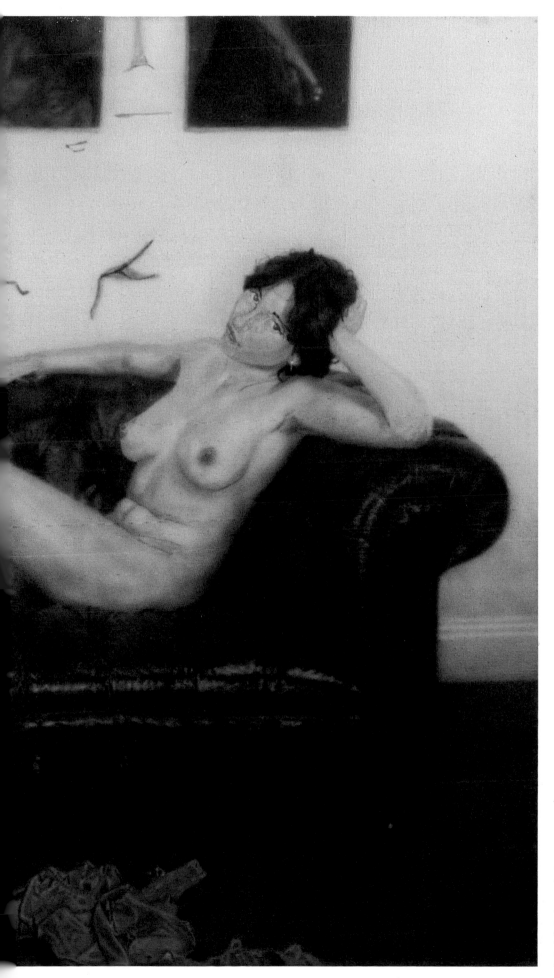

Untitled Seng-gye
This painting is one of a pair executed as a pastiche of Goya's paintings The Maja Clothed and The Maja Nude. Here the artist has used freehand airbrushing to create realistic textures – notice the soft highlights on the worn leather and the glowing skin – to emphasize the painterly effect and strengthen the intimacy of the nude figure. Compare this with the intimacy of the portrait by Yip Kam Tim on page 95: the intimacy here belongs to the nude figure and her surroundings. Although our gaze is drawn towards the figure, the artist has used the challenging stare and direct eye contact to echo both Goya paintings and to distance the viewer from the figure. However, this helps to create an inner and physical reality which forces us to see the nude woman as a whole person and not as an object. Unlike the Goya nude the stare is neither indolent nor sensual but has a purposeful quality that makes the composition more realistic. The painting is *entirely* sprayed: that is, there is no conventional brushwork or even knifing. Compare it with its fully-masked (non-identical) twin on pages 52-3. Acrylic on canvas, 36×48".

INRI Seng-gye
Although this painting conveys the idea
of a mask very well, the gold leaf was in
fact applied in the conventional way.
Look at the figure of Christ crucified,
however, and you will see how areas of
flat tone are used to create a three-
dimensional effect.

Chapter 4
Designs and Masks

There are images, thirty-five thousand years old, of men's hands on cave walls in Lascaux and Pech-Merle in France. These masked images were produced by blowing red ochre through a reed or hollow bone and over the hand held in front of the wall. Most of us will remember being given stencils when we were children. We pressed them hard against the paper, sloshed on thick water-paint, and when we removed the stencil, there was our bunny-rabbit or whatever, frequently with rather ragged edges where our inexpert hands had blurred the stencil.

Those childish stencils could be used just as readily with an airbrush but it is easy to cut (or buy) rather more adult *motifs*. (See Chapter 10.) Hand or stencil, the principle of masking remains the same: both are examples of what is known in airbrushing as *loose* masks, though 'free' masks might be a better term, because they can be freely used and re-used but they had better not be 'loose' when they are in place!

Loose masks are used for all sorts of purposes, but they are particularly useful when we want to do repetitive work of any kind: they can be very effective for decorating furniture, T-shirt painting and making belt-buckles. Loose masks are discussed at greater length on pages 48 and 49.

For more detailed work, professional illustrators use what are known as *contact* masks, though (once again) 'adhesive' masks might be more appropriate – after all, a loose mask is in contact with the ground, but it is not stuck to it.

The disadvantage of a contact mask is that it is rarely re-usable. In order to get the maximum possible sharpness, contact masks are normally made of very, very thin plastic film. Lifting the film usually involves stretching it out of shape, and even if you can lift it without doing this, the chances are that it will stick to itself and be ruined. Sometimes, small areas can be re-used, but that is all. The only normal alternative to plastic film is liquid masking, which is painted on and obviously cannot be lifted without destroying it.

One of the main advantages of a contact mask, is that it produces a much sharper line than a loose mask. Because it is in intimate contact with the ground, there is much less danger of the edge lifting and color blowing underneath.

The other great advantage is that contact masking can be enormously more complex than loose masking. For obvious reasons, it is impossible with a single loose mask to draw a line around an area. You can create a solid circle; but if you want the letter 'O', you will need to do one of two things. You can cut two masks, and hold the inner one down with a weight (a few coins will do) while you position the outer one around it. You can leave supporting struts of mask to hold the inner part in place – this is the way that your stencils used to look when you were a child, if you remember. With contact masks, on the other hand, you can cut some bits out and leave others in place – but you still need to work out the order in which you need to spray them.

By planning your masking sequences carefully, you can save a great deal of time and effort: drawing color 'roughs' with colored pencils is a great help. If you are going to use dyes or other transparent colors, planning can also save you a great deal of heartache; unless you actually want to overlay colors, you must protect *all* areas that you do not want to paint, as there is no way of correcting mistakes. It is important to decide whether you need to lay a mask to spray the area around it, or whether you need to mask an area to protect it from a single or several stages of spraying. Once you have produced a step-wedge (see pages 50–1) you will understand the potential difference in the finished work that could be achieved simply by removing the masking film in a different order. Examples of mask sequencing are given in Chapter 7.

In many ways, masking is the key to real versatility in airbrushing. A good mask-cutter can work from other people's artwork, and needs only to be competent at airbrushing to get first-class results. The most brilliant freehand airbrusher cannot, however, hope to duplicate the effects obtainable with masks if he uses the techniques of freehand airbrushing alone.

In all fairness, it is almost equally rare for a picture to be created by 'pure' masking, without any freehand work within the masked areas, but it can be done. The flat tonal areas in the picture opposite could easily be created by 'straight' masking and spraying, while the dark blue background contains very subtle variations (perhaps too subtle to show in reproduction) which could only conveniently be achieved with the airbrush – a thundery effect, designed to recall the events surrounding the Crucifixion and to echo the *terremoto* (earthquake) which is the climax of Haydn's *Die sieben letzten Worte* – the Seven Last Words.

A Simple Stencil

The original magazine illustration was mounted on a piece of board using spray adhesive, and the club and ball were cut out to create the mask.

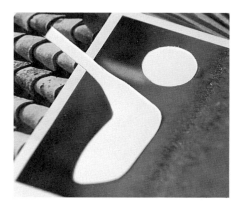

The area that has been cut out forms the final image. Before spraying the golf club cover the cut out shape of the ball.

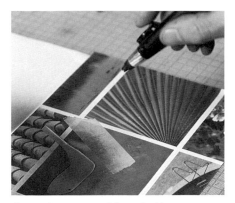

Protect the paper around the mask with addition sheets of scrap material, weighted down with coins. Otherwise, overspray will spoil your picture.

The idea here is to show just how simple, and effective, stencil work can be. The initial image came out of a magazine, and consists of nothing more than a golf club hitting a golf ball.

The picture is cut out roughly with a pair of scissors, and then glued to a piece of thin cardboard or even acetate sheet a good bit larger than itself: use rubber cement or spray adhesive. There is information on more sophisticated materials in Chapter 10.

The next stage is to cut through the picture and the board, *precisely* following the outline of the picture. At this point, you will have to use the most important tool that an airbrusher is likely to need after the airbrush itself: a very sharp scalpel or X-Acto knife (see pages 32–3).

The Swann Morton is held by some to be more controllable, because of its flattened sides. Others say that the X-Acto is more controllable, because it has a round handle and can be rolled in the fingers.

Either way, it is a matter of personal preference, but a supply of sharp blades is *not* a matter of preference; it is essential. Trying to work on film with a blade that is past its prime can be purgatory, because the blade tears what you are trying to cut. Some people manage to extend the life of their blades by sharpening them on a *very* fine slip or oilstone, but this really is hard work. For this sort of relatively coarse work, though, you can use blades which would be past their best for contact mask-cutting (page 50).

Swivel-blade scalpels are sometimes touted as ideal for cutting intricate shapes, because the tip of the blade trails behind the cutting movement and is therefore always in line with the cut. Most designs are tricky to handle, and some cause awkward gouges at angled corners. Others are excellent, however. Some people swear by them, and others swear at them, but it is largely a matter of finding which model (if any) suits you.

The ideal cutting surface is a plastic cutting mat, which will not blunt the scalpel as quickly as anything else, and which will last for an extraordinarily long time. Also, the surface is 'self healing':

the sides of old cuts slowly re-adhere, so that there is no risk of their suddenly diverting your blade and causing 'tracking'.

Otherwise, stout cardboard or Masonite is better than news-paper (which wrinkles) or wood, where the direction of the grain can affect the direction of the cut. Old cuts in either cardboard or Masonite will, however, have the same effect. Particle board will blunt your scalpel in double-quick time.

As you cut, remember that it is the *outside* which is going to form the mask; if you are going to make any awkward cuts, try to make them inwards, towards the original picture. Eventually, you will free the inner part from the outer; be careful not to tear the outer part, or to bend or warp it at all, because this will stop the mask from resting closely on the ground.

This mask, or stencil, is designed to protect the areas around the golf club wherever the mask is laid. The shape that has been cut out creates the final image.

Place the stencil on your ground – use a decent bit of white card or drawing paper – and spray your image lightly. Then, move the stencil slightly, and spray it again, a little heavier this time. Repeat two or three times, and you will have a remarkable impression of movement; it is repetition which creates this impression. If you use *two* masks, and move them in opposite directions, you will create an even more powerful impression.

It is quite possible that on your first attempt, you will not get quite as attractive a pattern as you had hoped. In this case, use a sheet of tracing-paper to sketch out a better relationship between the parts of the image, and use this as a guide when spraying. At this point, you are entering into the realms of planning and mask sequencing which are described more fully in Chapter 7.

The initial impression of the golf club, before the additional stages have been added.

A hair-dryer is used gently to dry the color between stages. Here, the three impressions of the club are present, plus the *first* impression of the ball.

The final version; a reasonable representation of a golf-club striking a ball.

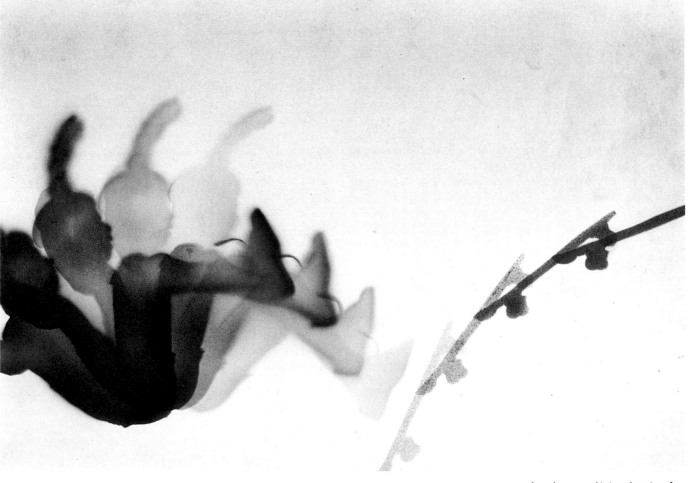

A much more sophisticated version of the same thing, using color and a more carefully-planned positioning of the picture elements. Planning could be done with the help of tracing-paper, so that the sequence can be 'tried out' by eye before marking on the final picture.

Loose Masks and Color Wheels

After your exercise with a simple stencil, try using all kinds of other materials as loose masks. Begin with a sheet of stiff paper: spray along the edge, as shown, to create a simple 'fading edge' effect with one side sharply defined and the other fading fuzzily away. Vary the distance at which you hold the airbrush, to vary the thickness of the fading line, and vary the distance of the mask from the ground, which will give a more or less sharp line.

Next, tear the edge of the paper, and repeat your mask experiments: again, you will find that you can achieve different effects by varying your spraying distance and the distance of the torn edge from the paper. Finally, try to tear out a simple, recognisable shape from the centre of the paper: a heart is easy to do. Then, after spraying through that, crumple it up and smooth it out again; the way in which the spray travels under the crumpled edges will show you how you can use chance as well as planning when you are making masks.

You may also care to try all sorts of other loose masks. Cotton wool is traditionally used to help create the impression of clouds, while some artists like to use their hands – but be careful when you do this, using low air pressure to avoid forcing pigments or ink into your skin, and never using poisonous pigments. Stockinette or nylon curtains also give quite wonderful fabric effects; basically, you can use anything with holes in it, or with fuzzy edges.

An equally instructive exercise, but one which is much more time-consuming, is making a 'color wheel'. You actually need two masks for this. You also need two separate kinds of colors: transparent inks, and opaque pigment paint such as gouache. The actual colors you will need are yellow, orange and red, and green, blue and purple.

The first mask is a circular hole in the centre of a large sheet of card. Use a cutting edge in your compasses, and make a circle

Lay the 'pie slice' mask over the 'hole' mask and spray with yellow ink or gouache.

Rotate the mask, clean and re-load the airbrush with the second color (orange or green). Spray the second slice of the wheel using the same medium as before.

This loose masking exercise shows you the different ways in which inks and paints behave: inks are transparent, and let colors underneath show through, while paints overlay and conceal the colors beneath them.

which is anything from 6 to 10 in (15 to 25 cm) in diameter.

The second mask is circular with a 'pie-slice' out of it. It should be a couple of inches (5 cm) greater in diameter than the hole mask. The 'pie-slice' should be exactly 60°, one-sixth of the circle. Measure it with a set-square or protractor, or use the old schoolboy's trick: the radius of the circle will fit six times onto the circumference.

Lay the second mask on top of the first. Mark the hole mask in 60° increments, too, so that you can rotate the second mask by one-sixth of a circle at a time.

With the masks arranged like this, load the brush with *either* ink or gouache. Spray the yellow. Use a piece of clean scrap paper to establish the spray density; it is very hard to guess just how much color you have used without a white to act as a reference. Also, spray a small area on your reference sheet to the same density as the 'pie'; this will help you spray other colors to similar tonal values.

Rotate the upper mask through 60°, and load the airbrush with the second color (green), using the same medium as before – either ink or gouache. Spray the second color. Repeat this for the other colors. When you have finished, you will have a 'color wheel', in which complementary colors are opposite one another and harmonious colors are side by side. The advantage of this exercise is not simply that it shows you how colors merge and drift when you are masking; it also serves as a reference for future work.

Now, repeat the whole exercise using the *other* medium. The difference should be noticeable: the transparent inks allow one another to show through, modifying the underlying color but not obliterating it, while the pigment medium overlays one color with another.

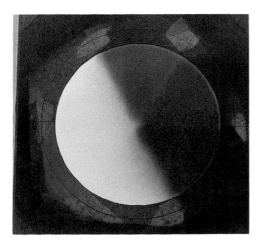

Spray the remaining colors in sequence to complete the wheel.

Contact Masking

A 'step wedge' like this is a useful exercise, as it teaches basic masking skills and also shows you the effect of repeated spraying with the same area. When you have completed your first step-wedge, start again but lift the masking strips in a different order. This will show you how the finished work can be affected by the masking sequence.

A useful exercise with masking film is the kind of 'step-wedge' shown here. It shows you how to lay the film; how to cut it; how to lift it; and how to spray. It also reinforces the skills you learned when spraying a flat, even tone (page 40).

Masking film is sold in varying widths, including 10 in (25 cm), 12 in (30 cm) and either 18 in (45 cm) or 50 cm (just under 20 in). Wider film is available, but it is often easier to build up larger areas from 18 in or 50 cm material; masking film is very thin and flexible, and the adhesive is very weak indeed, so dealing with wide material can be more trouble than it is worth. Some films are also stretchier than others; acetate films are the most dimensionally stable. Aztek markets its own brand of contact film in a range of widths from 12 in.

Store film in a cool, dry place away from direct sunlight. 'Cooking' masking film (for example, by leaving it in the sun or on a radiator) may either increase or decrease its tackiness, and it can also cause it to bubble and lift at the edges; the only safe way to deal with this is to cut off the afflicted parts, which is expensive and time-consuming. Once again, some brands are much better than others at resisting heat.

You can lay masking film on either virgin ground, or on ground that is already painted. If you are doing the latter, you must of course allow the ground to dry thoroughly before applying the second mask.

Smooth the film out gently, but do not burnish it hard with tools such as the back of a spoon, or you may find that it adheres too strongly and lifts either the ground or any color that may be on the ground when it is removed.

You will find as you are applying the film that it can be lifted and repositioned easily, but the longer it is in place, the harder it will be to remove. This is especially true if you allow it to become baked on; film which has been left in direct sunlight all day, then left overnight as well, can adhere all too enthusiastically.

Because masking film is fairly expensive, it is worth economizing by using ordinary household masking tape and the backing paper from the film; if you want to extend it further, use any cheap, clean paper to cover those areas which do not require accurate mask cutting. Do not use newsprint; the ink smudges, especially when it is wet and could easily spoil your work. Take the film an inch or two (3–5 cm) beyond the area on which you are working – the exact width will depend on the scale at which you are working – then tape the backing paper to the masking film rather than to the ground itself. Now you are ready to cut the film.

The difficulty with film cutting is that you have to restrict the depth of your cut *only* to the thickness of the film. Too deep a cut, and you will be cutting into the ground; too shallow a cut, and you run the risk of tearing the film as you remove it. There are few things more infuriating than a cut which is *almost*

The first step is drawing up the wedge on the ground; you can use as many or as few strips as you wish. Then lay the masking film, taking care not to trap any air-bubbles underneath. If there are any, smooth them out *lightly* with short, light brushing movements.

Cutting the mask is the hardest thing to learn in airbrushing; a light touch, with a very sharp knife, is what you need to practice. It is not that difficult to learn though.

Lift the first strip; if you use a scalpel, be careful not to damage the ground underneath. Spray the area you have uncovered. Lift the second strip and spray the *whole* area. Continue until you have removed all the masking film and lightly spray the entire area.

This deceptively simple but undoubtedly exuberant dragon is a comparatively straightforward masking exercise using a very simple masking sequence. The solid color is not particularly 'airbrushy', but the body, wings and nose are another matter.

perfect, so that the majority of the cut-out portion lifts cleanly but the last fraction of an inch tears, leaving a ragged edge and a raised portion of masking.

Film thickness varies, too, so it is best to stick with a particular brand of film and to get used to that. Even then, there may be occasions when you have to overlap two or even three layers of film, which means adjusting your cutting pressure once again.

The only solution is to use *very* sharp blades, and to renew them very frequently. If you are very good with an oilstone, you may be able to re-sharpen blades, but it really is hard work and it is only worth it if you cannot afford new blades; a fast mask-cutter may change blades every twenty minutes, having blunted only the last few hundredths of an inch of the tip of the blade!

Despite these warnings, it really does not take that long to learn how to cut cleanly and accurately – though you are almost certain to make mistakes at first. The main danger, once you have mastered pressure, is 'sawing' at the line in a series of small,

indecisive cuts. A smooth, steady, firm but light stroke is the key; if you can draw a clear pencil line of even thickness, you can learn how to cut masks.

After cutting, and before spraying, make sure that your edge seal is perfect by laying a sheet of tracing paper over the cut edge and running over it with your fingernail. The tracing paper protects the ground from dirt and your natural skin oils, and also stops you polishing or burnishing the exposed ground.

To remove masking film after spraying, simply peel it off. If there are any very small areas, do not forget them; slip a scalpel blade under a corner if you have sprayed all around the mask. Hold the artwork at an angle to the light to show up any unremoved areas of masking.

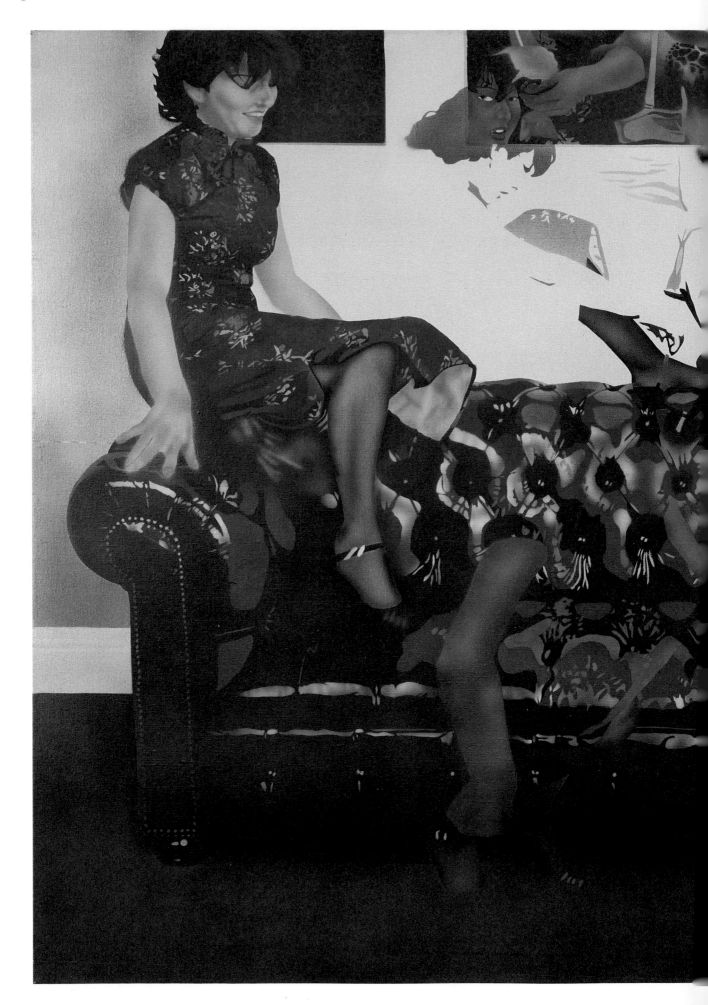

Untitled Seng-gye
In order to emphasize the superficial glossiness of the composition the clothed figure is deliberately depicted in a graphic style. The positioning of the woman with her head out of the image and the fact that she is looking into the picture, draw the viewer towards the picture but the completeness of the image denies participation. This feeling of alienation is strengthened by the smiling, almost laughing expression which hints at a private joke. However, the viewer is allowed to observe the private undressing through the selective use of shadows and the ghosting of minimal information. In contrast to these glimpses of time, notice the sharpness of the shoe and stocking which are represented in a deliberately provocative manner. Compare the definition of highlights and shadows which create the impression of a brash patent (plastic) leather sofa with the soft leather couch in the non-identical twin (see pages 42–3). This painting was created with only six masks, but they were very complex – at least one had over 1,000 holes, and mask cutting alone took a solid week. Acrylic on canvas, 36×48″.

Iron Hand Jurgen Wiersma
Many people refuse to believe that this is
not a photograph: the gauntlet, or
armored hand, is so realistic that they feel
it must exist. It is however a piece of
artwork by Jurgen Wiersma using the
airbrush and other tools. The original is
approximately 20×30 in (50×75cm).
When you have read this chapter, try
visualising this hand as a series of cylinders,
cones and other geometrical shapes (AA).

Chapter 5
The Third Dimension

In any painting, or photograph for that matter, everything is represented in two dimensions: the third dimension is illusion. Essentially, this illusion is psychological, or rather, perceptual; because we know that the real world is three-dimensional, our brains are willing to accept any clues which help us to see pictures that way. The illusion derives from roundness, depth and texture or reflectivity.

Roundness is represented by *chiaroscuro*. The word comes from the Italian, and means 'light/shadow'. Among painters, Rembrandt is usually held up as the master of chiaroscuro, though Caravaggio arguably used it better: Caravaggio's chiaroscuro involves a blending of light and shadow where they meet (which is, of course, very easy with the airbrush) while Rembrandt's chiaroscuro is much harder-edged: this latter technique, taken to its limit, is seen in Manet's work, while de La Tour worked in more the same style as Caravaggio.

All that it amounts to is this: the areas towards the light are brighter, and the areas away from the light are darker. If we add 'highlights' and 'shadows' even to a solid circle of color, we can create some semblance of depth: indeed, this is exactly the exercise shown on pages 58 and 59.

Depth is shown by perspective. This is described at greater length on pages 66–7.

Texture is shown by detail (you can actually paint realistic representations of, say, fabric) or by use of highlights; the size and shape of a highlight also depends on the direction and type of the light. This is the most difficult idea of the three to grasp intellectually, but the easiest to understand if you simply *look* at anything.

For example, imagine a ball-bearing and a wooden box. The highlights (and shadows) will be different according to the *size* of the light source (think of a window, or a projector lamp) and its *proximity* (with a close light source, the rays of light are divergent; with a distant source, they are almost parallel). If there is more than one light source, there will be multiple highlights and (if the lights are of similar intensity) multiple shadows.

Both highlights and shadows can be hard-edged or soft-edged, and it is from the sharpness of the highlights that we gauge the texture of an object; think of the difference between the highlights on (say) a billiard ball and a football to see how this works. To begin with, it is usually easiest to render fairly soft highlights and shadows, though we shall tell you how to do hard-edge highlights as well.

The most basic elements of shape are the cone, the cylinder, the cube and the sphere, and in this chapter we look first at how to create chiaroscuro effects with each of these – though arguably, the cube is not true chiaroscuro, but merely an example of contrast, which is the name correctly given to the technique of separating light and shadow with a hard edge.

At the risk of sounding repetitive, all airbrush work can be broken down into simple elements, and if you master these basic shapes, you should be able to see how other, more complex shapes can be seen as variations on the themes shown on the next few spreads.

> **Books:** If you want to understand at least some of the psychological theory behind the perception of depth, read *Eye and Brain* and *The Intelligent Eye* by Professor Richard Gregory (Weidenfeld & Nicolson), *Art and Illusion* by E. H. Gombrich (Phaidon) and *Drawing on the Right Side of the Brain* by Betty Edwards (Fontana).

Cylinder

Blood Drip Ramon Gonzalez Teja
This image demonstrates the use of a
cylinder within a specific context. Here,
the artist has carefully observed the
reflective qualities of glass and has used
highlights and shadows to create the
illusion of a glass container, in this case a
blood drip.

The six green images show each stage of
airbrushing in the left-hand column and
the result after each stage in the right-
hand column. The dotted black line shows

where the masking film should be cut and
the numbers show the order in which the
masks should be removed.

This cylinder has been formed with elliptical ends, to produce a
perspective effect. The sides are parallel, so this is an isometric
(rather than a perspective) drawing. The result is that the
cylinder appears to taper outwards, though this is only an optical
illusion. The cylinder should be sprayed in the following stages as
shown in the sequence above:

1. Remove the ellipse at the bottom of the cylinder.
2. Load the airbrush with the desired color and start to
 spray. Work in parallel lines fading to the top. Always finish
 the strokes over the masking film, not over the artwork.
3. Once the required finish has been achieved, allow it to dry
 thoroughly and then replace the previously cut mask.
4. Remove the surface masking of the tubular section.
5. Spray from one end to the other in parallel lines shading the
 body of the cylinder. To create a convincing impression of
 roundness, add a number of reflections spacing them closer
 together nearer the edges and further apart at the centre.
 The upper highlights correspond to reflections from the 'light
 source', while the lower ones are secondary reflections from
 the white ground upon which the cylinder is taken to be
 lying. If the cylinder were on a colored ground, the lower
 reflections would pick up this color.
6. Work over the cylinder slowly to build up form. When you
 have finished, let it dry and then remove all the masking film.

When you have mastered this simple shape, experiment with
cylinders of different dimensions; look at the cylindrical objects
in your home – a detergent bottle, a saucepan or a glass for
example – and then spray the highlights you need to recreate
these shapes and textures. Hard and soft-edged highlights and
shadows will have different effects on the impression of shape.

The Illusion of Shape
The tools and materials you will need to create the basic shapes, are listed
in the box below. For each shape you will need to draw an outline of the
image and cut the masking film so that it can be removed easily and in the
correct order.
1. Using a pencil draw the outline of the shape on a piece of tracing paper.
 For the cone and the cylinder use an ellipse guide to form the base
 unless you are confident enough to draw this in freehand.
2. Lay masking film on to art board or acetate. Use matt and not gloss
 masking film so that you will be able to trace a pencil outline on the
 surface.
3. Transfer the pencil outline of the shape from the tracing paper to the
 masking film.
4. Decide which areas of the shape should be separated to form a series
 of masks and note the sequence in which masking film should be
 removed.
5. Cut the masking film to produce the masks you require using an elipse
 curve, swivel knife, steel ruler and scalpel. Be careful not to cut the
 surface you are working on.
6. Before you remove the first piece of masking film, use an indelible
 marker to produce a registration mark across the cutting lines between
 each area of the shape. This will help you to reposition the cut-out
 mask more easily.
7. Remove the first piece of film and save it for later use.

Now you are ready to spray the shape and create the appropriate areas
of light and shade. If you are not sure where these should be, take a good
look at the objects around you and note where highlights and shadows fall
on different textures.
 Everyone develops their own technique: some people overspray the
ground, others overspray and then add highlights or leave white board to
shine through and spray around the areas where highlights are required.
 A method for spraying four basic shapes: the cylinder, cone, sphere and
cube is given on the next few pages but there are many different ways of
doing this and you will develop your own in time.

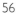

Cone

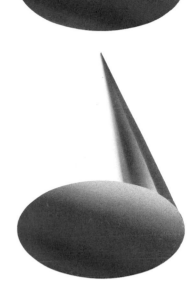

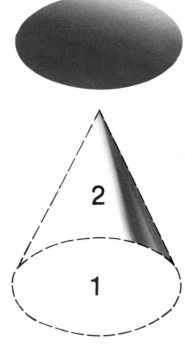

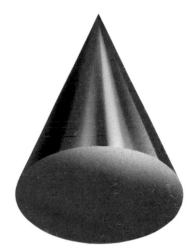

The six blue images show each stage of airbrushing the cone in the left-hand column and the result after each stage in the right-hand column. The dotted black line shows where the masking film should be cut and the numbers show the order in which the masks should be removed.

Equipment:	Materials:
Airbrush and air supply	Non-shellac ink
Scalpel or X-Acto	Good-quality smooth
Cutting mat	paper, card or
Ellipse guide	illustration board
Straight-edge	Masking film
Hair-dryer (see page 47)	

The cone is similar to the cylinder and you will find it easier to use an ellipse guide to produce the base.

1. Cut and remove the masking film at the bottom of the cone.
2. Spray the base of the cone in parallel lines working from left to right and fading to the top. Allow to dry and then replace the masking film. Use the registration marks to ensure that it is correctly positioned. Then remove the film covering the body of the cone.
3. Spray the dark lines along the right-hand edge of the mask and towards the centre of the cone. The sprayed lines should converge towards the point.
4. Now spray the left-hand side of the cone in the same way. Highlights can be added with white overspray or produced by leaving the ground to show through.
5. When the body of the cone is thoroughly dry remove the masking film.

Sphere

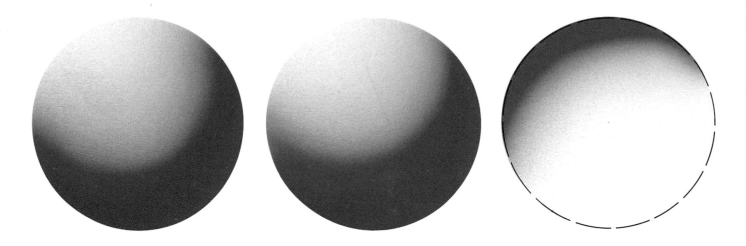

The sphere is rather more difficult to master than the cone or cylinder. You will need the same materials and equipment as before, plus a pair of compasses with a cutting attachment. Trying to draw the circle and then cut it freehand is likely to be hard work. If at all possible, look at a tennis ball before you start to paint as this will help you to realize just why the highlights and shadows fall where they do whatever the surface or texture of the sphere.

1. Cut out the circle with a pair of compasses; tape a coin to the paper under the point to avoid a hole. Remove the circle of masking film and spray the bottom edge of the circle.
2. Next, spray around the top edge of the circle, but this time emphasize the points in line with the shadow.
3. Put in a dark crescent, freehand. This creates the clearest impression of roundness.

Melons Jurgen Wiersma
This is obviously a much more difficult piece of artwork, but Jurgen Wiersma's 'Melons' shows how the techniques of drawing a sphere are applicable to real-life assignments. The airbrush has been used primarily for glazes, and for softening the brushed areas on the outside of the melon; inside, the gradation of the cut melon is achieved by airbrushing. (AA)

The six yellow images (below) show each stage of airbrushing a sphere followed by the result and ending with the finished work. The dotted line shows where the masking film should be cut.

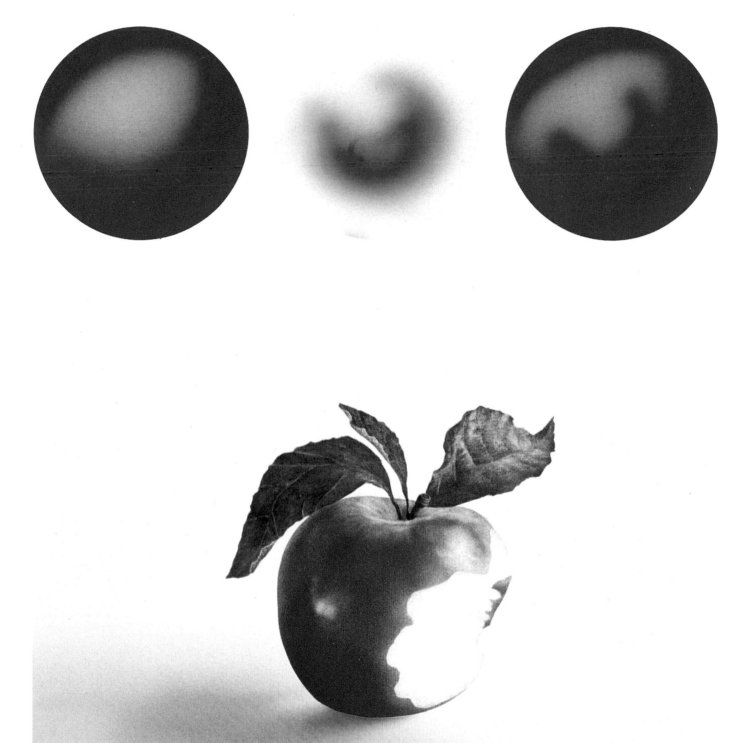

Apple Hewett
This is a clear illustration of the creation of a sphere. Note the difference in the shadows used to create the texture of the apple and those used for instance for the glass cylinder on the previous page.

Cube

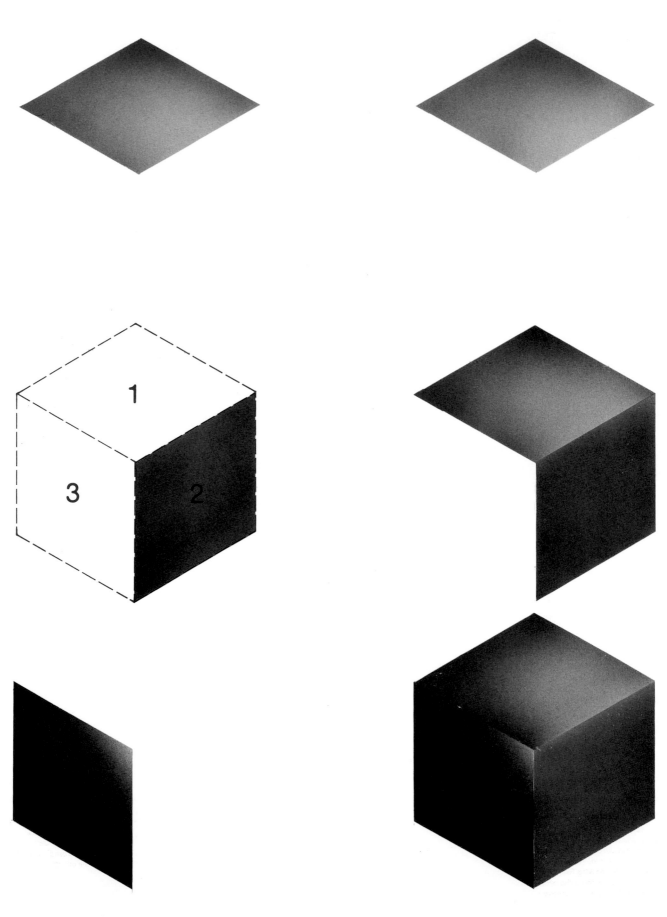

The cube, unlike the rounded shapes previously described, has no diffuse highlights to define its shape. Instead, the illusion of solidity is created by using three different tones for the three faces. The materials required are the same as those already described.

Anyone can draw a reasonably convincing cube, but using the airbrush for shading gives an even better impression of solidity.

Each of the three visible faces of the cube is a separate mask, or to be more precise, a separate progressive stage of the same mask.

1. Remove the first mask, and spray the lightest tone first – in this example, the top. If the mask is difficult to lift, use a piece of strongly adhesive tape, and lift the mask with that.

2. When the ink is dry, replace the first mask and remove the second. Spray again: this is the medium-tone.

3. Repeat for the darkest surface, in this case the left side.

4. This cube is 'lit' from the top right. By changing the relative values of the different faces, you could change the direction of the 'lighting': if the bottom face were the lightest, for example, the cube would appear to be lit from below, and (to quote *The Hitch-Hiker's Guide to the Galaxy*) 'hanging in the air in much the same way that a brick doesn't'.

The six red images (left) show each stage of airbrushing the cube in the left-hand column and the result after each stage in the right-hand column. The dotted line shows where the masking film should be cut and the numbers show the order in which the masks should be removed.

Perspective

Shape and perspective are different. Shape – the sort of thing we have been dealing with on the last few pages – is merely an outline, though by use of light and shade we can create an impression of roundness. Perspective, on the other hand, creates an impression of depth: it is perfectly possible to create an impression of depth with flat cut-out figures, as anyone who has ever looked through a Victorian stereoscope will know. Perspective can be confined to a single object, making it look as if it 'disappears' into the paper, or it can make some objects appear closer and others appear further away.

Perspective itself is far more complicated than most people realize. For a start, there are at least four different kinds of perspective:

1. Perspective of size. Even with no other clues, things which are bigger are perceived as being closer than things that are smaller. This is simply a matter of everyday experience.
2. Perspective of receding planes. Even if things are the same size, the ones at the bottom of the picture will often be read as 'nearer'. Once again, this is a matter of everyday experience: the things which are nearest to us are normally at the bottom of our field of view, and as we raise our eyes, we see things that are more and more distant. If you look at medieval paintings, you will see that this (and sometimes the perspective of size) is the usual method of conveying depth.
3. Aerial perspective. In real life, things which are further away are hazier and less distinct than things which are closer, as a result of water or dust in the atmosphere: the effect is much more pronounced on a misty or dusty day than it is after a shower, when you can sometimes see for extraordinary distances. It is also much *less* pronounced at high altitudes, because the air is thinner and clearer.
4. Vanishing-point perspective. This is the 'classical' perspective, and it can be drawn as single-vanishing-point perspective or multiple-vanishing-point perspective; two vanishing points are commonplace, and three can be used.

Any or all – or none – of these forms of perspective may be used in airbrushing.

Creating perspectives of size and perspectives of receding planes is easy, though it is worth noting that you can afford to make smaller objects less distinct than bigger ones. In a painting of a crowd, for example, the people at the front are normally well-defined, but the ones at the back can be drawn very sketchily indeed. As described at the beginning of this chapter, the brain will supply a great deal of detail which simply is not there in the actual painting.

As for aerial perspective, the easiest way to do it is to use washes and to work from the back of the picture to the front; alternatively, as shown in the illustration here, you can simply 'knock back' areas of detail with gray-blue pigment.

British Rail is the heir to a great graphic tradition – the pre-nationalisation railway companies were famous for their advertising. This poster from Boase, Massimi, Pollitt shows all the perspective effects described here, in a very clear fashion.

Classical Perspective

A straightforward square has no perspective whatsoever.

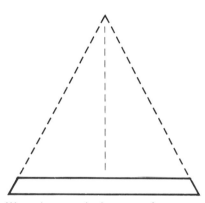

We can, however, take the square, and lay it on its side (in the sense of drawing it in perspective).

If we now add these two geometrical shapes together, the brain will readily 'read' it as a cube, drawn in this case with single-vanishing-point perspective. Compare this with the isometric rendition of the geometrical figures at the beginning of the chapter: in an isometric representation, there is no 'vanishing point' and the effect of linear perspective is lost.

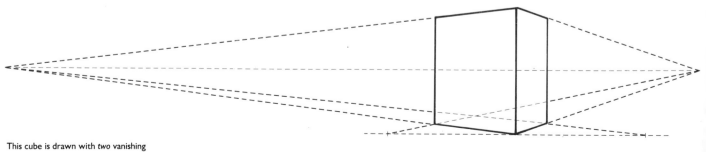

This cube is drawn with *two* vanishing points; the one on the left is further away than the one on the right, so the 'front' face of the cube is the one on the left.

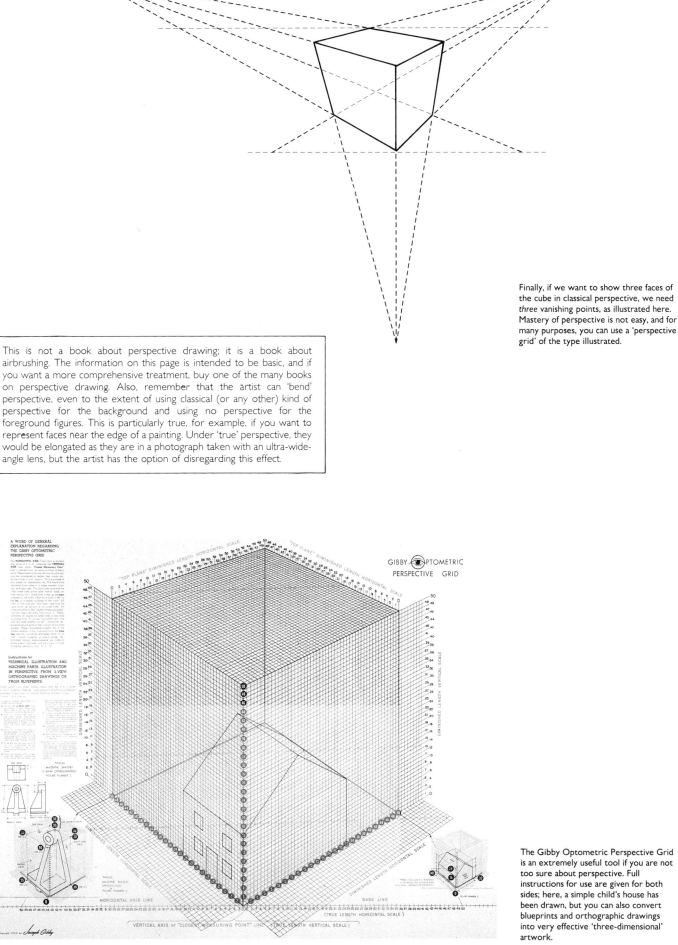

Finally, if we want to show three faces of the cube in classical perspective, we need *three* vanishing points, as illustrated here. Mastery of perspective is not easy, and for many purposes, you can use a 'perspective grid' of the type illustrated.

This is not a book about perspective drawing; it is a book about airbrushing. The information on this page is intended to be basic, and if you want a more comprehensive treatment, buy one of the many books on perspective drawing. Also, remember that the artist can 'bend' perspective, even to the extent of using classical (or any other) kind of perspective for the background and using no perspective for the foreground figures. This is particularly true, for example, if you want to represent faces near the edge of a painting. Under 'true' perspective, they would be elongated as they are in a photograph taken with an ultra-wide-angle lens, but the artist has the option of disregarding this effect.

The Gibby Optometric Perspective Grid is an extremely useful tool if you are not too sure about perspective. Full instructions for use are given for both sides; here, a simple child's house has been drawn, but you can also convert blueprints and orthographic drawings into very effective 'three-dimensional' artwork.

Highlights, Shadows and Starbursts

It is quite possible to create the illusion of solidity, even on an area of flat tone, by adding highlights and shadows. A closely related trick, which is probably best covered here, is the creation of 'farkles' or starburst highlights.

Highlights

There is quite a difference between highlights created freehand and highlights created with masking. Freehand highlights are very easy, but they create an impression of a certain softness of texture; the shiniest effect you can hope to create is akin to a waxy-skinned apple, or satin-surfaced chromium plate. All that you need to do is to decide upon the direction of the 'lighting', and then to add a little white pigment with a fading edge.

Masked highlights, on the other hand, give a 'hard edge' reflection which we associate with very shiny surfaces: polished metals, glass, and so forth. It is usually easier to mask *out* the highlight before you spray, rather than adding it afterwards. This is what was done here. If you are using dyes or watercolours, where paper is your only true white, this is of course your only option.

In most cases, specular reflections such as these are not 'pure' highlights either: they have a certain amount of detail in them. While it is perfectly possible to reproduce detail in exactly the same way as it would appear in a photograph, it is extremely difficult and time-consuming. It is usually much easier to simplify the reflection, showing perhaps a window-frame or simply an indeterminate blob like an etiolated human figure, and black or charcoal gray is the ideal color for this in most cases. Of course, if there is another color which is dominant in the picture, you may care to 'pick it up' in the reflection.

Finally, remember that not just light sources cause reflections; if something is standing on a light-colored ground, there are likely to be reflections of that too. You can see this clearly in the cylinder exercise on pages 56–7.

Shadows

As with highlights, the differences between freehand and masked 'shadows' are quite considerable. Their effect on texture is rather less, though hard-edged shadows are more appropriate (and a lot easier to do!) for surfaces with a less pronounced texture. Alternatively, you can 'split the difference' between freehand and masked shadows, and use loose masks.

Freehand shadows can create the impression of roundness, or the impression of weight. If we continue our exercise, we can see that adding a crescent of shadow further increases the impression of roundness.

If we added a shadow *underneath*, we would immediately create an impression of weight. Hitherto, the heart has been floating in a void; as soon as we add the shadow underneath, it is resting *on* something, and therefore has weight. For some odd psychological reason, the larger and more clearly-defined this shadow is, the heavier an object appears.

Masked shadows are only appropriate where the light is fairly strongly directional, and indeed, if the light is directional but hazy, you may have some difficulty in creating the effect you want. On a symmetrical shape, you can mask the whole thing and use a dark pigment (or dye) to create 'shadows' on one side, but make sure that the shadow corresponds to the highlights, if there are any!

With a more complicated object consisting of a series of planes, for example a house, you can also use a light coat of dark pigment as an overlay; if the object is illuminated by the sun, the shadows will be effectively parallel, but if it is illuminated by a closer light source, you will need to draw something rather like a perspective 'crate' to work out where the shadows will fall.

Starbursts

Starbursts or 'farkles' can be created partially or wholly with the airbrush, and it is largely a matter of taste which approach you use. An interesting point is that farkles need not be symmetrical, and indeed, asymmetric farkles are sometimes more effective: angles other than 90°, and one arm of the farkle longer than the other, are what is needed.

The easiest approach is usually to airbrush a small blob, with a fading edge, and then to add the lines with a fine brush or drawing-pen and white pigment.

The 'farkle' is added with a fine brush – though other artists prefer a drawing pen, some like a scalpel or X-Acto, and the bravest and most skilled sometimes use an airbrush.

Alternatively, you can cut a loose mask which consists of a narrow sliver out of the paper, perhaps a couple of millimetres (1/10 in) wide in the middle and tapering to a point at either end: you can scale it according to your needs, but it is surprisingly difficult to cut! Spray through the mask; let the paint dry; rotate the mask; spray again. One rotation gives you a four-pointed star and two rotations give you six, which is probably as many as you want. The increased middle density which comes from repeated spraying will probably be all you need, but you can always add an extra blob if you want.

The hard way is to draw your farkle entirely with the airbrush, unmasked, using a ruler to guide the brush. You need exquisite control at the beginning and end of the stroke, but a number of master-airbrushers use this technique and you may care to explore it.

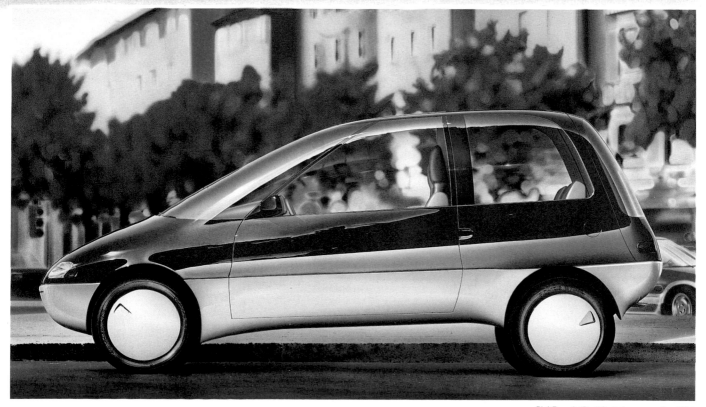

Phil Evans's 'Red Car' shows a really skilful use of shadows and highlights, but the underlying techniques are very similar to those demonstrated in the 'heart' sequence.

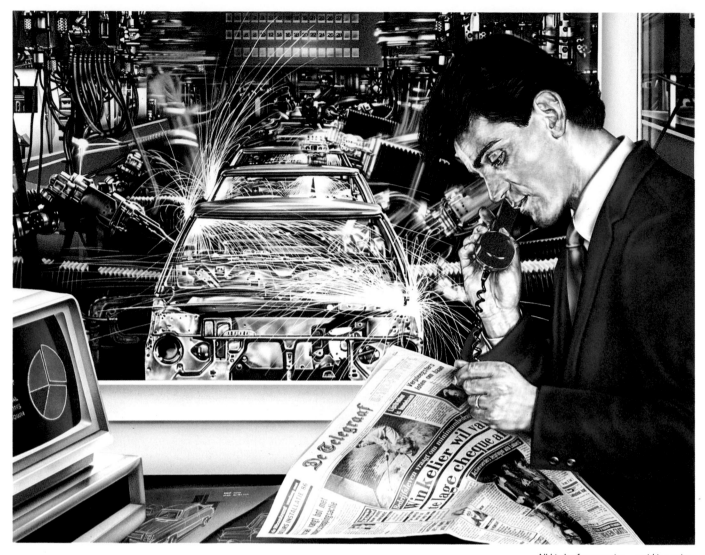

All kinds of perspective – vanishing-point, scale, receding planes, and aerial – are illustrated in this complex-looking picture. Perhaps curiously, the artist decided to use brush-work in the foreground; the contrast in technique is quite intriguing. (AA)

Plymouth Fury Mikio Okamoto
The car demonstrates two-point perspective as described on pages 62–5. Perspective of scale can clearly be seen as the car and plane are actually the same size but your brain tells you that there is distance between the car and the plane because you 'know' the plane must be larger.

Honda Prelude Hideaki Shioya
The exaggerated perspective of this
image is similar to that created by a wide
angle camera lens. Tight airbrushing has
been combined very effectively with
loose brush work to create the
impression of speed while sharp
highlights indicate the braking and
turning of the vehicle. Extreme contrasts
work superbly in this context although
they could have looked forced.

Chair Jens Holt
Perspective can be formalized, distorted,
and manipulated in many ways. Here,
there is classical vanishing-point
perspective which is almost divorced
from all other forms of perspective. This
picture could have been created almost
entirely without the airbrush – but the
very subtle piece of airbrushing on the
seat of the chair powerfully conveys
three-dimensionality. (AA)

Fosters' Tinnie Tom Liddell
Coca-Cola tins are something of a cliché in airbrush art, but to make the leap to a Fosters' tinnie lying in the surf shows an awareness of existing ideas combined with a fresh, personal vision.

Chapter 6
Tricks of the Trade

We have already seen how an existing idea can be 'lifted' and used, in the stencil exercise in Chapter 4 (page 46). This is only one example of a 'borrowed' idea.

Most creative artists keep a clip file of visual references cut out from magazines or newspapers; some also use a Polaroid Land camera to record things that they see, for future reference (commonly known as 'ref shots'). This is a habit worth cultivating, because visual awareness is something which can be learned: by some process of osmosis, you gradually come to recognize good design and bad, harmony and disharmony, and the use of different techniques.

It is also worth buying all the visually oriented books that you can. Because most artists are permanently short of money, they tend to haunt the secondhand bookshops and the discount bookstores; if you can afford it, new books are useful too. Do not confine yourself just to books on airbrushing: look in the fine art sections, the photography sections, the travel sections, and even the transport sections – anywhere you can find illustrated books – for pictures which say something to *you*.

Because the airbrush occupies an uneasy no-man's-land between mechanical reproduction and 'real art', the clip file and the library are doubly useful to the airbrush artist. You can use your file of visual references either as inspiration or as straightforward source material, copying them as best you can with your airbrush. In most of this book, in fact, we are really concerned with this mechanical aspect of airbrushing: it is, after all, a book about technique rather than a book about how to be an artist. Where you get your source material is up to you.

This may seem a somewhat cynical attitude, but for a commercial artist it is a fact of life, and for a fine artist, there is arguably no better training than deliberately trying to copy someone else's work. If that is all you ever do, you cannot really call yourself creative – but why do you have to be creative? There are occasions when a really good copy of something you admire is every bit as satisfying as an original but less inspired piece of work.

One thing which worries some people is the question of copyright – and this is a tangled web indeed. Normally, though, you will run into absolutely no problems *if* what you produce can be described as an original work of art *and* if you make no attempt to pass it off as someone else's work – in other words, as long as it is not a forgery.

In this case, 'original' simply means that you did it yourself: the subject matter does not have to be original. Two very different examples are the Coca-Cola cans which have now become almost a cliché in airbrush art (or Warhol's soup cans, for that matter), and a straightforward stroke-for-stroke copy of another artist's painting. If you try to pretend that your copy of a Van Gogh *is* a Van Gogh, you will be in trouble, at least if you try to sell it; but as long as you admit that it is your own work, you should have no problems.

Scaling and Copying Designs

Whether you 'borrow' your design from elsewhere or originate it yourself, sooner or later you are going to be faced with the problem of transferring it from its original home (a magazine clipping, sketch pad, or whatever) to the ground on which you intend to paint. There are a number of ways of doing this, but they can be broken into three groups: tracing, scaling, and projection.

Tracing is only of any use when you want to work same-size ('S/S', in studio parlance), for obvious reasons. It may be possible, though, to use an enlarging/reducing photocopier to scale the original to the correct size; machines which can handle reductions to 40%, and magnifications to 220%, are not unusual nowadays. You can copy two or three times to achieve the desired degree of magnification or (more rarely) reduction. Acetate tracing paper, known generically as 'Kodatrace' after the original Kodak product, is much tougher than the conventional kind.

One approach to tracing which may not have occurred to you, but which is quite frequently used in commercial studios, is tracing over a light-box. Light-boxes are surprisingly expensive if you want to buy one, but you can make one comparatively easily, and they do make life quite a lot easier. Use translucent Lucite or a similar plastic, and protect the top with a sheet of plate glass. So-called 'daylight' or 'color-matched' fluorescent tubes are somewhat more expensive than ordinary ones, but they are still worth the difference if you ever have to look at color transparencies.

Scaling is the traditional artists' method of transferring a sketch to a full-size canvas, and the easiest way to do it is as follows:

First, make up a transparent scaling grid from a piece of acetate film and fine-line tape (see pages 32–3). This will be used over your original.

Second, *lightly* draw the same sort of grid, suitably scaled up, on your ground. For reproduction, use 'non-photo-blue' pencil to draw the grid; it will not reproduce in *black-and-white* lith or PMT reproduction, though of course it will 'read' in color.

Now, simply use the grid over the original as a guide for scaling up (or down) the design onto your ground.

Some artists prefer a square grid, while others swear by a grid with diagonals as well. The triangulated grid makes it easier to judge angles and fine details, but it also means that you are working among such a deluge of lines that you can become royally confused. The best idea is probably to sharpen your drawing skills as best you can, using a simple square grid most of the time, but constructing triangulated grids for details when you really need to do so.

Projection is rather trickier than it looks, though its big advantage is that it automatically gives you perfect scaling. There are two kinds of projector you can use: conventional slide projectors (diascopes) and projectors which can accept flat copy (episcopes). Among episcopes, you can either buy a modern graphic-arts projector like the Kopy-Kake shown here, or you can sometimes find old episcopes or epidiascopes for remarkably low prices. They are enormous pieces of machinery, and can only be used for horizontal projection, but they normally have a much bigger platform and some can project original copy as big as 10×12 in, 25×30 cm or even bigger.

The drawbacks to projection scaling are surmountable, but you have to be aware of them. The most obvious one is that you block the light-path from the projector when you are drawing, but this is more of an inconvenience than a real

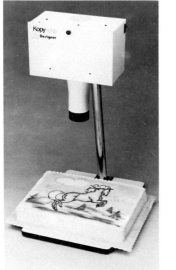

The Kopy Kake projector makes vertical projection very much easier, but it is limited to quite small originals. The company supplies a wide range of pre-drawn patterns and illustrations, designed specifically for use in this projector, to help commercial cake decorators.

If you can draw well enough, you can reproduce your original designs freehand. Most people do not have Ray Mumford's ability as a draftsman, however, and prefer to use a grid of some kind.

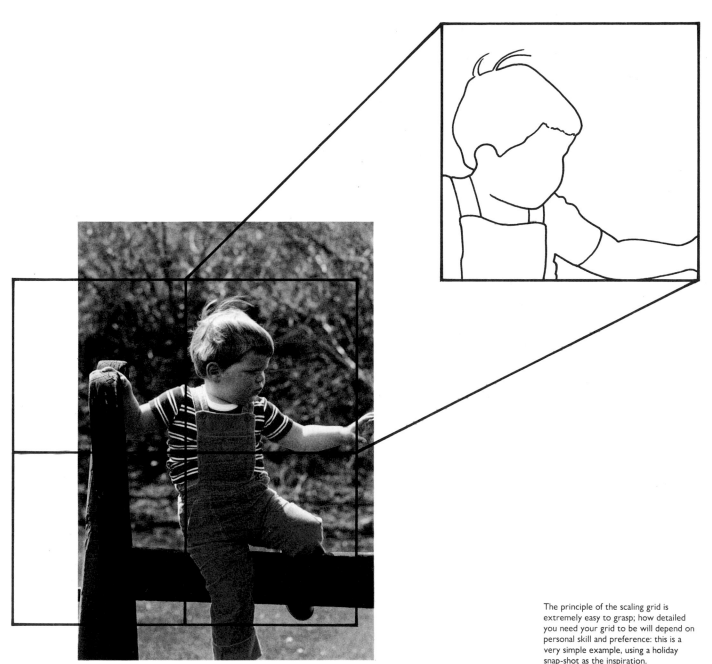

The principle of the scaling grid is extremely easy to grasp; how detailed you need your grid to be will depend on personal skill and preference: this is a very simple example, using a holiday snap-shot as the inspiration.

drawback. Secondly, there needs to be the right balance of projected light and ambient light, or the image can be hard to see: the easiest way around this is to work in a darkened studio, and to fit a dimmer to the studio light-switch. The third difficulty, which is the least obvious, is also potentially the most serious.

It is that you need to complete your tracing from the projection *in one session*, or at the very least, you must leave the whole set-up absolutely untouched if you leave it overnight or go away for lunch. If you do not, you are likely to find it unbelievably difficult to set the projector up again in exactly the same way so that the image corresponds at all points. Even if you do not touch the projector, loss of registration can be caused by vibration or heat-induced 'popping', when the slide expands in the mount and bows outwards. Some projectors, and some mounts, are very much better than others at avoiding this: the very best thing is to use uncut strips of film in an old-fashioned glass-gate filmstrip projector.

Transferring the Design. You can work on the masking film, using a Rapidograph or something similar; you can use a hard pencil directly on the ground; or you can use tracing-down paper. The advantage of the first approach is that you can see the design more clearly, but it can only be used for the initial drawing; otherwise, the thickness of the Rapidograph line will obscure the cut. The risk of gaps is then considerable.

If you use pencil, use a hard lead and press gently. The line will be dark enough to see, but light enough not to show even if you are using transparent inks – remember, in airbrushing the lines will only be at boundaries between colors anyway. When you remove the masking film, it will also remove some (but not all) of the pencil mark.

Tracing-down paper is a sort of highly specialized grease-free carbon paper: the transfer medium is actually jewellers' rouge. You lay the design on top, run over it with a sharp pencil, and the design is automatically transferred to the ground. The lines are faint, and should not be visible in the final design. There are some proprietary tracing-down papers on the market, but the old jewellers' rouge paper is still the favourite of many artists.

Lettering

'Down at the Club Tonight'
Ray Mumford
A popular and very effective technique is 'neon' lettering. The real difficulty lies in creating the 'flare' effects, which is done with controlled overspray; when you are adding the dark background, you take care to lessen the density as you approach the (masked-out) lettering. This is by Ray Mumford, and once graced the cover of Street Machine magazine.

The original letter is rubbed down and cleaned with petrol . . .

You then simply spray over it, and give the paint time to dry . . .

The final stage is simply lifting the letter with adhesive tape. Use Scotch tape or Sellotape rather than masking tape – you want something fairly adhesive.

You can add other airbrush techniques to stock lettering, creating special effects of your own. This is a simple fade.

The easiest way to get lettering onto your work is with self-adhesive letters such as Letraset. There are several makes available, but Letraset is the best-known and although it is a trade name it is used as a generic term, like Hoover and Thermos, at least in Britain. To get the very best results, there are several things worth knowing.

The first concerns reproduction size. For illustration, you will normally be working at least 50% up, and quite possibly two-up or twice the size of the final result. This means that you are going to have to spend quite a lot on large sizes of Letraset. Trying to economize by working smaller is a great mistake, and is a mark of the inexperienced or 'wing-and-a-prayer' illustrator.

The second is that in order to work at all, Letraset and its ilk use a waxy interlayer between the lettering and the paper or plastic support. This waxy interlayer can look awful if it is left on the illustration, and worse still, it can act as a resist and stop airbrushing from 'taking' properly. You therefore need to clean the letter, and the area around it, very carefully using a cotton-wool bud such as a Q-Tip (another trade mark that is used as a generic term). For a solvent, petrol is ideal – not motor fuel, but the kind of volatile petrol used in lighters.

With any dry-print material, it pays to use the freshest possible stock: as it gets older, it becomes less and less willing to separate from the backing paper. This has three undesirable effects. You have to press harder and harder to rub it down, which can mark the ground; the danger of broken-up lettering increases: and it also becomes more difficult to remove from the ground. This is particularly important if you want to get white-out-of-color lettering, as described below. There have in the past been offers, whereby you could exchange ten old sheets of partially-used lettering for one brand-new one, but not all manufacturers offer this.

For white-out-of-color, you lay the lettering in the usual fashion; clean it with petrol, as already described; and then spray over it. Then, when the color is *thoroughly* dry, you use a bit of adhesive tape to lift the letter, exposing the white ground underneath. This is a tricky technique, and will not work with all grounds, all media, or all types of rub-down lettering. As a rule, illustration board is the best ground, and Letraset works well, but apart from that, you will simply need to test things for yourself.

If you now want to add color to the letter, you can lay a mask, cut out the letter or lettering, and spray in the conventional way.

For other types of lettering, a great deal comes down to your own individual skill and sense of design. The techniques are exactly the same as for any other type of airbrush work, involving creating (or 'borrowing') the design; scaling it onto the ground; masking; and spraying. Once again, take your inspiration from printers' catalogs, copyright-free source books from Dover and other publishers, and catalogs put out by dry-print manufacturers.

Lettering is one area in which an enlarging/reducing photocopier, as described on pages 72–3, can come in very useful: if you blow up a small letter, it will look very rough, but it is relatively easy to clean up its lines when you transfer it to the ground and cut the masks. If you have access to a PMT machine, Kodak's PMTII materials, especially the self-adhesive tracing film, can be extremely useful for this.

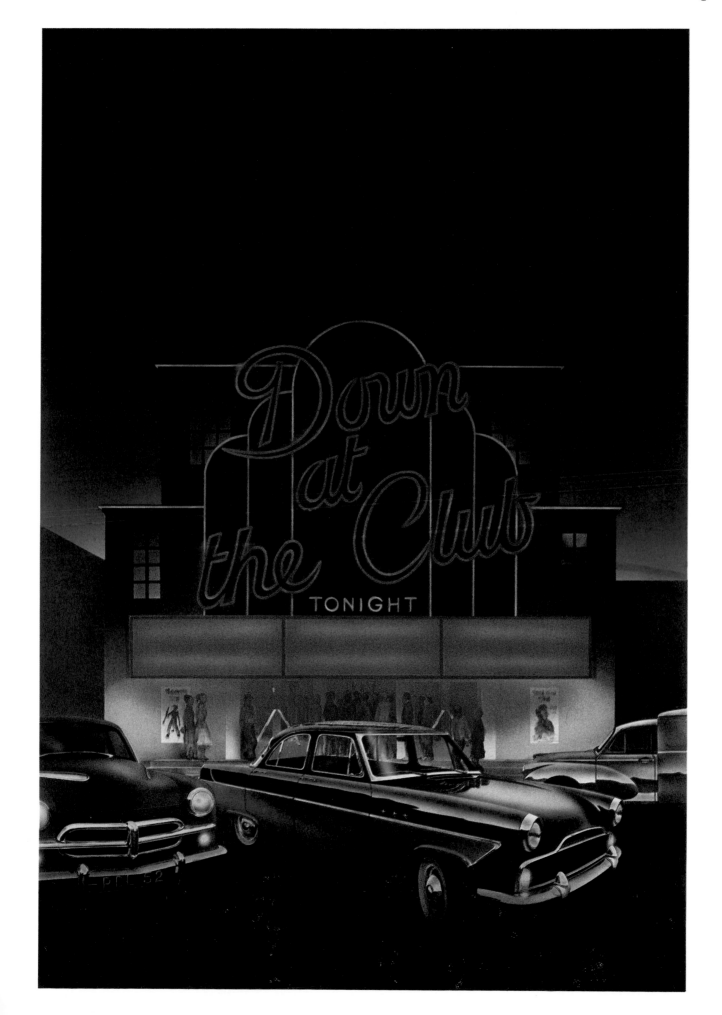

The Aztek logos on this page were produced with a prototype Aztek airbrush using liquid acrylics on artist's board. Further information on creating the illusion of a shiny surface is given on the next spread. The techniques shown here can be used with a combination of colors (bottom right) or a single color with sharp transitions from light to dark and high definition to create the illusion.

1. Draw an outline on 'Kodatrace' and transfer or trace the image on to the illustration board.
2. Overlay the entire image with 'Friskfilm'. Cut the masking film along the edge of the top surface of all of the letters, but no not remove the film yet.
3. Cut along the horizon line leaving a meniscus at the edge of the top surface.
4. Now peel away the area below the horizon line.
5. Using black, spray along the horizon fading out rapidly below the line.
6. Load the airbrush with green and spray over the black fading down to the bottom of each letter. The base should be almost white with a gradual fade between the two

The illusion of a shiny surface is created by the sharp transitions from light to dark on for example, the horizon line (above). This line curves upwards at the edge of the top surface creating a minscus which conveys the illusion of shape. Notice the use of this device on the 't' (below) where light and dark areas meet on a curved surface.

As a finishing touch you can use opaque white to create intense highlights on sharp corners (below centre).

The dividing line between the top surface and the chamfered edge can also be emphasized with white highlights. Position a ruler on the top of the chamferred edged and scrape a line with a very sharp scalpel to highlight the join between the two surfaces. Alternatively use a 'Rotring' pen loaded with white to create the same effect.

extremes of dark and pale green.

7. Peel off the top section of the central masks above the horizon line. Add white to the green to lighten the color and spray along the top edge of the letters. This pale green should fade to white as it nears the horizon.

8. Remove all the masking and when dry lay a new mask to cut the second stage.

9. Cut the outline of each letter and the line between the top surface and the chamferred edge. To convey the roundness of the 'e', for example, a meniscus should be cut where there is a transition from light to dark. If the surface is angular the transition from light to dark should also be angular.

10. Peel off all the areas in shadow and spray these first with black and then with green.

11. Peel off the mask from the light areas and gently spray these areas with a mix of white green.

12. When the artwork is dry, remove all the masking film.

Chrome

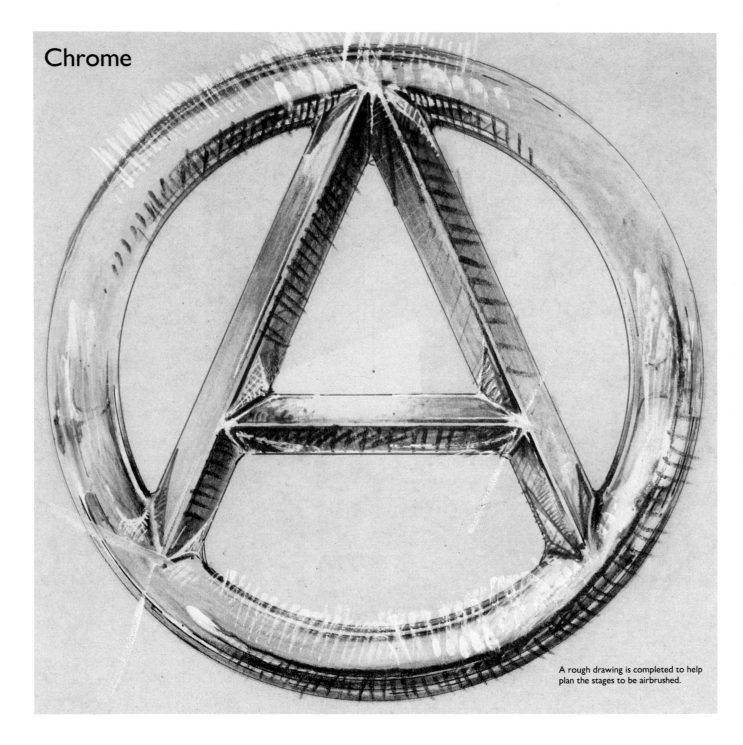

A rough drawing is completed to help plan the stages to be airbrushed.

Because of the way it can lay absolutely textureless color, without any brushmarks, the airbrush is uniquely well suited to the representation of shiny metal surfaces. These effects look far more difficult than they are: basically, all they require is a straightforward understanding of reflections. Remember that the angle at which light strikes a surface is *identical* to the angle at which it is reflected – as physicists say, 'the angle of incidence is equal to the angle of reflection'.

The example shown is a common piece of graffiti, the 'Anarchy' symbol. It suits our purposes very well, because it shows the use of straight and curved lines, and the net result looks very much like the manufacturer's logo on an automobile – in fact, it is very similar to the trademark for Seddon Atkinson trucks! The contrast between 'high-tech' chromium and the essentially anti-technology basis of anarchy also draws a nice contrast between form and content – this would be suitable as

an illustration for a magazine article on anarchy, and it might even make a good poster.

The basic symbol is constructed using a ruler and a pair of compasses. We can either draw it to size, or use an enlarging/reducing photocopier to give us the final size we need. In any case, it is not a bad idea to take a number of copies of the original, so we can experiment with different techniques.

On one of the photocopies, use colored pencils to 'rough in' the highlights, shadows and reflections. Also indicate the direction of the light; this will make visualizing your highlights much easier. In this case, the 'three-dimensional' shape chosen can be seen clearly from the illustration; you can work out for yourself how to create other three-dimensional shapes.

The color of polished metal is usually quite weak, but it is perceptible. Your highlights will be pure paper-white, but chromium is slightly gray-blue; nickel is rather yellower; brass

The blue highlights are sprayed in first (top).

Next spray the red reflections (centre) and add shadows, with black, to help create the illusion of a shiny surface.

When the masking is peeled away you can decide whether you need a background color or any additional highlights.

Adding a red background improves the final image.

and gold are very alike; bronze has a little more brown in it; and copper is reddish. What is more important is the 'reflections', and the very darkest of these will actually be black. The other 'reflections' can be any color you like; we have used red, as black and red are the traditional colors of anarchy, and blue for contrast. A color rough will help you to work this out.

Once you have worked out your design, you can transfer it to the ground; tracing-down paper is one possibility, or simply re-drawing it is another. It will be a very light line-drawing, with delineating lines between 'reflections'.

The illustration shown was created using transparent dyes, so the sequence begins with the lightest areas and builds up to the darkest. With pigments, where one color overlays another instead of showing through, the reverse order would be called for. Also, the sequence described is for multiple-masking; it is possible to use fewer masks, even as few as two or three, but it

requires more thought and more experience.

The blue highlights are done first: the light blue represents reflections from the sky. Cut the mask; spray; let the ink dry; remove the mask.

Next, add the red reflections, and the black lines. The edges of the black areas are softened with white. As you can see, this is a remarkably simple operation, but it is difficult to see what is going on because of overspray on the mask.

Finally, you will need to re-mask the whole symbol and paint in the background. As you can see, a 'chrome' symbol without a background is not really very dramatic; the deep, anarchic red is what makes the chrome stand out. The colors used here were flame red, tinted through with scarlet, with some violet at the top. During this final color-laying, allow plenty of time for drying – use a hair-dryer if necessary – and keep checking the edges of the masking.

Graffiti

The graffiti style, first popularized by illegal artists working at night with spray cans, has now become artistically legitimate; in case you wondered how they get the colors right in darkness, the answer is that they label the spray cans.

One of the great advantages of the graffiti style for the novice airbrush artist, though, is that it is very quick: Felix Braun and Tom Bingle, the two art students who created the picture on the previous page, did the whole thing from initial drawing to final painting in a single (long) day. Compare this with the six or seven days which Ray Mumford took for the work in Chapter 7. Also, a certain lack of finesse is almost expected: as one of them said, 'if people don't see a mistake, they don't think it's real graffiti'.

In fact, while they were working on the picture, other students at the same college (they were working in an art room at Filton Technical College) dropped in to try the brush for themselves, and the results were very interesting. They used it in ways that were often more akin to a spraycan-artist, with fast sweeps and sudden puffs, but as they grew to master the new brush, they explored all kinds of other techniques, including very fine lines. Several, who had previously steered clear of the airbrush because they thought that it was difficult to use, unreliable, and limited, went away vowing that as soon as it came out, they would buy one.

The graffiti style also allows you to try an enormous range of techniques in an uninhibited way: Tom and Felix showed the classic 'fine art' disregard for the niceties of technique, and ploughed on regardless.

Unlike outdoor graffiti, this illustration involved both contact and loose masking. The drawing took about half an hour, using compasses and straight-edges as well as working freehand. The whole drawing was then masked.

The mask was then cut above the skyline, and carefully removed; it would be replaced later. An interesting technique was the use of very deep cuts, which actually scored the illustration board: this is particularly useful if you are using art markers (which were used for the figure, the dragon, and the CIC logo on the right), as it stops colors 'bleeding' across lines. It also comes in handy if you are going over lines with a Rotring (which is how the fine black lines were created), as it provides an automatic guide for the tip of the pen. The sun was loose-masked. The sky colors were painted in mixed reds and pinks.

Next, the clouds were added with a pinkish-violet, using a paper loose mask to create the flat base; the curly upper parts were drawn freehand. White was added around the edges of the cloud, on the sun side, with fine squiggles for cirrus effects. Overspray under the loose-masked sun meant that the right-hand side was distorted and there was an overall pink tinge; white, added on one side to conceal the fault, paradoxically gave a *more* dramatic effect than they would have achieved by doing it 'properly' with a contact mask.

With the sky mask back in place, the next section to be removed was the skyline and everything except the lettering, the circle to the right of the lettering, the figure, the dragon (with its paint can) and the CIC logo column on the right.

Tom Bingle at work on 'Real Deal Art'. Notice the way he is using coins to weight down a loose mask.

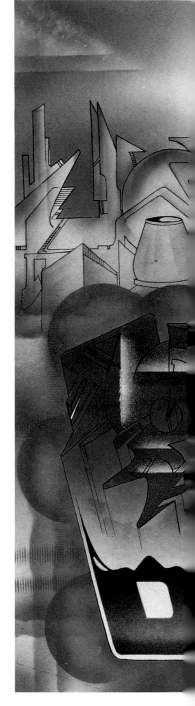

'Real Deal Art' Crime Incorporated Crew, Bristol.
Gouache and art marker on illustration board, approximately 22×16 in/ 45×55 cm.

A gray spray, with various pieces of loose masking (circles and straight edges) took care of the skyline: the shadow effects are sometimes realistic, sometimes arbitrary. This spray faded just below the skyline.

Next, a green spray was used to surround the 'Real Deal Art' logo. Some of the spraying was freehand; some (especially the circles) used loose masks; and for the ridged effects to the left of the lettering and above it, a comb was used. The green merges with the gray above.

A more bluish gray, again with a variety of loose masks, completed the background on the right of the picture. The 'bubbles' around the foot of the logo were sprayed in with a loose mask. The green circle to the right of the lettering was uncovered, then sprayed with a loose mask to protect the surroundings; there is more comb-work and other loose masking inside it.

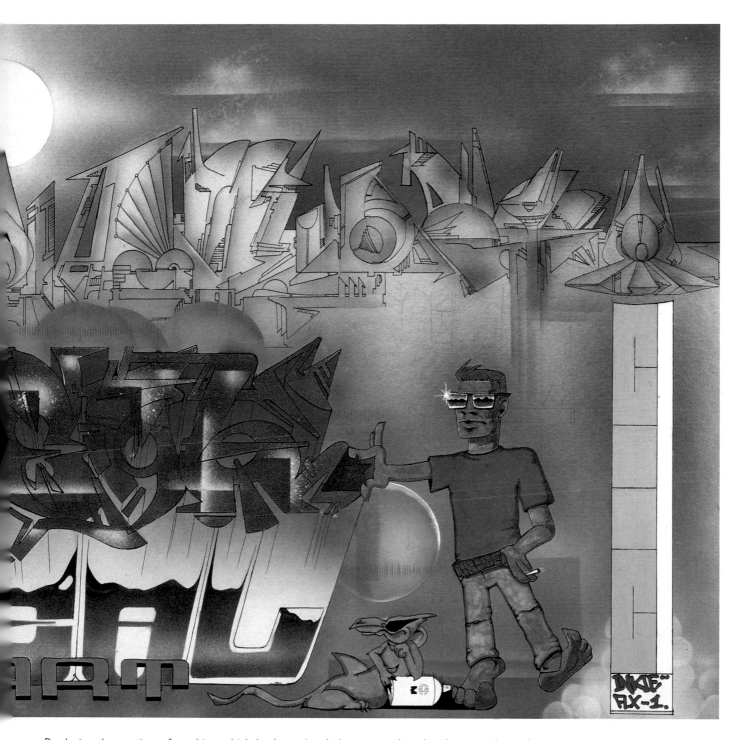

Replacing the section of masking which had previously been removed was difficult, but possible; an alternative would have been to re-cut the whole mask, but re-laying the old mask was quicker, and speed contributes to the graffiti-style look. The 'Real Deal Art' lettering was then unmasked and re-masked in three separate stages – the orange, the blue and the brown.

The word 'Real' was sprayed with a deliberately spattered effect, overlaying orange on yellow, again with loose masking. The blue and the purple were deliberately laid smooth, but graded, to create the impression of chrome (see pages 78–9).

This was the end of the airbrushing. The masks were removed, and black lines were added with a Rotring pen. Not all pencil lines were inked in, and indeed, you can see some pencil-work under the gouache above the figure which was never cut, masked or inked.

The word 'Art', the figure, the dragon and the logo were all colored with art markers: these were particularly useful for the uneven finish on the faded jeans, and the markings on the dragon (where two greys were used). The Rotring came into play again for the spectacles, the cigarette, and the black hills reflected in the sunglasses. The 'farkle' on the sunglasses was done with a very fine brush.

While the picture may not be to everyone's taste – the mere mention of the word 'graffiti' puts some people's teeth on edge – it demonstrates the simple truth that you do not have to be the world's greatest technician to create striking original art with the airbrush. You need a steady hand for mask cutting, and you need plenty of patience, but a deliberate studied roughness and a determination to get the picture finished *fast* can produce something which many people would be pleased to have on their walls. There is more information on Crime Incorporated Crew in the Acknowledgements section at the end of the book.

Chapter 7
Masking Sequences

The four spreads in this chapter cover the creation of the piece of artwork at the end of this chapter. Two spreads deal with the monochrome part – the hands and airbrush – and two are concerned with the color. The monochrome work is deliberately more highly finished than the color, in order to show contrasts of technique.

First, finalize your original drawing onto thin layout paper: if your finished drawing is on thick paper, it will be more difficult to transfer a crisp, clear outline onto the ground. Lay the drawing on the ground (art board is best, or use a good grade of paper), and use tape or pins to hold it in position. Be careful to keep adhesive off any areas which will subsequently be sprayed, as it will affect the texture of the sprayed finish.

Use tracing-down paper (pages 72-3) between the drawing and the ground; do not use tacks or adhesive, as these can cause marks on the ground. Rubbing these out is easy enough, but once again, the action of the eraser on the board will affect the spray texture.

Transfer the drawing by pressing down with a hard, sharp pencil. If you are not familiar with tracing-down paper, practice on some scrap paper before you start: if you press too hard, you will have pencil marks on your ground, but if you press too lightly you will find the illustration hard to see.

Remove the drawing and the Transtrace and lay the masking film. There are different ways of doing this, but the two most common are to roll it off the backing paper (page 51) or to remove the backing paper entirely and to work vertically or near-vertically, holding the film like a curtain, and allowing it to make contact on the bottom edge first, then working it upwards. Smooth out any air bubbles, very gently.

Cut the first mask, in this case the hand. It is a good idea to practice with a test piece of film to see how much pressure you need to put on the blade.

Consistent control and light pressure should enable you to cut the film without marking the ground. Any marks on the ground will show on the finished artwork.

When you have finished cutting the mask, peel it away very carefully and save it by laying it on a piece of backing sheet.

Set the airbrush to fine/medium, and 'sculpture' the shape. Work decisively but *slowly*, testing your spray away from the area to be sprayed before you venture into the cut-out. This will enable you to get even spray coverage. Do not lay the color too fast, or you run the risk of getting the ground too wet with subsequent 'bleeding' under the edges of the mask.

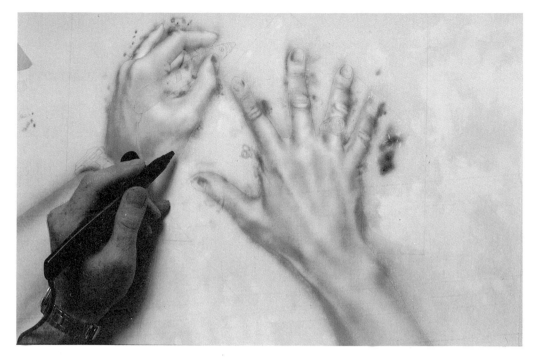

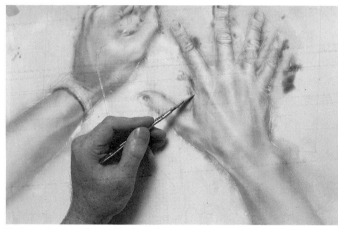

'Knifing', as here, can be used both to add texture and to lighten too-heavy areas. One of the great advantages of high-quality illustration board is that you can knife and spray and knife and spray again, almost indefinitely.

When the hand is dry, you have two choices. You can either reposition the mask *very carefully*, or you can remove all the film and cut the next stage.

The next stage to be sprayed is the finger-nails. The spraying and knifing techniques are exactly the same here as already described, and it is important to emphasize that you cannot really hurry airbrushing. Even so, compare this painstaking process with 'Real Deal Art' (page 80).

Repeat these stages for the ring, the watch, and the details of the airbrush. Here, you can see the main body of the airbrush being unmasked. As an aside here, if you want realism, try to set aside your preconceptions about what something looks like, and *look* at it instead.

Spray in the main body of the airbrush, not worrying about small highlights but once again 'sculpting' the smooth fuselage shape of the body. If you keep the direction of the lighting firmly in mind, you can see which areas should be lighter and which should be darker.

Returning to the scalpel, pick out the small highlights on edges and corners. It is details like this which really make the pictures three-dimensional. Be careful, though, to scrape *very* gently with a *very* sharp scalpel, and to go for a smooth 'satiny' finish: if you scratch too hard, or if the highlights are too clearly defined, you will lose the impression of roundness.

Peel off all film, after checking that everything has in fact been sprayed. If you have forgotten a small area, even a finger-nail, you will need to do quite a lot of re-masking in order to do that single step in isolation.

The finished hands in isolation do not look right, as there are no shadows to lift them off the surface. This makes the little finger look very awkward indeed, as it is not clear that it is being used as a support, with the rest of the hand a couple of inches (say 5 cm) from the paper. The wash in which the shadows are added is covered later.

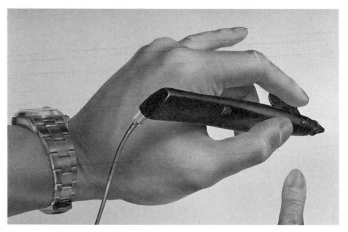

A close-up of the left hand shows clearly how different finishes look when airbrushed. The metal watch should be airbrushed to produce a polished surface. Notice the line around the watch face. Use the knife to scrape the surface of the watch strap very lightly. These highlights create the satin finish.

Make a note of the details that are appropriate to the subject. Here, pores and lines have been added to create a rougher texture on the hands. This helps to make the skin look realistic.

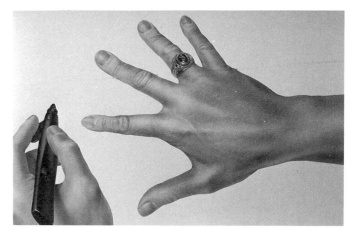

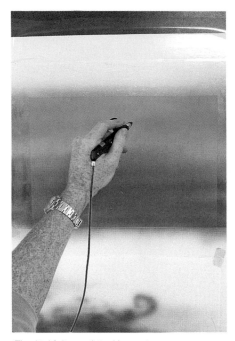

A new mask is laid, as already described in the monochrome section, to protect the hands and the border. The foreground is protected with a mask of paper or card, at the horizon line. Set the spray to a medium range, and working back and forth as described on page 40, paint in the graduated yellow of the lower sky.

Work red into the sky, laying a second fading wash on top of the existing yellow. Be careful here: spray travels further than you may realize, so do not take the red too far down into the yellow.

The third fading wash is a blue, again worked from the top so that it fades into the red. This gives the deep color shown. Be particularly careful here, as blue overspray onto yellow will give you a green!

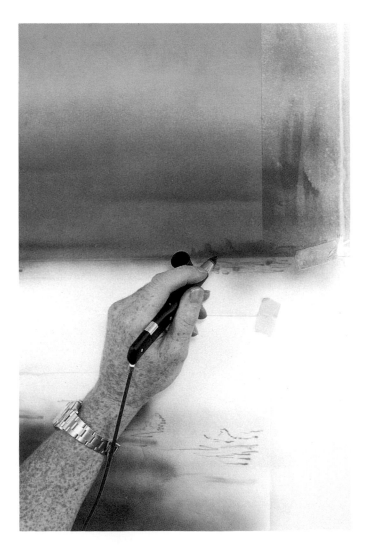

Set the airbrush for fine work, and draw the soft distant clouds and rock formations. Because these are in the hazy distance (see aerial perspective, page 62), freehand drawing is perfectly acceptable.

Remove the paper mask; you are now about to start painting the foreground.

The initial foreground gradation is in the same sky tones of yellow and orange, though of course this will be dulled down later.

The airbrushes in the 'airbrush graveyard' are created using loose masks, as described on pages 48–9. Use thin, high-quality card for these.

Because the sky is translucent, you will be able to see your under-drawing as a guideline for positioning the loose masks.

Hold the mask down evenly while you are spraying, and do not spray too close to the mask or you will lift the edges causing overspray. Be very careful to mask the rest of the work, because overspray travels alarming distances and may well wreck your picture otherwise!

In order to create the shadows from the airbrushes, use a piece of paper as a loose mask. This will give a fairly soft-edged effect, but once again you must cover the rest of the work in order to prevent lines appearing elsewhere.

Gently peel the film from the border and the hands. This is a delicate operation as any paint beneath the masking film can lift if you are not careful.

This is the finished article, minus one essential stage – the shadows. You can see from this why they were not added at the monochrome stage: they need to be sprayed over the background color in order for them to sit on the work properly.

Lay a piece of tracing paper over the artwork and draw an outline of the hands. Add the outline of the shadows to this tracing. Cut out the shadows and use the tracing as a loose mask which will give the shadows a soft-edge. Spray the shadows making sure that they are darker towards the finger-tips (where the hand is in touch with the ground) and lighter away from the finger-tips to give the hand greater solidity. To produce this fading tone, lift the mask away from the ground and use less paint or bring the airbrush away from the surface. The shadows at the edge of the masking paper and beneath the artwork can be created in the same way to complete the work.

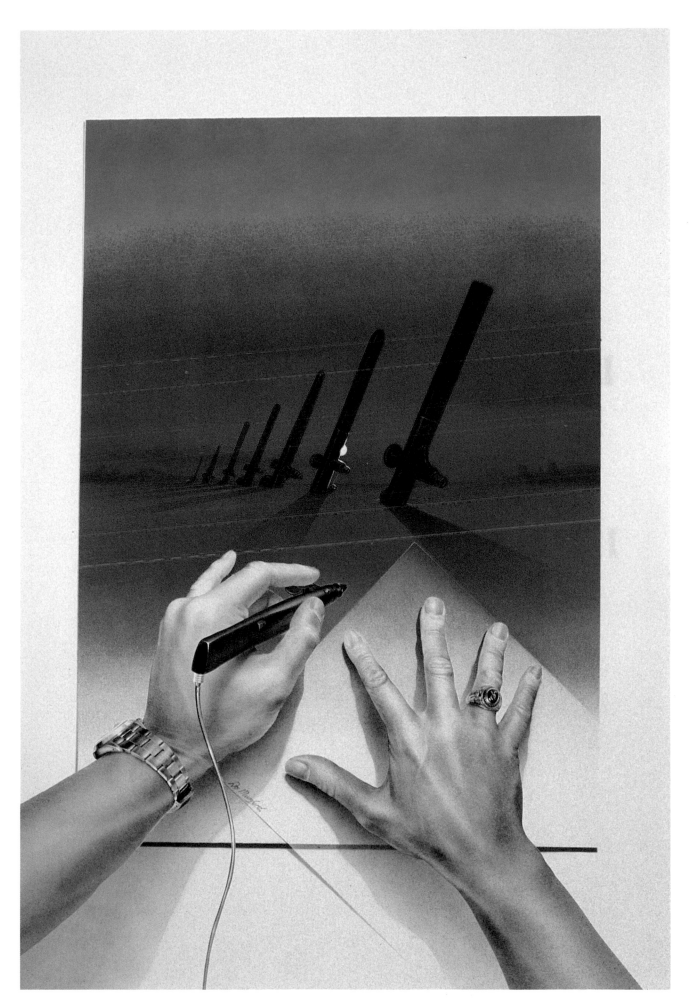

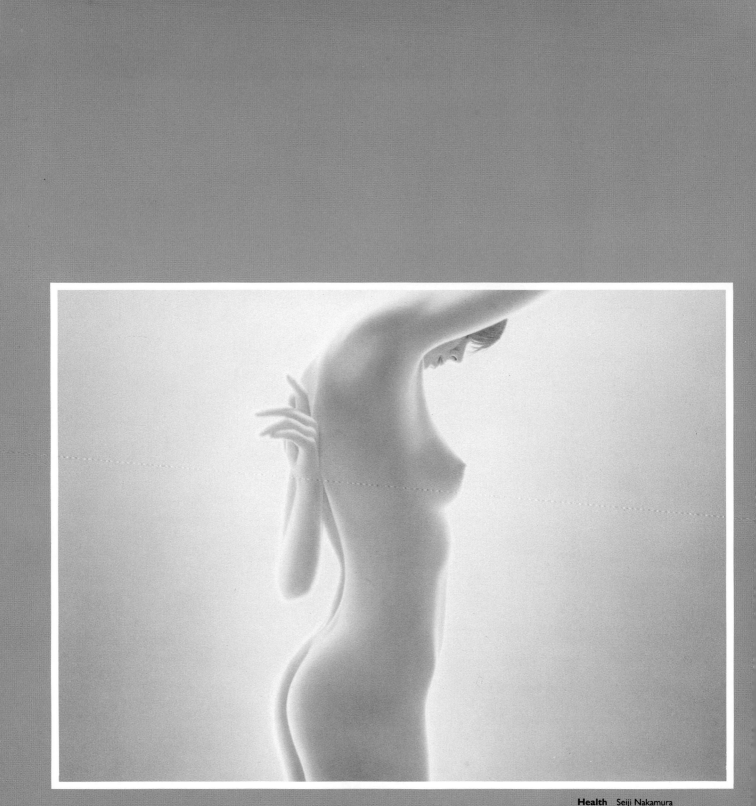

Health Seiji Nakamura
This subtle and natural study of the
human figure shows the delicate use of
freehand work with the minimum of soft
masking to achieve a painterly effect
rather than the sharply defined contours
associated with a graphic illustration.
(JCA)

Chapter 8
Fine Art and Graphics

There is a tradition, which we follow to some extent in this book, of separating 'fine art' and 'graphics' or 'illustration'. The illustrator is a commercial artist, working to a brief, who produces 'artwork' as distinct from 'art'. The fine artist, by contrast, works according to an inner spring of inspiration; his pictures stand alone, in their own right.

While this distinction can undoubtedly be made and defended, it is equally certain that it is impossible to draw any hard and fast line between fine art and illustration. The best illustrators produce work which most people would be delighted to hang on their wall as 'fine art', and to deny their talent would be mean-minded and foolish.

It is only since the late 1960s, however, that the airbrush has gained much currency as a tool for the fine artist; until then, it was seen as 'merely' a tool for illustrators. So deeply entrenched was this attitude that some people automatically dismissed any work produced with the airbrush, on the curious grounds that it was 'mechanical' and therefore not 'artistic'.

To show how strong this feeling was, a little story may be relevant. As late as 1980, a leading airbrush artist was haughtily assured by one major gallery in London that they did not handle the work of artists who used airbrushes and 'that sort of thing'. He went through their stocks and pointed out a number of pictures which incorporated effects that could *only* have been accomplished with the airbrush. Concealing their embarrassment manfully, they replied that while some of the artists might have used airbrushes, they were not airbrush artists . . .

It is only fair to add that many airbrushes *do* have a somewhat 'clunky' mechanical feel. They lack the almost sensuous qualities of regular brushes. One of the advantages of the new airbrush, incidentally, is its extremely supple and sensitive action, which restores a good deal of painterly feel to the physical process of painting. Even so, many fine paintings have been produced with traditional airbrushes, and it would be a rash person today who denied that the airbrush could be used to create fine art.

Since the airbrush has become 'respectable', there has been something of a turnaround in public attitudes. Indeed, when we were discussing this book with one art student, he argued that *too much* emphasis was being placed on the role of the airbrush in fine art.

In this book, there is a fairly unashamed emphasis on the illustrator's craft, for two reasons. The first is that many fine artists who work with the airbrush do so on a very large scale – sometimes as much as nine or ten feet (say three metres)

square. When a painting of this size is reduced to fit onto a page, an enormous amount is lost. All texture is reduced to the same slick, 'airbrushy' finish, and details become microscopic. This alone means that the painting cannot really be appreciated in the way in which the artist intended.

The second reason is that while you can learn a good deal about artistic vision by looking at fine art, you will not necessarily learn very much about the techniques of airbrushing. Illustration, on the other hand, can literally be used to illustrate a particular technique or approach; and because the original is likely to be a lot more manageable in size, details and textures are much more clearly seen. As a matter of interest, most airbrush illustrators work 'half up' or 'two up', making the illustration 50-100% larger than it will appear in the final reproduction. This helps disguise minor flaws, and generally makes it easier to work. Wherever possible, the degree of reduction (or in some cases, enlargement) is given beside illustrations in the text.

In other words, while you can learn a great deal about fine art from illustration, you may not be able to learn so much about illustration from fine art. Because this is a book about *how* to paint with an airbrush, not about *what* to paint with an airbrush, it has therefore concentrated on technique rather than on content – though of course we hope that you will also be impressed by the content.

The few 'fine artists' whose work does appear in these pages are, therefore, chosen mainly to show just what is happening in the world of fine art: they are selected from the leading names in that world. Where possible, we have also tried to draw lessons from their work; but this has not always been possible, because the simplest techniques in the hand of a great artist can have more impact than the most complex techniques in the hands of a lesser painter. Remember too that an airbrush is a tool, not a medium, so it can be used *with* other tools, including conventional brushes. In fact, many artists who are otherwise wedded to conventional brushes use the airbrush for glazes and for skies; it excels for both.

Finally, even if you want to use your brush primarily for (say) cake decorating or fish-painting, you may still find it useful to look at the work of illustrators and artists, just to see how the airbrush *can* be used. As we shall repeat at intervals throughout the book, the airbrush is a tool, and like any tool, it has to be mastered. Once you have mastered it, you can take it in entirely new directions. It's up to you.

Thangka Robert Beer
This owes a great deal to traditional
Thangka painting (see page 31), but
Robert Beer has adapted this severely
circumscribed art-form to create an
image which is not strictly traditional, but
not wholly independent of tradition
either.

Tomato in the Water
Toshikuni Okhubu
A superb example of painstaking visual
analysis. The creation of a satisfying
picture like this is dependent on the
artist's ability to train his eye to
observe the subject meticulously. In
producing the image the artist must draw
what he sees, not what he thinks he sees.
Not all subjects can be observed directly
– high speed photography must have
been used as reference material for this
piece.

Movie star 'Tomoyo Harada'
Yip Kam Tim
The lack of surface texture is a unique property of airbrush work and the artist has used this here to bring the subject and viewer closer together. The cropping of the image and the quality and definition of the illusion of different textures enhance the composition, making it more intimate than it would have been using any other artists' tool.

Portrait Talia Fisher
An example of Talia Fisher's monochrome work has already appeared on page 36, but this color picture is fascinating in the way it combines the effect of a hand-colored photograph with a kind of tenderness which would be very hard to achieve with a camera.

Monroe and The Marx Brothers
This stylized image mimmicks the classic view of Hollywood and demonstrates another way in which portraiture can be used. In this advertising context the airbrush helps to set up a situation that never actually happened by giving it a feeling of reality.

The International Airbrush

The exact date of the invention of the airbrush is not known but it was about 1893 when an American, Charles L. Burdick patented a machine in England, and marketed it through the 'Fountain Brush Co'.

Since then the instrument has been refined and its uses and adaptations have multiplied all over the world. Although originally used mainly in photo retouching it has grown to be possibly the most important single instrument used in the graphics world today. The airbrush is a highly versatile instrument, and more adventurous uses and techniques are constantly being discovered. The limitations to its capabilities only depending on the skill and imagination of the artist.

America provided some of the earliest well known examples of airbrush illustration with the drawings of Alberto Vargas which became widely known from *Esquire* magazine, and later, *Playboy*, The 'Vargas' girl was actually patented, and during the Second World War, adorned American planes over Europe, becoming a symbol of liberty and all things American.

The heyday of purist airbrushing in London, was in the sixties and early seventies, with artists like Terry Pastor using an all encompassing technique with every part of the drawing, masked, cut-out and sprayed with the minimum of hand-work involved. The well known book *The Butterfly Ball* by Alan Aldridge, illustrated by Harry Willock, used this technique, which in this case included a holding line of thin black ink to strengthen the final image. This method was extremely popular at the time, enabling the artist to fill in every section with the airbrush. As the colours were not butting up to each other, but were separated by the black holding line, it meant that mask cutting did not have to be as accurate as in later methods. Inks and dyes, being transparent, were used when a holding line featured in the illustration. Styles and techniques evolved as more and more artists realized the enormous capabilities of the airbrush. The Americans set a trend with the 'West Coast' Style of illustration, featuring highly chromed cars or trucks, usually set in dazzling sunlight with strong blue skies. Then there were drawings of hamburgers, Coca Cola bottles and all the paraphernalia and ephemera of American life, all with strong contrast and hyper-real detail. This style carried over to England and Europe with many imitators who became style setters in their own right. The early paintings by Michael English of giant Coke caps and cans, toothpaste tubes and the like, were stunning at the time, and have now become evocative of the period. Philip Castle developed a style that was his own, although reminiscent of Vargas, becoming known for cars, planes, and girls with various chromium appendages. His technique was interesting, based mainly on gouache, and his work reproduced exceptionally well with the portrait of Elvis Presley metamorphosed from a juke-box being one of the best examples, is now world famous. About the same time artists like David Jackson in London and Pierre Peyrolle in France cultivated a more precise style, that encompassed a broader range of subjects than just chrome and cars, and pushed the realms of realism still further. In particular, both Jackson's and Peyrolle's figures and faces were outstanding and the clever use of tricks like spraying through a piece of fine net curtain to achieve a convincing texture on an illustration of clothing that Jackson sometimes used, added to the overall realism. Peyrolle's work attained an almost Dali-esque quality with powerful surreal images. At this time the materials were generally gouache and/or photo-dyes with water based inks becoming increasingly popular. Highlights were still mainly put on using white paint, either by hand or with the airbrush.

The Japanese began to be noticed from the mid-seventies, with amazing standards of finish and precision, the chrome robots of Hajirne Soratarna are a superb example of tight technique allied with imaginative subject matter. The drawings became famous and attracted many imitators, setting ever higher standards, and increasing competition both domestically and internationally. The 'wet figure' illustration by Yosuke Ohnishi, and his close-up drawings of jeans with incredible detail in the texture also became well known. The 'Splash' drawings by Toshikuni Ohkubo attracted excited comment in the profession, by achieving the almost impossible, not only capturing the translucent qualities of water, but also attaining a perfect understanding of its movement.

In Europe at the same time the use of the airbrush went forward in leaps and bounds with adventurous artists like Adrian Chesterman creating an effective yet simple technique. His method is to make the first stage of his drawing in monotone, using black dye diluted with water to various strengths. The solid blacks will often be put in by hand. Then the whole drawing is 'colored up', spraying transparent inks and dyes through the airbrush. The method is similar to tinting a photograph, which was one of the original uses for the airbrush. Immediately after spraying, the drawing often looks crude and unimpressive, but the final stage, when the artist uses a scalpel and different erasers of varying textures to create hard and soft highlights, gives it a dazzling finish that reproduces exceptionally well. As there is no opaque color used, the full vibrancy and luminosity of pure dye is unimpaired. With many high quality magazines and annuals published around the world nowadays, there is so much information being exchanged that it is difficult to be precise about national trends. Suffice it to say that the accomplished airbrush illustrator who masters his art, and is aware of the high standards in demand, can treat the whole world as his market place. The airbrush is part of the armoury of all accomplished illustrators as there is generally a much less rigid approach to airbrush drawing today

Many artists, like David Nelson, who is now in Melbourne after two successful years in London, can use a multitude of techniques as well as traditional airbrushing. The illustration will often consist of many methods, and even media, with the airbrush playing an important part for speed and finish. The Australian scene is further enriched by the work of Mark Salowski in Sydney, who uses a purist approach to obtain a strong realistic finish, and Otto and Chris, two artists who work as a team, who virtually pioneered airbrushed cartoons in that part of the world.

Marcel Rozenberg, a Dutch illustrator based in Rotterdam, is another example of the broader use of airbrushing although he is a painter in the accepted sense. He works in acrylic on prepared mahogany, an unusual method in itself, but is not troubled by employing the airbrush in many ways, to help cover a large area, or to soften a highlight. This would have been frowned upon by many purists in the past, but today the whole illustration world is opening up to adventurous artists with an 'anything goes' approach to creating imagery.

The techniques vary from artist to artist with many different media now designed specifically for the airbrush, including liquid acrylic, which gives a range of strong, bright colours that are also very robust. It also helps if the airbrush itself is tougher, as many models often clog up or spit if they are not treated very delicately. The airbrush is also used widely in other fields as well as graphics; in animation, model making, sculpting and even taxidermy. It is this versatility and adaptability that assures the future of the airbrush throughout the world, in fine art and other areas. As the finish that can be achieved, with the variety of materials available, ensures that it will remain an essential tool for the designer, artist, illustrator and enthusiast.

Dick Ward

Koala surfing Vision Graphics
A technical *tour de force*. Hard and soft masking have been used to create textures and to emphasize the perspective, depth and curves of the board and the wave. Look carefully at the way light has been used to create the impression of speed and excitement.

Coca-cola cap and Fanjet
Michael English
Michael English's Coca-Cola cap is one of
his best-known pieces of work, but he
has changed his style a great deal over
the years; 'Fanjet' (acrylic and gouache, 6
feet by 6 feet) is an example of his
latest work, which he regards as much
more typical of his current style.

The Hi-Jacking of the Airbrush

Cosmos Kazuaki Iwasaki
A mystical feeling created by the softness of the airbrushing is used to establish an impression of reality. One of the most effective uses of the airbrush is to create almost photographic or photo-realistic images, often of things that have not yet been seen but are futuristic or a product of the artist's imagination. The ambiguity of this device is part of the attraction. Contrast this photo-realism with the atmosphere of unreality *Retreat to the Future* (below). (JCA)

Kazuaki Iwasaki 10

Although the airbrush began as a tool for fine art, it was rapidly appropriated by photo-retouchers who used it to 'lose' wrinkles and the like from their clients' sometimes scraggy features. At the time, there was a considerable movement for 'objectivity' and 'honesty' in art, and the airbrush was therefore seen as 'dishonest'. Because of the ease with which a skilled retoucher could mimic photographic effects, it was also seen as 'mechanical'.

On the other hand, it was precisely these qualities which endeared the airbrush to illustrators and to a very few fine artists. Before the Second World War, hardly any fine artists explored the potential of airbrushing to any great extent: apart from Charles Burdick himself and a few other pioneers whose work is now almost completely forgotten, the only pre-war artist of note whose airbrush work is remembered is Man Ray. Strongly reminiscent of photographs, these 'Aerographs' of which Ray was so proud are like much of his photographic work: interesting as intellectual exercises, but somewhat lacking in immediate appeal as pictures.

A great deal of excellent airbrush work was produced from the 1920s (and even earlier), and some of the posters from the Second World War are superb pieces of illustration even today – in fact, that era is still being 'mined' by advertisers and design students. Even so, it was not really until the 1960s that the airbrush began to gain any very serious place in the world of fine art. But what does 'fine art' mean? Essentially, the use of the airbrush in fine art is exactly the same as the use of any other medium or technique, whether it be Jackson Pollock's dripping and dribbling technique (Pollock apparently tried the airbrush, or at least the spray-gun, but never found it congenial) or the precise brushwork of Fragonard: it is a tool, a means of expressing yourself.

It would be foolish, though, to deny that there is an interrelationship between the tools an artist uses, and the expression of his or her vision. At this point, a very interesting new light is cast on the nature of the airbrush.

Painting – or for that matter, all art – can be considered in terms of 'equivalences'. To take an obvious example, we could try to paint every hair in a beard, or we can lay on the paint thick and fast and create the *impression* of a beard. We can even get away with using totally unrealistic colors, if we can carry the viewer along with our own way of seeing. Equally, we can use a highly stylized form of representation, and people will still understand what we mean: just think of ancient Egyptian cave paintings, where we can still see pharaohs and dancing girls, even though the representation is far from photo-realistic.

But the airbrush *can* mimic photography, with its potential for smooth, grainless tonal representation and for 'hard-edge' representation via the use of masking. It is possible to produce paintings which look like photographs, in fact, and this illusion can be heightened still further if the images are reproduced photomechanically (for example, in a book or on a poster) rather than being displayed on their own. Two schools which grew directly out of this are 'photo-realism' and 'fantastic realism'. Photo-realism is concerned with producing pictures which are effectively indistinguishable from photographs, such as Jurgen Wiersma's gauntlet on page 54, while fantastic realism creates pseudo photographs of things which never existed or could exist.

It is important to realize, though, that these are only two types of painting which can be created with the airbrush, and that many more 'painterly' effects can also be achieved – as, indeed, this book shows. What we are concerned with here is more a question of *how* to paint, rather than *what* to paint; and that is the subject of the next two spreads.

Retreat to the Future
Glen and Peter Hewett
24 × 36 in (60 × 90 cm approx),
acrylic on canvas

Watercolors

Boy and Leopard Seng-gye
Seng-gye worked in many media, and this
is one of his more playful pieces. Are the
boy and the leopard fighting, or playing?
Watercolor, original approx 12x16 in,
30x40 cm.

The airbrush owes its very existence to watercolors; Charles Burdick, the inventor of the first airbrush (he went into production in 1893) was an enthusiastic watercolorist, and he wanted a way of overlaying colors without mixing them, a subject to which we shall return in a moment. Surprisingly, only one of his pictures – a very fine portrait, now in the hands of the DeVilbiss Company – seems to have survived.

Unless you use extremely heavy paper (300 lb or above), you will need to stretch watercolor paper for airbrushing in exactly the same way that you would stretch it for any other watercolor painting: dampen it thoroughly, either with a sponge or in a bath, but do not get it sopping wet. Then, fix it to the board with broad gummed brown-paper tape. If you do get it too wet, it may shrink altogether too much: one artist was awoken by a loud bang in the night, and upon jumping out of bed to investigate, found that his drawing board had actually been snapped in two by the contracting paper!

When you are masking and cutting, another problem rears its head. Because of the yielding surface of watercolor paper, and its roughness, you are faced with two requirements which are somewhat contradictory. You must have the masking film pressed well down, and cut it carefully, or you run the risk of color seeping back under the mask – although with the light, fast-drying spray typically used in watercolor, this is less of a problem than it might seem. You should never allow your ground to get wet in watercolor, but there is a knack to spraying it, and you can only learn it by practicing.

If you cut too deep, or press too hard at the edges of the mask, you will, however, leave a minute groove in the paper. Then, if you remove the mask and spray over the whole area, there is a serious danger that the color will accumulate in the groove. Masked watercolors are, therefore, something of a test of mask-cutting delicacy. It is worth mentioning in passing that Charles Burdick was a master of *freehand* watercolor.

For obvious reasons, it is more convenient to use tube watercolors rather than the cake form; mixing up enough color, in enough intensity, for use in an airbrush would take for ever if you used cake colors. Mix it up in exactly the same way that you would for brush-painting, in a small jar: stir it with your brush until the color is well mixed, and load the airbrush with an eyedropper.

The delicate luminosity of watercolors is due to the incredibly finely divided pigment, which soaks into and among the fibres of the paper, so that the light which is reflected from the painted surface is a mixture of the color of the pigment and pure paper-base white. For this reason, watercolor is the only medium where several coats of well-diluted color do *not* equate to a single coat of thicker color: at one extreme, you get the extreme delicacy reminiscent of Cottman, while at the other, you get the much stronger colors of someone like Moreau.

Urban Speed Star Hideaki Kodama
Another example of careful observation.
The stylized use of the airbrush in the
background helps to create the impression
of bright and dappled light which gives
light to the whole picture. This is
reflected in the foreground by the
highlights on the roof, windows and hood.
The blurred area to the left and spatter in
the foreground provide distinct contrast
to the highly polished bodywork and
sharply defined shadows and reflections.
(JCA)

The inevitable consequences of this transparency (or at least translucency) are threefold. First, you cannot disguise errors by overpainting, as you can with pigment media – and by the same token, any sketching on the paper is likely to show through, unless it is at a color boundary.

Second, there is a limit to the number of overlays which are practicable. Although you can run to ten or even twenty layers of paint if you are using pigments, anything more than a very few coats rapidly begins to look muddy if you are using watercolors. You can manage more overlays if you are using weak, spectrally related colors such as yellows and greens, or blues and violets, but if you use colors from opposite sides of the 'color wheel' (pages 48–9), you will end up with colors which are very muddy and degraded.

Third, *all* overlays darken the colors on which they are laid. This is true even if you are using (say) a pale yellow over orange: the orange will be darkened. This is obvious enough, but when the colors are close together in the spectrum and the second color is in addition very weak, it is all too easy to forget.

Watercolors are made simply of pigments, gum arabic and preservative, all of which are not only water-soluble but also re-soluble; that is, they can always be re-dissolved by adding water. This means that the airbrush is the *only* way of overlaying water-colors without disturbing color already laid; which is, after all, why Burdick invented the airbrush in the first place. It also means that watercolors are ideal for use in the airbrush, as they can easily be washed out even if they are left to dry in the brush – although, of course, we do not recommend this!

Perhaps one of the most fascinating things about watercolors is that this very old-fashioned medium is probably more versatile now than it has ever been before. You can draw with watercolor pencils (or more accurately, pencils with water-soluble colors); you can work the colors in with a brush, and add more color the same way; and then you can use your airbrush as well. The great watercolorists of the past would have envied us beyond belief.

Author	Title	Publisher
Jacqui Morgan	*Watercolour for Illustration*	Watson Guptill Publications New York
J. M. Parramon	*The Complete Book of Watercolours*	Parramon Editions
Charles Reid	*Painting What you Want to See*	Watson Guptill

Oils, Alkyds and Acrylics

There are three modern 'painterly' media that can be put through the airbrush. There are the traditional oils, usually with a linseed-oil base but sometimes with another natural-oil base such as walnut; there are acrylics, which are water-soluble when wet, but dry to a plastic film which is extremely difficult to remove; and there are alkyds, which are based on a synthetic resin and are spirit-soluble like oils. In fact, oils and alkyds can be intermixed freely on the same canvas.

The easiest way to mix any of these paints for use in the airbrush is to squeeze some paint out of the tube; thin it with a small amount of the appropriate thinner, using the brush to mix it; and then to put the thinned paint plus *more* of the appropriate thinner into a small jar with a tight-fitting lid, and shake furiously. Filter the mixture before use; the tea-strainer test (page 24) is invaluable.

Most people agree that oil-painting with an airbrush is a bit too much like hard work, but there is a difference of opinion on whether alkyds or acrylics are the better alternative.

The drawbacks of oils are that they are difficult to mix consistently; they settle; they are often less smooth than alkyds or acrylics; and, of course, they rot the canvas unless you protect it with assiduous priming. This last is particularly important in airbrushing; when you are cutting masks, you have to exercise enormous care not to go through the primer to the canvas, or you will negate the protective effect of the primer in that area. They also dry unevenly, with different degrees of gloss, which is one of the reasons for varnishing – it gives the whole paint surface an even texture and reflectivity.

There is potentially a problem with 'wet-on-wet' versus 'wet-on-dry' with oils. If you are using a brush, you can work wet-on-wet for anything up to a few hours; then, the underpainting forms a skin. If you try to paint on this, differential drying rates will lead to wrinkling and cracking, so consult the manufacturers' drying-time tables and WAIT before painting the next layer. With an airbrush, this intermediate period when you cannot paint is not obvious, and if you lay a second coat during this

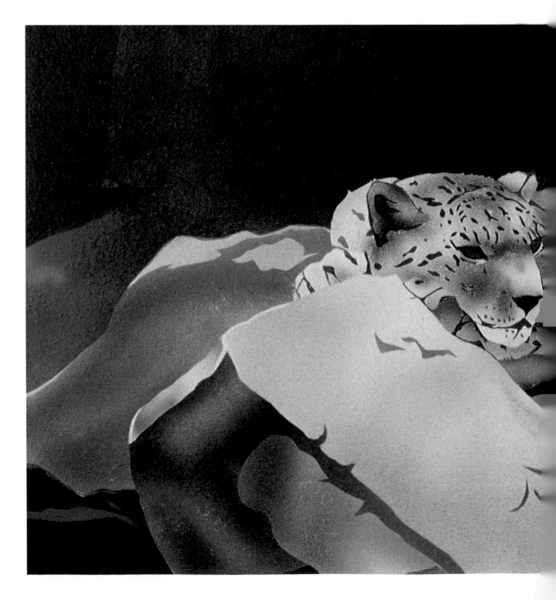

Leopard Seng-gye
Seng-gye's interest in big cats is illustrated again by this painting of a leopard at rest; acrylic on watercolor board (which proved a troublesome and easily-abraded surface), approximately 12x24 in (30x60 cm)

period, you may run into problems.

Finally, the consistency of oils for airbrushing is sometimes inconveniently thick. If you over-dilute oils (in other words, if you add too much turpentine along with the linseed oil), the turpentine can evaporate and leave a powdery, insubstantial pigment layer which is not properly bound by the oil.

Acrylics are water-soluble, and require no primer whatsoever: they can be applied to virgin canvas if you like. Unlike both oils and alkyds, they are normally (though not invariably) formulated with non-toxic pigments, so a simple face-mask will do instead of a respirator (page 12). On the negative side, they dry rapidly inside the airbrush, and once they have dried, they are no longer water-soluble; they can be difficult to clean out: the nozzle will require prolonged soaking, perhaps for two or three days, though plastic nozzles are inherently easier to clean than metal ones; the paint just slips out once it is loose.

Acrylics also have a tendency to form a deposit inside the nozzle of many airbrushes, though once again this should be less of a problem with the new design. With thick acrylics, you can even get stalactites of paint on the nozzle; these are tiresome to wash off a synthetic resin nozzle, and can be quite loathesome on metal.

Alkyds are the wonder-drugs of modern paint technology. They are actually synthetic alcohol-based resins, which cure to an extraordinarily permanent finish. They have an even drying time (and drying surface) on the canvas; there is no need for priming; the drying time in the airbrush is very slow (anything up to an hour poses no problems — just blow the brush through with turpentine substitute or white spirit); and they offer the option of applying a very much thinner glaze than would be possible with oils, because they can be diluted almost indefinitely, without the problems which can be encountered with oils.

On the negative side, the range of colors available as alkyds is rather more limited than the range of colors available in conventional oils, but there are still enough for any practical application (try to find a color you cannot mix from the alkyd range available!) and the colors that are available are all extremely permanent, Three and Four Star on the Winsor & Newton four-star rating system. Likewise, some of the same toxic pigments are employed as are used for oils, but this is simply to give the same quality as oils: many painters prefer to use these pigments, taking the proper precautions, in order to get the effects they want.

To sum up, we have no real hesitation in recommending alkyds as easily the best of the three 'oil' media for the airbrush; alkyds, watercolors, and car enamels (not acrylics) are probably the three best choices of all. It is also worth repeating the observation made on pages 90–1 about scale: with a large canvas, the ability to cover broad areas *and* to do fine work with the same brush is a blessing.

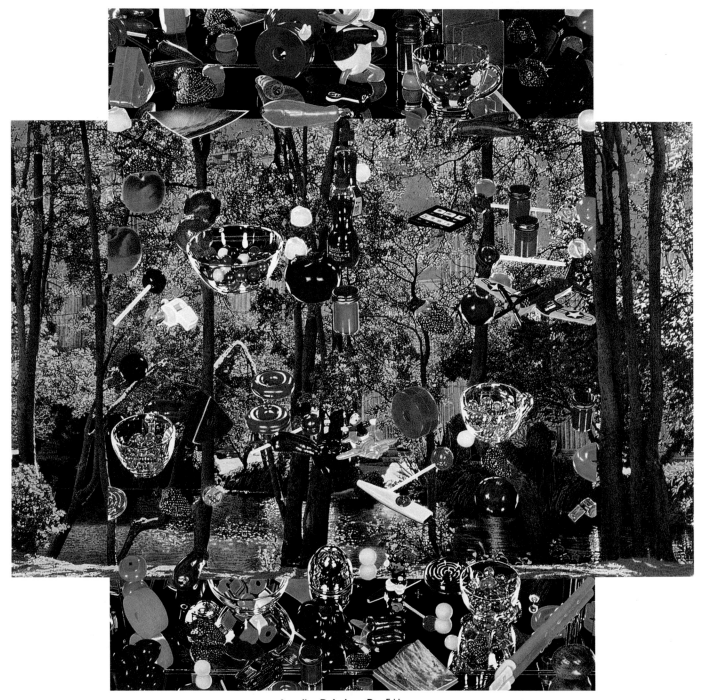

Arcadian Delusion Don Eddy
Don Eddy is best known for his 'hyper-realist' pictures of glasses. 'Arcadian Delusion' shows how he has moved away from this style. However, Don's meticulous attention to detail is still very much in evidence.

Ghostbusters Yip Kam Tim
A variety of techniques have been used here including masking and freehand work. The figures in the foreground have been produced using the techniques described on pages 44–50. Notice how the shadows on their bodies have been created using a single mask for each color.

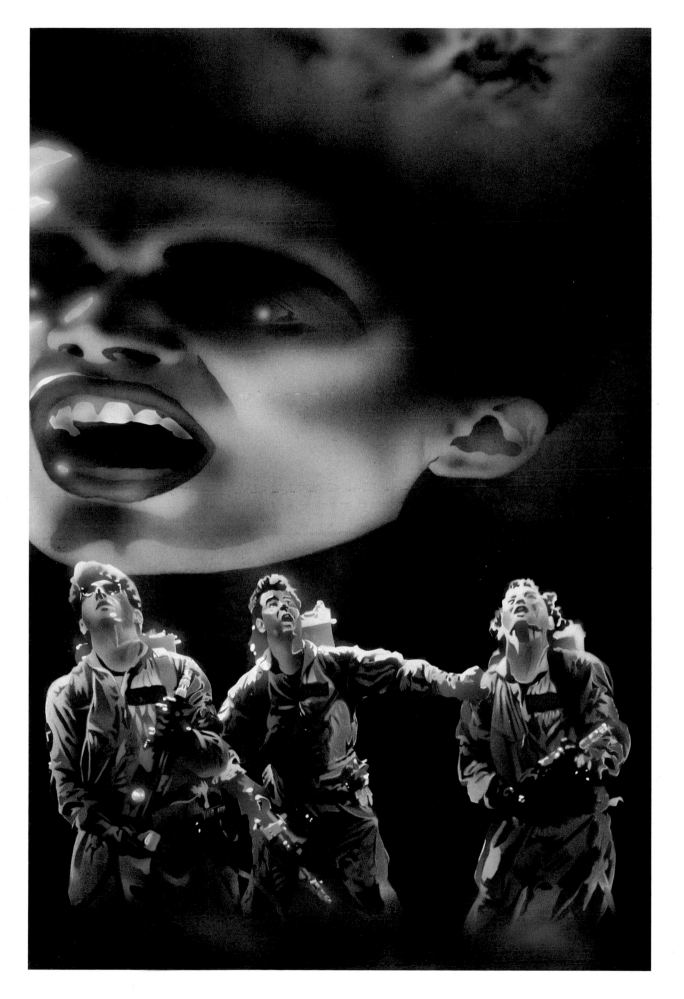

Chapter 9
The Automobile and the Airbrush

There are two reasons for taking an airbrush to your car. One is to touch up flaws or marks (especially rust) in the existing paint, and the other is to create your own paint job.

For straightforward touching-up, the airbrush has the enormous advantage over the time-honoured spray-can and paint-pot that the airbrush is vastly more controllable. This is relevant not only when it comes to 'feathering' the edges of a touched-up area into the main body of the paintwork; it is also important if you want to get a factory-quality finish, because the only way to do this is to use different mixtures of medium and thinner for the different coats. You cannot do this with a spray can, for obvious reasons, and traditional coach-painting with a brush requires special materials and a lot of experience. With the right airbrush, which includes the Aztek design, you can even touch up metallic paints, which are almost impossible otherwise.

Even if you have neither the time nor the inclination, therefore, to customize your car, you may still find the airbrush extremely useful.

If you are planning on creating a custom paint job, there is good news and there is bad news. The bad news is that customizing a car all over is a *very* time-consuming process, and that unless you do the best job you possibly can, the result is going to be distinctly unimpressive. The good news is that it is not a particularly difficult process, and that provided you are prepared to work methodically and carefully, you can produce show-standard finishes with a surprisingly small amount of practice.

You may care to start with panels which can be painted in isolation, like the hood or the trunk, before you go onto the main body of the car; there is something peculiarly distressing about removing and painting over work which has taken you days or even weeks; the temptation is always to leave it, even though you know that it is not up to the standard of your later work. For some psychological reason, it seems to be easier to re-do it if it is on a separate panel.

There are also three other points which are worth reiterating here. One is the safety point first mentioned on pages 12–13: many automobile paints are inflammable and contain toxic solvents, so work in a well-ventilated area and wear a mask or better still a respirator. In most countries there are legal requirements for professional spray booths, so take this one seriously.

The second point is that you have to have somewhere *clean* and *cool* to work. Dust will wreck your glossy finish, and direct sunlight won't even let you lay a decent coat of paint. The third is that the *only* way to get a first-class finish is to build up a large number of thin coats. The optimum thickness for each coat is no more than three-thousandths of an inch, less than one-tenth of a millimetre. If you lay the paint on too thick, you will get runs, cracking, crazing and 'orange-peeling'.

'Tommy' Ray Mumford
Ray Mumford's 'Tommy', a theme based on the rock opera by The Who, featured such remarkable feats as 'flippers' which appeared to move as the onlooker moved his or her head; the trick was accomplished by means of 'flip-flop' paints. Fish-scales or mica are suspended in lacquer to give the paint a refractory or reflective quality which can be used to create special effects. Ray rarely does cars nowadays – he is too much in demand for other kinds of work – but he has never been surpassed as an artist who uses automobiles as his 'canvas'.

The Grand Design

If you are really certain that you want to give your car or motorcycle a custom paint job (and you need to be really certain, because you are going to look pretty silly if you lose interest half way through), you need to have an overall master-plan or vision in your mind of how it is going to look.

It requires a special kind of imagination – an artist's eye, if you like – to 'see' your car or motorcycle as it will look when it is finished. Unless the whole design is integrated from the beginning, the whole can be *less* than the sum of its parts: no matter how good each panel is, the end result can be 'bitty' and visually unsatisfying.

To help you work out your personal master plan, you may find it very useful to ask yourself the following five questions:

1. Which designs have stuck in your mind most?
Unless you think about this question, you may not be too clear about what direction your own custom paint job should take. Do you like the classic patterns, such as fish-scales, flames, and understated panel-lines which follow the lines of the car? Or do you prefer murals, realistic pictures, even comic strips? And do you like subtlety, with a controlled palette of colors, or vividness?

Also ask yourself if you have ever seen paintings which made you say to yourself, 'That would look good on a car.' Look in a few art books; go to the galleries, if there are any in your area. Whether your tastes run to Liechtenstein or Rembrandt, Picasso or Bosch, Constable or Hockney, you may be able to get a lot of inspiration from the work of other artists.

2. Do you want a car for show, or a car for the road?
Show cars can afford to be subtle and complex. Out on the road, what you want is to hit-'em-between-the-eyes. A subtle,

Arcadia Ray Mumford
'Arcadia', on a VW LT10 van, is one of the most brilliant pieces of car customizing in the world. This extraordinary frieze by Ray Mumford is entirely freehand.

complex mural takes time to appreciate; IMPACT can be appreciated in a few seconds at the traffic lights.

3. Have you the skills to create the effects you want?
A number of major artists have worked with cars as their 'canvas'. But if you are not a major artist, maybe you would be better off either with patterns, or with artwork 'borrowed' from somewhere else. Using scaling techniques (pages 72 and 73) and repetitive patterns (next chapter), you can put together something far beyond the artistic talents of the average person. If you are way better than average, then good luck to you – but be realistic about your own abilities.

4. Have you a sense of unity?
Just having a theme is not enough; all sorts of paintings have been based around a theme, and still fallen on their faces on the vehicle. In addition to the theme, you need a 'focal point'. This is the feature which immediately draws the eye to the car; the rest of the theme can then be explored at leisure. The classic place for the focal point on a car is on the hood, though it is also possible to use the side of the car – the fenders, door panels,

and the sides of the trunk as your major canvas. If you choose this route, you can either go for symmetry, and have substantially the same designs on both sides, or you can have very different 'focal points' on the left and the right.

5. Will your planned artwork help or hinder visibility?
Visibility is a double-edged sword. On the one hand, a highly visible car is a safety feature: if people can see you, they don't run into you. On the other, a highly visible car is highly visible to the police as well as to other motorists. If your car is really vivid, it had better conform to all construction and use regulations in force in your country or state, and you had better drive it carefully. Also, if you drive a potentially camouflaged vehicle, you may do well to drive with your headlamps on!

Once you have answered all these questions, it is time to start doodling. If you are not much of an artist, consider photographing all the panels that you intend to paint, as square-on as possible, and have decent-size photographic prints made. Then, either by tracing or scaling, make drawings that you can use as a base for your custom sketches and ideas. You may even find it useful to make photocopies of these drawings so that you can try out a number of ideas.

Preparing the Ground

The best-applied paint job in the world is only as good as the metal (or fiberglass, or filler . . .) underneath. No matter what the surface, it must be flat and smooth; and if it is metal, it must also be rust-free.

This is not a place for a discourse on panel-beating, but it is worth pointing out that there is a limit to how much you can do yourself; by all means use a hammer and dolly to get the shape roughly right, but beware of stretching the metal so far that you have a bulge instead of a dent to contend with. If you then need to fill dents more than 1/4 in deep, or 3/8 in at most, consider either replacing the panel or at least letting in a new sheet.

With any luck, though, you won't need panel-beating, and in that case, or when the panel is as good as you or your panel-beater can make it, clean it down to bright metal. Either use a wire brush and sanding disc, in which case you will need a dust mask or respirator (this applies to all subsequent sanding operations too) or use a chemical paint-stripper – or combine the two. Get rid of all traces of paint, as well as rust.

Ideally, you should then apply a 'metal conditioner'. This is typically a 10% solution of phosphoric acid, which should be treated with respect: wear rubber gloves and eye protection, and use steel wool to apply the solution. Leave the panel for a couple of hours, then heat it to cure the phosphate, taking care not to blister the surrounding paint. Finally, wash the surface with water and dry it before painting. This etches the metal and provides a good surface for an epoxy primer, which comes next. Alternatively, you can simply apply a rust-inhibiting primer, usually based on zinc or iron oxide. Do *not* apply the primer too thick; its function is not to level metal, but to protect it and to provide a good ground for the filler. Sand the primer with 80-grit paper; anything coarser will probably take it straight off again.

If you are going to use filler, apply it in several thin layers (maximum 1/8 in or 3 mm) and allow plenty of time for drying or curing between layers. Unless you are a very skilled sculptor, do not attempt to build up the shape of the damaged panel; instead, leave the filler to dry and rough-shape it with a Surform or similar 'cheese-grater' tool. Do this at each stage if necessary, and if you are using a catalytic curing filler such as Bondo, do it before the filler is fully dry; if it is too wet, it will clog the cutter, and if it is too dry, it will be harder work. After shaping the final

coat, smooth it first with coarse 36-grit sandpaper, and then with 80-grit; this is still pretty coarse stuff.

If you want to fill in the traditional way, using a filler that bonds permanently to the metal beneath and gives a perfect surface for subsequent work, consider 'leading' or filling with a

solder-like lead alloy. This is apparently not as difficult as it sounds (though it is not something which most amateurs attempt), and you might be surprised if you saw the amount of lead that went into an old Rolls-Royce or something similar; it was often 10–20 lb (5–10 kg) and sometimes it was twice as much as that.

When you are sanding, always 'feather' each layer into the surrounding bodywork. You can *feel* the smoothness of your handiwork with the tips of your fingers, and this is what professionals do. Any sloppiness at this stage will almost certainly come back to haunt you when you get to the final paint stage.

Next comes the acrylic undercoat. This does not need to be thick, though it can be put on slightly thicker than surface coats. Again, it is better to apply two or three thin coats with a brief drying time between than to try to lay it all on at once. Drying times will vary according to the temperature and the paint you are using; follow the manufacturers' instructions.

A useful professional trick at this point is to blow on a very light 'guide coat' of black lacquer. When it comes to sanding, this will show any low points or other areas which you have not sanded; the 'guide coat' is of course removed entirely during the sanding. Begin with 150- or 180-grit, then go on to 220- or 240-grit; it will then be ready for acrylic enamel, urethane or polyurethane. If you are using acrylic lacquer (see overleaf), leave it overnight and sand it again in the morning with 600-grit wet-and-dry.

Checklist for Preparation
Mask or respirator
Wire brush
Sanding disc or orbital sander
Metal conditioner Bare-metal primer Filler
Surform or similar 'cheesegrater' tool
Acrylic primer
Black acrylic lacquer for 'guide coat'
Sandpaper in the following grades:
 36-grit 80-grit 150-grit 240-grit 600-grit (for lacquer only)

It takes a brave man to tear a Rolls Royce to pieces, just to paint a picture on it. Ray Mumford, pictured here in a somewhat more youthful *avatar*, is such a man.

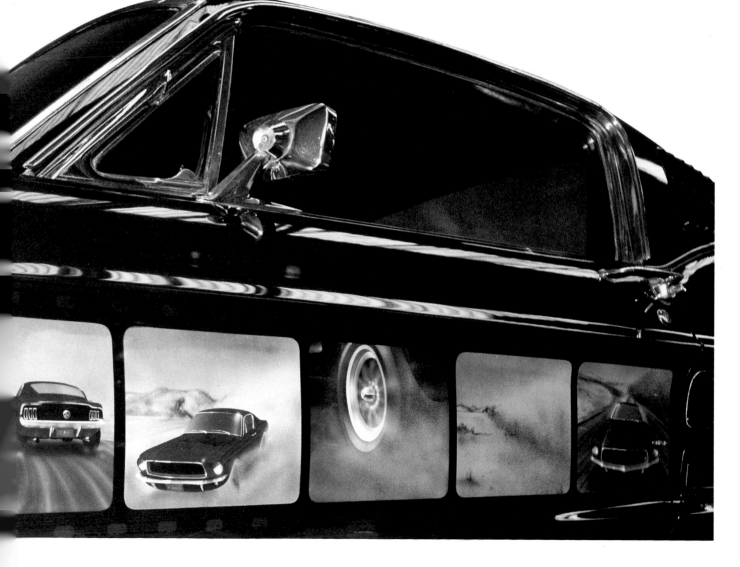

Painting

The previous page was intended mainly to demonstrate the importance of starting out with a good surface, and to impress on you that it is not as easy as you might think. Unless you are confident that you could carry out that kind of preparation step-by-step, you would do well to go and get yourself a book on car spraying. Here we are concerned with getting the paint on the ground: remember, what you are using as a ground is what many people regard as the finished product!

Armed only with an airbrush, even with a high-flow nozzle, you would be foolish to take on more than one panel at a time. You may therefore decide to have the underpainting done commercially, or to do it yourself with a bigger spraygun, if you want the whole car covered with a matching ground at a single stroke. You *could* do it with an airbrush, but it would take a long time.

If you decide to adopt a piecemeal approach, it is worth either using a stock color (which will be easily repeatable) or buying enough paint to cover the entire car, even if you only paint one panel at a time. The checklist for other materials and equipment is as shown in the panel. In what follows, we have assumed that you are working on a small area, such as a hood (bonnet) or a motorcycle tank. Also, ALWAYS use a lid on the paint cup: it is all too easy to spill paint on the work, usually just as you are finishing off!

The intriguing thing is that you will find it much easier to paint the car panel-by-panel with an airbrush than you would to paint the whole car with a bigger spraygun. This is because you are much less tempted to put too much paint on the ground, which leads to runs. Use the same techniques as described on pages 40–41 for a 'flat wash', and just build the color up as necessary. If you are only retouching a small area, the technique will be as for the restricted-area freehand ground illustrated on page 40–41.

Some paints cover much better than others, and if you want to spray (say) yellow over black, you may do best to use a light undercoat between the two. Alternatively, if you treat a piece of car customizing as a piece of fine art (which is not unreasonable if you are taking it seriously), you can use the same kind of masking logic that is described in Chapter 7 and cut masks from masking film.

Choosing paint nowadays comes down to choosing between acrylic enamels (including urethanes and polyurethanes) and acrylic lacquers. The enamels go on fast and require fewer coats, which is why they are widely used commercially, but they also require higher spraying pressures, dry slower, and never give quite the same quality of finish as lacquers. Lacquers dry faster – you can rub down a lacquer coat within 15–20 minutes of applying it – but you need more coats and you also need to buff the finish more carefully. For our purposes, lacquers are probably the best bet.

Before you do any painting whatsoever, you need the right environment: either a spray booth, or a large, area out of direct sunlight, which is free from both dust and insects. Then, make

For an article for *Street Machine*, Ray demonstrated how to paint a mural in black and white, and then to colour it in – a strong argument for buying the magazines!

'French Connection' (right), was the first vehicle on which Ray had a free hand and the idea was triggered by the name of the film. The car was airbrushed before Ray visited Paris and the image is his first imaginative interpretation of the subject. It was the first 'romantic' piece of work to be used on a car and caused quite a stir at the time. A later version on the same car completed in 1980, includes accurate details of the Champs-Elysées and gave Ray a chance to work on the car after visiting the city.

sure that the surface to be painted is absolutely dry. If there are any moldings or pieces of trim that you want to spray, blast them with air to make sure that there is no water trapped in them; if you use the airbrush for this, make sure it is empty of paint first! Next, degrease the area to be painted; proprietary degreasers and de-waxers beat lighter fuel and other improvised cleaners hollow. Last, you may like to go over the area with a 'tack rag', a proprietary resin-coated rag which removes every mote of dust. Again, there are formulae for making up your own 'tack rag', but you have to know what you are doing if you want to make one which will not leave any deposits, and indeed some professionals refuse to use a tack rag, on the grounds that they *always* leave some deposits.

Mixing the paint for spraying will depend on the temperature at which you will be working. In hot weather, you will need to add less thinners to the paint than in cold; the paint takes a certain length of time to reform and flow after it has been sprayed on, and if you use it too thin it will dry too quickly and form 'orange peel'; excessively thinned paint can also cause premature oxidation of the color itself. Instructions for mixing are given on the paint cans; follow them faithfully, and don't just guess; use measuring cups to get the right ratios.

To get the very best finish, give as many coats of color

lacquer as your patience and your budget will stand, using the recommended proportions of paint to thinners for the temperature at which you are working. Using only a few coats of color, and then many coats of clear lacquer, gives a 'false' depth to your work which is ultimately unsatisfying.

Allow plenty of time between coats, usually 15–30 minutes depending on temperature (the can will tell you; go for the maximum). Then, for your last coat, spray a 'fog' of paint at the maximum recommended dilution, but about 50–100 per cent further away than you have been working so far; increase the spray width by turning the roller *against* the direction of the arrow. This 'fog' coat is *essential* with metallic paints, which otherwise will mottle and give an effect very different from the one you want.

For the real 'inside track' on car customizing, read the magazines: *Street-Machine* is probably the leading magazine in the UK, and *Hot-Rod* is the American equivalent.

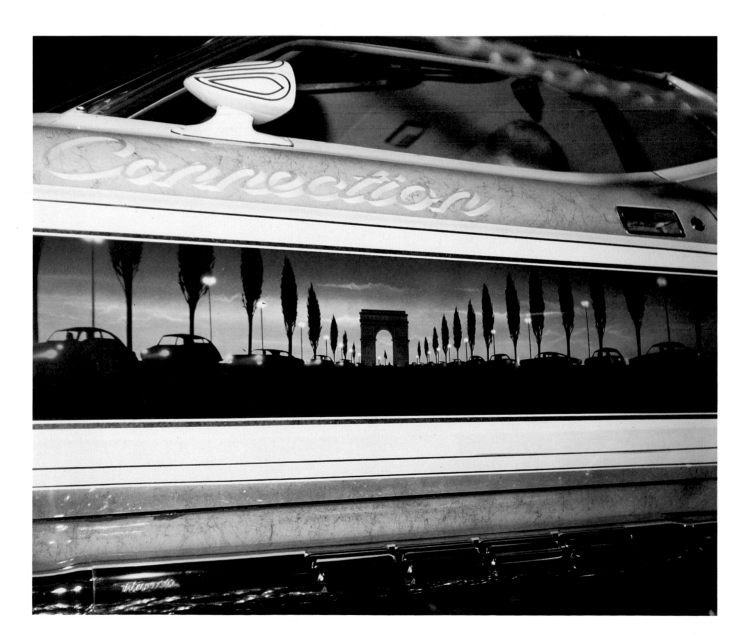

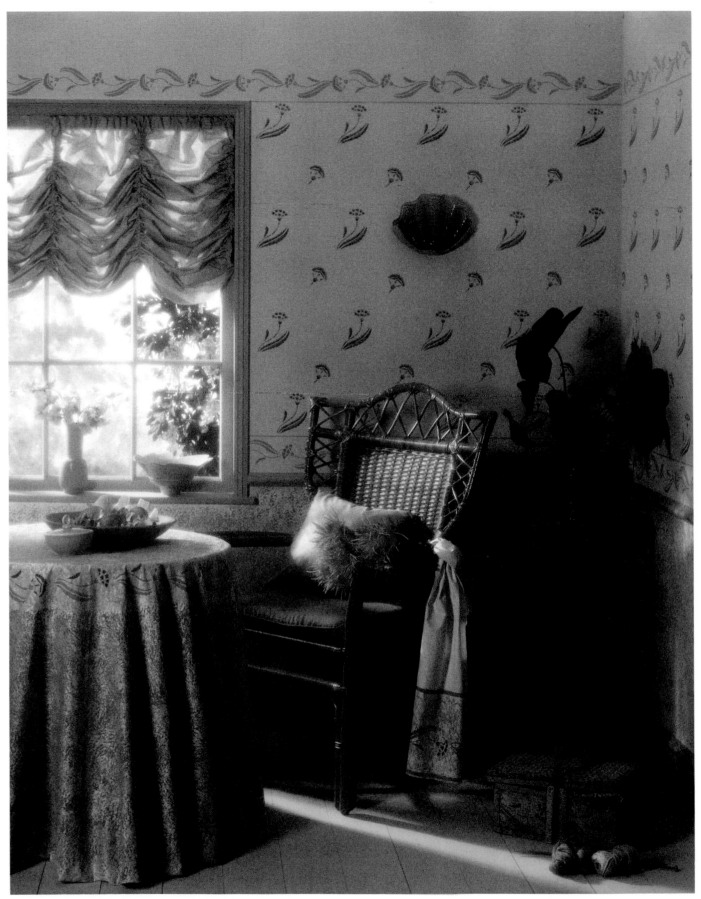

Interior, courtesy Michael Flinn
The only limits to how far you can take
stencilling are personal taste and
patience. This interior, courtesy of Micky
Flinn of Stencillitis, shows an integrated
stencilling theme applied to a whole
room.

Chapter 10
Stencilling

Stencillitis is the name of one of the leading British suppliers of pre-cut stencils. It sounds like some sort of disease, and with good reason; once you catch stencillitis, you are likely to become badly infected and stencil everything in sight, provided that it does not actually jump when you start work. And stencilling with an airbrush is more versatile, and arguably even more infectiously fascinating, than other forms of stencilling.

Stencilling is really only the repeated application of loose masks (pages 48–9), but it does have a number of special qualities of its own. Also, airbrush stencilling is rather different from conventional brush stencilling, but we shall come back to that later.

The first point about any kind of stencilling is that you really need quick-drying paint in order to work sensibly: with slow-drying paints, you will smudge the previous step if it is not dry. Japan lacquer is the medium recommended in many books, but automotive paints are ideal for many applications, and of course you can also use special media for particular surfaces: wood stains, glass paints (pages 142–3), fabric dyes (pages 140–1) and so forth.

The second is that stencilling can involve remarkably complex masking – certainly, rather more than we suggested on pages 46 and 47. This will become much clearer in what follows.

The third is that because almost all stencilling is a 'step-and-repeat' process, you need to make some provision for registration. At its simplest, this amounts to ensuring that a simple repetitive border continues in a straight line, and does not veer upwards or downwards; with more complex stencils, it involves careful measuring and calculation of spacing in order to make sure that the stencil does not suddenly run out of space, as in the well-known slogan THINK AHEad, with the letters getting steadily smaller as you try to fit them in.

Fourthly, you may well have to adapt your stencils (whether you cut them yourself or buy them ready-made from someone like Stencillitis) to suit the ground. You can use the same *motif* for a bathtub or a dado; but the rounded corners of the one, and the square corners of the other, may well require a degree of ingenuity if you want the pattern to look continuous and all of a piece.

Turning now to the differences between conventional stencilling and airbrush stencilling, the great advantage of using an airbrush is that you can get effects which are infinitely more subtle and delicate than you could hope for with a brush, including the possibility of using several different colors with a single stencil. The only major drawback is the danger of overspray, which means that you have to be a lot more careful when it comes to masking the rest of the work: brush-stencillers normally only reckon on a border of about 2 in (50 mm), while an airbrush stencil artist would be better advised to reckon on a foot or more, at least 300 mm.

If you are spraying something that can be moved, it is a good idea to work out of doors or in the utility room or garage (without the car in it!) rather than in the living-room. This not only solves overspray problems; it also means that you have plenty of fresh air.

Finally, the difference between regular airbrushing and stencilled airbrushing is that if you are decorating walls or floors, you will probably get through quite a lot of paint, so it is likely to be a good idea to use the large 8 cc paint cup. You may also wish to use several paint cups (and possibly several nozzles) if you want to swap colors a lot.

Modern Stencils

Modern stencils are a far cry from the sort which you may remember as a child, or from the metal stencils which some people may have encountered in the armed forces or in production-line work.

The most common material is acetate sheet, which is strong, waterproof, dimensionally stable, and (unlike previous stencil materials) transparent or translucent, depending on the type you choose. Some people still use old-fashioned oil-board, especially for very detailed work, but oil-board stencils are neither as strong nor as long-lasting as acetate sheet, and of course the fact that they are opaque makes registration that much more difficult. Another possibility is 'oaktag' paper, which some people waterproof (after cutting the stencil) with polyurethane varnish.

The thinnest acetate sheet you can use is something like Kodak 'Kodatrace' tracing paper, which comes in rolls, but this is too thin for many applications; it is really only suitable for comparatively simple stencils, without any fine detail, secured with spray adhesive (see below).

For general use, the best choice is acetate between 0.005 and 0.010 in (approximately 0.1 to 0.25 mm). You can buy this at good art supply shops, but getting the thickness you want may require a bit of explanation: what some people call 'oh-one-oh gauge' (0.010), other will call 'ten thou', 'thou' being short for 'thousandths' and pronounced accordingly. To make life still more confusing, many Americans call a 'thou' a 'mil', which is *nothing* to do with a millimetre. The thinner gauges are easier to cut, but the heavier ones are stiffer and more durable. The material is supplied in sheets, and if you can, it is as well to carry it home that way; if you roll it, you may have some difficulty in getting it flat again. If there is any curvature, draw, cut and stencil from the concave side.

Some people prefer to use completely transparent sheet, drawing the pattern with waterproof ink; there are several grades of 'write-on-anything' marker which are usable, but for the best precision you need a Rapidograph or other drawing pen. This ink can be wiped off while it is wet, but once it has dried, it is permanent.

With the right subject, it can be very hard to tell where the color changes. The red/green bunch features deliberately coarse spatter to show how the color mixes on the ground, while the red/yellow bunch is done more finely. Both are details from the bunch of grapes stencil on the next page.

Stencilling can be particularly effective in a child's room, as this charming design (Stencillitis again) shows.

Others prefer translucent sheets, which accept many more kinds of marker including pencils. Translucent acetate is very like tracing paper – indeed, 'Kodatrace' *is* frosted acetate – and copying the pattern is perfectly easy, so the main reason for using clear acetate is to be able to see the pattern repeat more easily when you are actually stencilling. With brush-stencilling, there is something to be said for this, but with most airbrush media you will soon render any stencil opaque, so it does not matter much.

For patterns, you can use stencil books; 'copyright-free' books from Dover and other publishers; or any other source, including your own designs. Designing and cutting stencils is covered overleaf: the illustrations on this page were done with pre-cut stencils from Stencillitis, and show the range of effects which are attainable with the airbrush.

The range of effects obtainable with an airbrush is very much greater than can be achieved with a conventional stencil-brush. Here we see spatter, solid color, various ways of 'streaking' the tulip, and finally a two-color (red plus yellow) version, all done with the same stencil.

'Cottage Tulip' is one of the simpler designs from Stencillitis, and can be sprayed without supplementary masking.

Designing and Cutting Stencils

Regardless of the source of your design, you are likely to have to scale it to suit your particular application, and the techniques described on pages 72 and 73 are relevant here. There are two important things to remember when designing stencils: 'bridges' and registration marks.

'Bridges' are the areas between the holes in the stencil, and they fulfil two requirements. One is to hold the stencil together, and stop it collapsing, and the other is to separate areas of color. Leaving strong enough bridges is one of the fundamental skills of stencil design.

Quite often, a single design will involve two or more stencils. This can be to avoid having to cut an unduly large hole; to fill in gaps left by the bridges on one stencil by judicious use of the other; and to allow areas of butted color.

The problem with large holes is that the stencil can become floppy. This makes it difficult to handle and prone to damage, and runs the risk that parts of it will lift when you are spraying. The use of two stencils to avoid this is shown in the illustration.

Filling in gaps makes the picture more rich and luxuriant, even if it does make greater demands on registration.
There is little to say about the actual cutting of stencils which has not been said elsewhere, but there are a few points worth making.

First, a self-healing cutting mat is probably the best surface, though most books on stencilling advocate the use of glass: this is essential if you are using an Air Nouveau electric stencil cutter, which is ideal for all but the most detailed work on acetate but which would of course mar a cutting mat.

Second, you will often find it easier to use a larger size of scalpel or X-Acto than you would use for normal mask cutting,

though you may find that a big, heavy craft knife (again as recommended by many books) is altogether too clumsy.

Third, the technique of cutting is rather different from conventional contact mask-cutting. You are dealing with a thicker, tougher material and you are trying to cut straight throught it; it does not matter if you cut into the ground beneath. You can therefore get away with less sharp blades, and you may wish to save blades which are already worn out by contact-masking standards to use for cutting acetate masks.

Once you have cut your stencil or stencils, you need to consider registration marks. These have two purposes: to ensure precise positioning of a repeated pattern, and to ensure precise register of two-part or three-part stencils. The standard registration mark is a cross in a circle which is easy with a transparent stencil; the way to achieve registration with oilboard or oaktag is to draw the registration marks and then to punch out the centre of each one with a leather-punch or something similar. With many stencils, though, the registration marks are simply a dotted outline of the repeat pattern.

You can set up your registration marks in a number of ways, but the easiest is to draw light cross-lines connecting the corners of a square or rectangular piece of acetate. This gives you an automatic centre-point, and by measuring out from the centre-point you can draw four registration marks.

While you are spraying, cover the registration marks with a piece of masking tape so that they will not be obscured by the paint when you spray it (or allow spray through, if you are using oilboard or oaktag), and extend the edges of the stencil with clean lining paper, newsprint paper (newspaper is a lot riskier), or whatever.

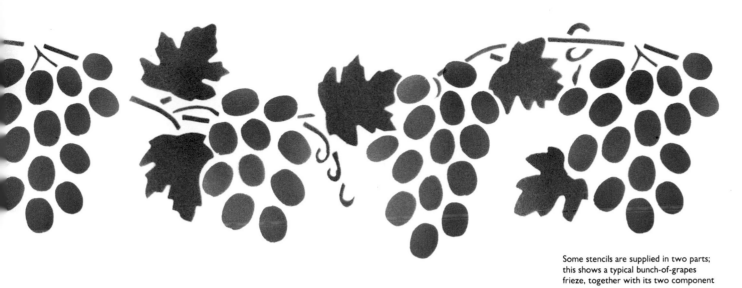

Some stencils are supplied in two parts; this shows a typical bunch-of-grapes frieze, together with its two component parts.

Two-part stencils are essential where the stencil would otherwise droop or sag.

Embroidered Cushion Wren Loasby
The use of a three-part stencil is just one stage in the making of this embroidered cushion. The picture shows the stencilled canvas, part of the stencil and the finished cushion.

Positioning Stencils – and Some More Ideas

Arches Wren Loasby
These decorative arches demonstrate the use of simple shading and creative stencil cutting to produce an interesting *trompe l'oeil* for an interior wall. (JB)

No matter whether you are stencilling on a sewing-box a few inches square, or a floor or wall which covers an enormous area, you need to take care in positioning your stencils. You can do a lot by eye, but if you want to work in a straight line, you need to draw some kind of guide-line.

On some surfaces, you can use a very faint pencil mark which can subsequently be erased; on others, you may find a chalk-box very useful. Commercial versions are available which consist of a box of chalk with a roll of string inside, rather like a retractable tape-measure. You pull out the string, secure both ends (assistants come in handy here) and then snap the string against the floor a couple of times to make a line of chalk-dust. It is remarkably effective, and the line is very easily erased. If you cannot find a commercial chalk-box, then a piece of school chalk and a string will make an acceptable substitute: just rub the chalk past the string (or vice versa) to impregnate the line with chalk dust.

There are a number of books about stencilling, but they are surprisingly short of information about stencilling with the airbrush. One of the best books on general stencilling, written by a practicing professional stencil artist, is *Stencilling* by Michael Flinn and Jill Visser, published by Macdonald Orbis in 1988. Michael is the proprietor of Stencillitis.

For verticals on large pieces of work, especially walls, a plumb line is indispensable. You *can* improvise one, but they are not very expensive and you can buy one at any builders' materials emporium. The line itself can be chalked in the same way as the chalk-box line, if necessary.

With the line of the work sorted out, you can consider spacing. With some simple repetitive patterns, you need not worry about this – you just carry on until you stop – but with others, you may need to calculate your spacing if you do not want your pattern to stop awkwardly with a half-completed *motif*. A useful tip here is to start measuring from the *middle* of the pattern, so that your arrangement is symmetrical; you can then end on a half-pattern, or readjust your spacing so that you have a number of whole patterns repeated either side of the centre. If you are doing a lot of stencilling, you might consider making up a 'spacing wheel', which leaves a mark at regular intervals when you roll it along.

When the time comes to attach your stencils to the ground, there are three main approaches you can use. One is to hold it down with your hand, or (on a horizontal surface) with a few weights; this is usually the least satisfactory. The second is to tape it down with masking tape, and the third (which is certainly the most convenient) is to spray the back of the stencil with aerosol adhesive, and simply stick it down. Do not press it down too hard, or it will be difficult to remove. You may need to re-spray the back of the stencil from time to time, and you may also need to clean it periodically both to remove the

This 'fish-scale' pattern is something between loose masking and stencilling. The repetitive design is created simply, using the mask shown two-thirds of the way down the circle. Popular in car customizing, this effect can also be used in many other places – and, of course, you can always cut different-shaped masks. With a little imagination you can create an entire range of decorative stencils that repeat the same simple pattern.

accumulated adhesive and to remove the lint and other bits of fuzz which it will inevitably pick up – check your stencil for cleanliness before using it!

On corners, if you are using a repetitive pattern, you may have to exercise a bit of ingenuity. Some people use a duplicate stencil, creasing it neatly down the middle so that a *motif* is symmetrically arranged on the corner, while others make copies of *part* of the stencil (or mask off the bits they do not want) in order to 'fill' the corner. If you are working in a corner, it normally looks better if the pattern recedes into the corner, rather than coming out – though some people like ornate extra work in a corner.

In addition to commercial stencils, and the *motifs* you cut for yourself, do not neglect the possibilities both of repetitive geometrical figures and of much simpler work. An example of the former is the 'fish-scale' effect which you can create by using the kind of simple repetitive mask shown on this page; an example of the latter is a polka-dot pattern, which can easily be made up using a piece of graph-paper and cut out using a leather punch.

You can also combine stencils with other effects, using coarse cheesecloth or nylon net curtains to create a 'fabric' effect as described on page 48. And (heresy though this may be), you can even combine airbrushing with regular stencilling, using a stencil brush, a sponge, or the other techniques described in stencilling books.

Als de stress toeslaat, geef uw pakje dan aan de grootste koerier ter wereld.

New York doen we binnen één dag. EMS heeft dagelijks vliegverbindin-
gen met 81 landen. Opgewacht door duizenden auto's en motoren die
uw pakje of document razendsnel afleveren.
 In Nederland vertrekt uw zending van één
van de 450 Exprespostkantoren. Dat is dus altijd vlakbij.
 In het buitenland werkt EMS samen met de

Als uw pakje moet vliegen, geef 't dan aan de grootste koerier ter wereld.

Rome doen we binnen één dag. EMS heeft dagelijks vliegverbindingen
met 81 landen. Opgewacht door duizenden auto's en motoren die uw
pakje of document razendsnel afleveren.
 In Nederland vertrekt uw zending van één
van de 450 Exprespostkantoren. Dat is dus altijd vlakbij.

Als de uren tellen, geef uw pakje dan aan de grootste koerier ter wereld.

Londen doen we binnen één dag. EMS heeft dagelijks vliegverbindin-
gen met 81 landen. Opgewacht door duizenden auto's en motoren die
uw pakje of document razendsnel afleveren.
 In Nederland vertrekt uw zending van één
van de 450 Exprespostkantoren. Dat is dus altijd vlakbij.
 In het buitenland werkt EMS samen met de
internationale postorganisaties. En beschikt daarmee over 't grootste
netwerk ter wereld. Met de meeste ervaring. Dus absoluut betrouwbaar.
 Vóór het eind van de dag gebracht of
opgehaald, betekent voor de belangrijke handelscentra in Europa én
New York: de volgende ochtend bezorgd. Gegarandeerd.
 Wilt u meer informatie? Wilt u gratis de
EMS Service Guide ontvangen? Bel dan
de EMS-adviseur. Gratis: 06-0454.

Express Mail Service. Wel zo snel. Wel zo zeker.

EMS DE WERELDKOERIER VAN PTT POST

124

Chapter 11
Airbrushing and Photography

One of the earliest uses for the airbrush was in photographic retouching, and it is still very important today; but contrary to popular belief, very few retouchers work *only* with the airbrush. Most use conventional paintbrushes as well, because there are many occasions when it is quicker and easier to retouch a spot (or even a small area) with a conventional brush than to go to the trouble of masking and spraying. Squirrel brushes, with the long central hair removed, are much more useful for retouching than sable, because they are stiffer. They can be hard to find, but they seem to last for ever.

It is also important to remember that an extraordinary number of effects can be achieved purely photographically. A 'ghost' shot of an automobile engine, which apparently allows you to see 'through' the hood is easily achieved with a simple double exposure; in one shot, the hood is in place, while in the second it is removed.

Having said that, there are many occasions when airbrushing is vastly easier than retouching with a conventional brush. They fall into two groups. In one, the airbrush is used to 'idealize' the subject and bring the camera's rendition closer to what the photographer (or the art director) wants to show. In the other, the airbrush is used purely creatively, to produce a melding of photography and artwork which cannot be mistaken for anything in the real world but which nevertheless *looks* like a photograph.

Among the 'idealizers', there are two further sub-groups. Those who work on machinery and the like normally use masks, with some freehand work, as shown overleaf; those who work on portraits (or more rarely, landscapes) work almost exclusively freehand. Both need a brush with extremely fine control.

With any retouched work, much of the illusion is lost if the retouching is evident. For this reason, the airbrush artist normally does three things to conceal his handiwork.

The first is to use smooth (*not* glossy) prints for retouching; this makes it much easier to 'lose' the texture of the retouching. The second is always to work larger than the final image is to be reproduced, normally 'half up' (50% bigger), 'one up' (twice as big) or even 'three up' (three times final reproduction size). The third is never to exhibit the retouched work itself, but to make a further copy for display or for the printer's use. Printers can and sometimes do damage work, and a retouched original is both more susceptible to damage and more time-consuming to replace. There may be occasions when, for some artistic reason, you *want* to exhibit a retouched print, but you should be aware of the risks.

Whatever the purpose of your afterwork, you should *never* work with an original. This is especially true if the original is irreplaceable, such as an old family portrait. Always make the best copy you can; only in a desperate case work on an original, and then only after you have made the best possible copy. Some retouchers always order two or three copies of any print that they are asked to work upon, in case of accident or error.

When copying, do everything in your power to suppress flare, as this is *essential* in preserving a full tonal range. Use a high quality lens with a deep lenshood, and shield the lights carefully. Photograph the original against black paper or velvet to remove *all* flare from the background.

Never attempt to airbrush an unmounted print, as it will almost certainly cockle or at least curl. Ideally, dry-mount it on a good-quality board; at the very least, mount it securely with spray or rubber adhesive. It helps if the mount size is somewhat bigger than the picture area, as this leaves plenty of room for pinning the picture to a wooden drawing-board or something similar. Traditional fiber baryta-base papers take airbrushing much better than modern resin-coated papers.

Airbrushing can be combined with photography in many ways, but in this case the brief was particularly mind-blowing. Using the 'locating shot' photography, the artist was asked to create the impression of a high-speed delivery van or courier's motorcycle, *in the appropriate national colours*, streaking past. Just imagine trying to airbrush those streaks, with steadily increasing density . . . (AA)

Basic Retouching

During development of the airbrush, several prototypes were hand-made and hasty reference pictures were taken. Then the need arose for a well-finished (but still recognizably photographic) representation of the brush. Adam Morrison did the retouching.

The most basic form of retouching is spotting out dust-marks, but this is always done with a brush; black marks are removed with bleach or with a scalpel ('knifing') and then retouched with a brush.

Next in the hierarchy comes 'blocking' or 'blowing out', removing an unwanted background so that the principal subject is seen without distracting surroundings. Typical applications might include removing the background in a factory, so that a machine can be seen clearly, or removing the supporting wires, clamps, etc, in an 'exploded diagram' photograph.

Blocking used to be done with a paint-brush and photo-opaque on the negative, but as 5x4 in is the *minimum* size for most purposes, most modern photographers prefer to work on a print, and to make a copy-neg from this.

Almost any high-density white paint can be used, but Schmincke's *Aeroweiss* range is available in a number of different finishes which dry to match the paper surface. This can be important even in reproduction, because it makes lighting the retouched picture easier when it comes to copying it. Masking can be done with regular masking film, or with masking fluid if you really find that easier.

Dilute the paint as little as possible, and use the standard technique for a flat wash. Do not expect to cover the background with the first coat; you may well find that you need three, four or even five coats to obliterate the background completely. Give each coat plenty of time to dry, which can be frustrating; *Aeroweiss* requires at least twenty minutes per coat at a temperature of about 70°F, 21°C.

You may, however, decide that you do not really need to obliterate the background completely; in some cases, merely 'ghosting' it out can be even more effective. This is especially true if you are trying to draw attention to a particular building in a street (or in an aerial view), where you can show it in context without letting the context overwhelm it. In other cases, where there is a white edge, a gray or even black background may be more appropriate.

If the subject is *really* complicated, and requires (for example) power cables or cooling ducts to be shown, you may wish to consider either drawing these in afterwards or simply fading them out as they go 'out of shot'; the latter can be more effective than running them all the way to the border of the picture.

At this point, we are beginning to enter the next realm of retouching, which is what we have already called 'idealization'. This was traditionally used to 'lose' wrinkles and other signs of age on a portrait, but this is less important than it used to be. People are often more willing to see themselves as they really are, and in any case, skilful lighting and the use of a touch of soft-focus (not enough to be obvious) is quicker, easier and cheaper. Like blocking, this used to be done on the negative; the usual tools were a soft lead pencil or weak pink dye.

Another popular target for the refinisher's brush was the nude. As recently as the 1950s and 1960s, many pin-ups were given an unreal perfection by the determined use of the airbrush, so that the girls looked as if they were made out of some wonderful (and often sexless) new pink plastic. Most of

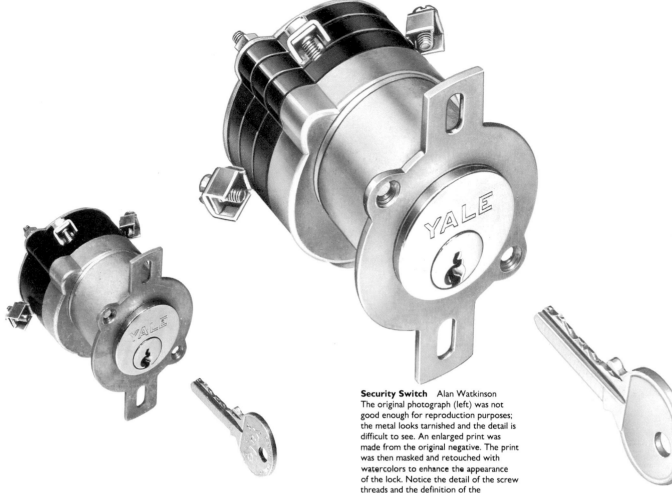

Security Switch Alan Watkinson
The original photograph (left) was not good enough for reproduction purposes; the metal looks tarnished and the detail is difficult to see. An enlarged print was made from the original negative. The print was then masked and retouched with watercolors to enhance the appearance of the lock. Notice the detail of the screw threads and the definition of the retouched image.

these aberrations have now fallen by the wayside, too.

The main use for refinishing nowadays is for 'idealizing' advertising photographs, and one of the most obvious examples is machinery. Even a brand-new machine, fresh from the shop, may well lack the kind of gloss that is required for a catalog illustration. The same is even more true of components, as the illustration shows. The work is almost invariably done with masking and a range of grays and whites, and often comes down to nothing more than the kind of cone/cylinder/cube exercises described on pages 56–61. If you want to combine blocking and idealizing, let one stage dry *THOROUGHLY* before attempting the next, as it is all too easy (and all too depressing) to lift the work you have already done when you do the second stage.

Professional color retouching is often done on huge duplicate transparencies, at least 10x8 in and frequently 11x14 in, but this is extremely demanding and very expensive. A single 11x14 in 'dupe tranny' costs about as much as five rolls of process-paid Kodachrome, and many retouchers will ask for a spare (or possibly two spares) if the work is critical. Not only are the transparencies costly, but a full set of retouching dyes can cost almost as much as a good airbrush: it is essential to use these dyes, as this is the only way you can be sure that the picture will reproduce properly in print. The selective bleaches are short-lived and have to be made up from scratch (and from expensive ingredients), and many of the ingredients are not things that you would want to spray anyway. Working with prints is considerably easier, as you can use pigments, but the selective bleaches are still tricky to make up and to use.

There are different sets of retouching dyes (and bleaches) for most different positive and negative emulsions (Kodak 'Ektachrome', Cibachrome, etc), and the appropriate chemicals *must* be used with transparency materials. With prints, something like the Schmincke range will normally be perfectly satisfactory.

The best basic book on airbrush retouching comes from one of Aztek's rivals, Paasche. Somewhat old-fashioned and uninspiring in appearance, it is nevertheless full of first-rate practical information. It is called *Airbrush Technique of Photographic Retouching*, by Walter S. King and Alfred L. Slade. The recommended US price is $8.85.

Restoration

A very specialized application of idealizing is recovering old, damaged photographs. Usually, these are portraits which the owner wants restored for sentimental reasons. The techniques required for this are substantially the same as those required for any form of advanced retouching.

It is not unusual to exhibit the retouched master, though a copy-neg and a reprint would be a better idea. As already mentioned, you should never work on the original, but the size of the copy may be subject to conflicting requirements. One is the natural desire to work as large as possible, and the other is the danger of over-enlarging a print which may only be of carte-de-visite size (about 3x4 in, 7x10 cm) and which may look 'mushy' if it is blown up too much.

How far you take your restoration is up to you, but many photographers prefer a recognizably photographic print with a few defects to one which is effectively just a photo-based painting. Unless you are willing to obliterate the picture completely (in which case you would be well advised to start with a weak, slightly bleached print), you will need to master a number of photographic techniques which are not related to airbrushing: copying with filters, increasing or decreasing contrast with development, bleaching dark spots, filling light spots with a brush, and so forth.

Assuming you start with an averagely bad original, your course of action should be as given below. Note that stages 1-5 are photographic, rather than related to airbrushing; if you are not a photographer yourself, discuss them with a friend who is.

1. Copy the original, using filters if necessary. Use a blue filter to intensify faded sepia images, and filters of the *same* color as stains that you wish to remove (green for green ink, for example). A blue filter will unfortunately intensify reddish, yellow or brownish stains, but the increase in image contrast is sometimes more important. Making the copy not only preserves the original; it also means that you are spraying on a smooth, flat surface. An old, torn print is effectively impossible to retouch properly.

2. Develop for slightly *less* than the normal time, in order not to build too much contrast.

'Before and after' photos
Well-loved photographs, carried in wallets, often end up in the most appalling state. In order to achieve this degree of restoration, you would need a great deal of practice, but the basic techniques are as described in the text.

Schmincke's range of airbrush grays is unrivalled for this sort of work, but they are still pigments. For the ultimate in control, you need to use dyes and bleaches – dyes are more realistic than pigments, and bleaches are 'cleaner' than white paint. Both are, however, extremely difficult to master: one elderly retoucher reckoned that he had spent seven years learning to mix grays, before he learned anything about retouching.

3. Make a working print. The more airbrushing you intend to do, the weaker (flatter and less contrasty) this print should be. You may wish to use sepia-toning, in which case you should make the print considerably lighter than normal; just compare the tonal range of an older print with a new one.

4. Bleach out any black marks, working on a wet print, and take care to neutralize the bleach.

5. Fill any light spots (including those you have bleached) with a conventional brush.

6. Mix a range of tones for the airbrush. Take care to match color ('warm' with browns or 'cool' with blues) as well as tone.

7. Work on the background first. If there are corners missing, spray over the ugly marks and paint in a reasonable imitation of the missing material. If you are dealing with trees, for example, a rough approximation will suffice; the

eye is willing to 'read' a blob as what it expects. The same is true of clouds.

8. Spray the hair, clothes and any other dark areas, taking care to preserve the differentiation (if any) between them and the background. You can normally do this freehand, but it is the one area in which you may wish to use masking film. The reason for spraying any large dark areas first is that dark overspray makes a picture look gloomier, while lighter-colored overspray rarely has any adverse effects – though you should always attempt to keep any overspray to a minimum. Use a cotton wool bud to remove unwanted overspray.

9. Spray the flesh tones and other light areas, and add highlights to the darker areas, using the techniques described for painting a simple sphere (pages 58 and 59).

10. Return to the darker tones, using them *with great restraint* to add 'shadows' to the finished work.

Other Photographic Applications

Much less accomplished than the other hand-colored photograph on this page, this picture still has a certain charm. It was built up on a 'thin' sepia print, as described in the text.

The creative photographer can find many other uses for his airbrush skills, from 'pseudo-mounting' to hand coloring and 'comping' (see below).

'Pseudo-mounting' is a way of creating a magnificent-looking exhibition 'mount'. The photograph is printed on an oversize piece of paper – perhaps 20×16 in for a 12×16 in print, or 30×40 cm for an image 20×30 cm – and dry-mounted on a piece of board the same size. The whole image is covered with masking film, which is then cut slightly larger than the image to give a white border. Cut slightly deeper than usual, to create a fine cut line in the emulsion itself, and remove the outer film. Spray this outer area, using the standard techniques for a flat wash; this is the 'pseudomount', and you can use any of the traditional 'salon' colors such as burgundy, Connaught green, etc, or something more vivid. Fix the colored border with spray fixative (to prevent damage) and remove the masking film over the image. The effect is superb, particularly for sepia and other toned images.

As an aside, you can use your masking skills to mask prints for selective bleaching and selective toning, though this is hardly an airbrush exercise.

As for hand coloring, this used to be the only practical way for most photographers to get a color image. Professional hand colorists were extraordinarily skilled, as the illustration opposite shows. Nowadays, the technique is used in three ways. One is in the original way, for pure realism. The second is to add color to selected areas of an otherwise monochrome print; red lips on a black-and-white photograph are now almost a cliché. The third is to add color for its own sake in order to create an original work of art. Although this is the most typical modern usage, it has as long a history as coloring for realism.

The techniques for all three types of coloring are similar. Transparent dyes are normally used, with a very light hand; this allows the underlying photographic detail to show through, which adds to the sense of realism. Using pigments obscures detail, but can produce considerably more impact; just think of the difference between a pair of lips that are tinted, and a pair of lips painted a solid color with pigment. You can if you wish add details to the solid areas. If you look closely at a pair of lips, you will see that the texture involves surprisingly deep cracks at right angles to the line of the mouth, and these are accentuated with lipstick. To re-create the impression of texture, use black and white pigments together.

If you are coloring the whole picture, it is as well to start with a fairly 'weak' print; ideally, you should make a normal print and then bleach it, as this will normally give a more convincing effect than a print which is under-exposed to begin with. Some people like to use a sepia print, rather than a regular black-and-white.

While there is no need to use photographic retouching dyes, in that you are not trying to match the dyes in a color print, you may still find it easier to do so. The reason for this is simply consistency; if you want to do much work with photographs, it is a good idea to standardize your technique as far as possible.

If you are good enough, it is perfectly possible to blend photography and artwork, as shown at the beginning of this chapter. There are two ways of doing it.

By far the easiest is to start off with a good, big color print and to apply pigment-based paints directly onto that. Because you are working on a print, you can always have another one made if you make a mess of it. Some people like to exhibit these hand-worked prints in the original; others prefer to make a copy-negative and to reprint, so that the print surface is uniform. This adds to the illusion that the work is pure photography.

For reproduction, a far more complex process known as *comping* (from 'composite') is used. This is extremely difficult, and cannot be explained in detail here, but in outline it works as follows.

The different components of the picture, whether photographic or artwork, are each photographed onto large transparency films, typically 11x14 in, in the same scale and proportions as they will appear in the final image. A sheet of clear acetate is laid over each image, and masks are cut which correspond to the shape of the component on a particular film. The mask is made with dark red film, and the acetate-plus-mask is then contact-printed onto black and white lith (lithographic or process) film: this results in an opaque negative mask, with a clear space where the picture component is.

Each component film, sandwiched with its lith negative mask, is then contact printed in sequence onto a single sheet of color transparency film. The result is a picture with all its component images in the right place, and in the right relationship to the other components. Detailed retouching, using transparency dyes and a brush or airbrush, then completes the picture.

Retouching your Photographs by Jan Way Miller (an A. M. Photo Title) was probably the best book available on general retouching at the time of writing, though it concentrates more on other techniques than on airbrushing. If you also buy the Paasche book (box, page 126, and *The Focal Encyclopaedia of Photography* (Focal Press, London) you will have a good basic library.

This hand-colored picture, from the collection of Frances Schultz, was probably made for theatrical publicity purposes. It is remarkable in that it is on an opalescent film base, so that it can be 'read' either as a print or (as shown here) as a transilluminated transparency.

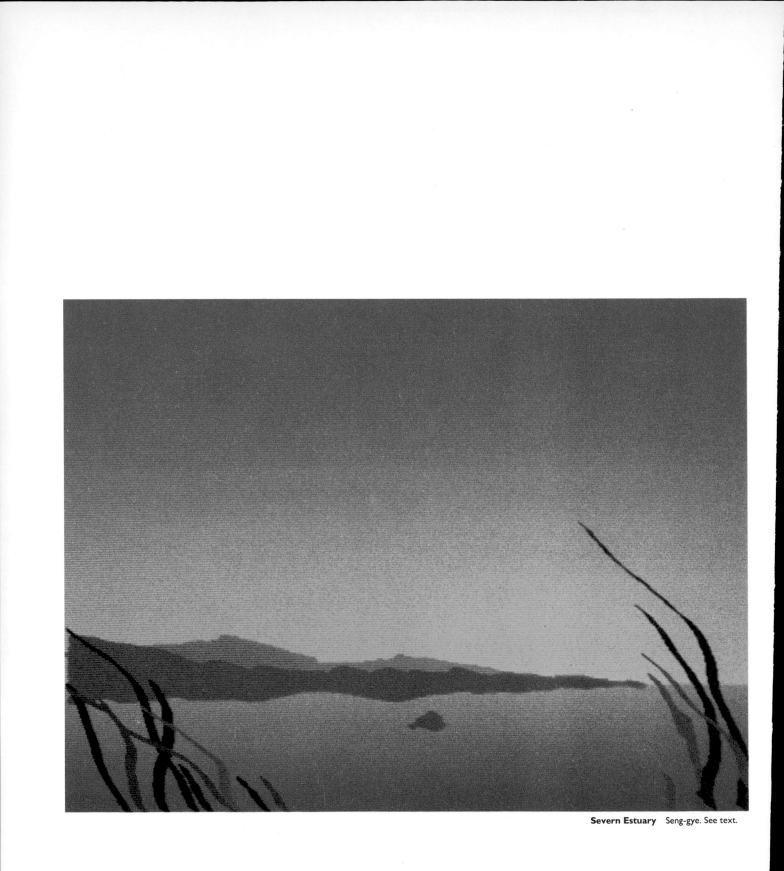

Severn Estuary Seng-gye. See text.

Chapter 12
Other Applications

Versatility and Variety

There are innumerable other specialized applications for the airbrush, and it is only possible to touch upon a few here. Many pages, for example, could be given over to the use of the airbrush in fabric painting, which is used on a remarkable range of clothes from designer dresses to T-shirts to Japanese kimonos. There are many other possibilities which can be mentioned only in passing: glass painting, for instance, or painting on ceramics. There is so much that could be done with the new brush that exploration of its full capabilities must be left to specialists in the various different fields.

One thing which is important, though, is that in many cases the airbrush is *not* used alone. Often, it will be used in conjunction with other tools. In model-making or fish taxidermy it will be used together with a conventional brush; in frosting it will be used together with an icing-pipe or icing-cone. It is worth stressing this because it is all too easy to be carried away by the versatility of the airbrush, and to use it where another tool would be more appropriate. Admittedly, the new design is more versatile than conventional airbrushes, and it can replace other tools more often; but it is not a 'magic bullet' which will hit every target without any skill on the part of the user.

This point about skill is important, too. One of the wonderful things about the airbrush is that it 'grows' with you. You can begin by using relatively simple techniques, and by basing your work on adaptations of other people's artwork, and still get excellent results. You can also use it to create unique, original works of art, limited only by your own imagination and skill; and this is true whether you choose to work on conventional canvas or on a T-shirt. You can 'cross-fertilize', using techniques normally applied in one area for some completely different application. You may do this purely for your own pleasure, but

it is also in this chapter that you will find some real possibilities for making money – T-shirts come to mind again, but there are also many people who make a living by cake decorating. Whatever path you chose, the distance you can travel along it is considerable.

One other point worth making about the future of the airbrush is that it is *not* under threat from computers, at least at the moment: in fact, airbrush artists are having a field day *because* of the computer.

The picture opposite is a computer-generated image, and as is clear, the standard of resolution is nothing like what is required for most illustration purposes – although, of course, much higher-resolution images *are* possible, especially if the computer can be linked in to a video scanner of the type used in printing: the original transparencies from which the pictures in this book were taken were 'scanned', and the reproduction quality is certainly high enough on the printed page.

At the moment, though, this technology has not been fully explored. The result is that computers are being used as very versatile (and very expensive) ways of generating 'scamps' or 'roughs', from which artists produce the finished work.

Of all the systems currently available, Quantel's 'Paint Box' was the accepted industry standard, and its quality was the target for which other manufacturers aimed; of course, in the computer world, such matters can change almost overnight.

As an example of what may be possible in the future, however, the picture opposite is worth studying. The gradation in the sky was achieved electronically, by specifying the limits of two tones and letting the computer grade between them, and at the time of writing the Quantel was also the most convincing 'electronic airbrush' when it came to line-drawing.

Medical and Technical Illustration

Students of medicine and students of engineering are both aware of the same awkward truth: when you are confronted with something in real life, it very rarely looks like the neat, clean illustrations which you have in your notebook. The relationships of parts are unclear; they are obscured by other parts; even the shapes may not be quite what you expected.

Photographs are not a lot better. They usually have the advantage that they are carefully-selected specimens, with good clear descriptions; but even then, there is a great deal of difference between the picture and real life. At the very least, a dissection (whether of a laboratory rat or an automobile) is frozen at a particular instant in time, when some things are uncovered and others are not; and because you cannot see through things, you cannot understand the relationship of one thing to another.

The skilled technical or medical illustrator bridges this gap between theory and practice in an excellently simple way: a good illustration *does* allow you to see into things, but by careful use of color and 'ghosting' it can make the underlying relationships of the parts more comprehensible.

What the technical or medical illustrator does is to take engineering or anatomical drawings and convert them into perspective drawings; and then, with a blend of experience and constant input from the technical subject-matter expert, he or she fleshes out the bare drawing, literally so in the case of medical illustration. The illustration can use partial cutaways, or it can suggest 'X-ray vision' by means of 'ghosting'.

For obvious reasons, technical illustrators tend to specialize, and the importance of researching your subject carefully cannot be overemphasized: obviously, you are going to be very unpopular indeed if you get a technical illustration wrong, and you might be surprised at how many people are ready to 'nit-pick' when it comes to apparently trivial errors. In another field entirely, the picture of Shiva in the Foreword is an example of this: the details of his pose, the things he holds, and even the colors used are governed by strict iconographic rules, and anyone who breaks them can expect someone to notice and complain.

Different artists approach 'ghosting' in different ways, but one logical sequence is as follows:

1. Make a (very light) pencil drawing in which *all* detail is visible; this will be confusing, but forms the basis for the work.

2. Make two or three photocopies of the drawing, and work on them with colored pencils to create 'color roughs' to check exactly what you want ghosted, and what you want clear.

3. Using the best of the color roughs as a guide, work on the original pencil drawing (or a new one). Do the opaque parts (complete with highlights) first, then add the 'ghost' parts by spraying lightly – remember, you can always add more color if you need, but you cannot easily take it away!

Motor Keith Harmer
Often a cutaway drawing of a motor is easier to understand than the motor itself and it is certainly a lot cheaper and easier to commission than a three-dimensional cutaway. Notice that the cutaway sections are contained within the subject so that the form is not lost. The surfaces that have been cut away are emphasized in red so that the internal parts are clear.

Skin Kevin Marks

This illustration by Kevin Marks appears
in Gray's Anatomy. Each section of the
image was masked and lightly sprayed
with the appropriate base color. The
ridges and dimples on the surface of the
skin were emphasized freehand and final
details were added with a conventional
brush and a scalpel. To create the texture
of individual cells on the section of the
skin that has been lifted, several loose
masks were used and increasingly darker
tones of purple and pink were sprayed on
to the image. The hair folicles were
masked and airbrushed in stages using
loose masking to create shape and form. A
tracing paper mask was used for the
purple sweat gland at the front of the
block on the right and the yellow strands
around the gland were frisked and then
painted with a brush.

Alvis Tom Lidell
This cutaway drawing of an Alvis, by Tom Liddell, is not merely technically interesting; it is a thing of beauty in its own right.

E-type Jaguar In this illustration of an E-type Jaguar, white lines have been used to keep the form of the car intact. Careful use of ghosting allows the internal parts to be revealed. The light red overspray on the hood is a particularly good example of this.

Model Making

This may not be the best photograph in the world, but the detailing on the tank cannot be denied. The model is about 5 in (13 cm) long.

The airbrush as a model-makers' tool has two distinct areas of use. One is the conventional application, that of duplicating (in miniature) the finish of the full-scale original. The other is the possibility of 'distressing' a perfect model, or trying to reproduce the weathering and natural wear-and-tear of the original on which it is based. You can use an airbrush to paint plastic, wood, metal or any other material, though these pages deal mostly with plastic modelling. Once again, you will rarely use the airbrush in isolation, though conventional brushwork will normally only be needed for very fine detail such as rivet-heads, gun-muzzles and so forth.

For regular finishing, the airbrush is simply used as an ultra-miniature spray-gun, though there are a number of points worth making. One is the usual warning, about several light coats being better than a single thick one; obviously, any runs or similar marks will look even more obvious on a miniature piece than on, say, an automobile panel.

Secondly, it is worth knowing that you can often get a matt finish, even with gloss paints, if you put on the last coat finely enough. Use a 'mist' coat, and the paint will be half-dry as it strikes the ground: it will dry matt as a result.

Thirdly, it is often easier to paint parts in isolation than to try to mask them. On a model car, for example, you will find it easier to spray the body *before* you mount the brightwork; on a

Architectural models are produced to show every aspect of a proposed building in three-dimensions. Spray guns and airbrushes are often used to create the finish required. In this example, courtesy of The Modelmaking Business, multiple layers of paint have been sprayed on to the model at different pressures to build up texture and recreate a range of effects. The brickwork shown here was produced using low pressure and between four and six different colors. The resultant spatter gives the surface a mottled but realistic texture. An airbrush was also used to back-spray the perspex windows.

sailing ship, cannon barrels may be batch-painted black (for iron) or green or gold (for bronze) before they are mounted on the carriage.

Fourthly, plastic paints may well stick to masking film with at least the same gusto as they stick to polystyrene models, and may well lift with the mask when you try to remove it. Test the paint on a piece of masked sprue or other scrap before you try masked work on a model.

Finally, it is well worth wearing a mask, and possibly eye protection as well, as it is all too easy to keep working closer and closer to the model until you are almost touching both the work and the airbrush with your nose. If you wear spectacles, especially with plastic lenses, you can really have problems! Try to keep a reasonable working distance, or at least, try to protect your lungs and eyes.

Moving on to 'distressing' (to borrow a word from the antique faker's vocabulary), this can in turn be divided into two techniques. One is the simulation of wear, and the other is the simulation of dirt.

Simulating wear is more difficult, as it requires considerable preparation at the initial painting stage, where you have to simulate the actual finish of the real thing. For example, a tank is made of steel, which is painted with a rust-inhibiting primer, which is in turn covered with the camouflage paint. If you want to simulate this on a plastic model, you will need two or three coats of aluminum paint; a coat of red paint; and then the camouflage.

When all the coats are thoroughly dry, use the very finest abrasive paper you can get ('crocus paper') to rub through the outer layers at any natural abrasion points: corners are obvious, but there are also some points on the armour-plating of the tank itself which you may feel would look better with scratches and rubs, revealing the undercoat or the 'steel' underneath. Be careful not to cut too deep, or you will reveal the plastic – though a *very* limited application of aluminum paint (with the airbrush, not a paintbrush) can be used to cover up such errors. For really deep scratches, incidentally, consider marring the plastic surface with a hot miniature soldering iron before you start painting.

To add 'dirt', use paint to simulate mud. Also consider 'spatter' effects (page 40/41), which can create the impression of mud-splashes. Normally, a strongly directional spray is best, as it mimics the direction of movement of a car or other vehicle, and the prevailing wind if you are spraying something like a bush beside a model railway line. This technique works best at 1/12 to 1/24 scale, though it can be used as small as 1/72. Anything much bigger than 1/12 is hard to achieve realistically.

> There are a number of manufacturers of highly specialized modelling paints. It is worth knowing that if you want the ultimate in detail, some of these manufacturers give instructions for thinning paints in order to achieve the right scale thickness – in other words, making the paint on the model (say) 1/12 as thick as the paint on the real thing. This is of course *only* possible with a highly controllable airbrush.

Confectionery

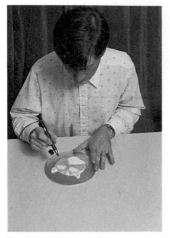

The tiger is airbrushed *off* the cake; it is later attached with a couple of dabs of icing.

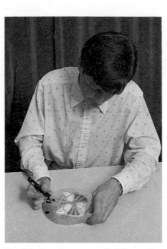

The lightest colors are applied first and the darker colors are sprayed over the top.

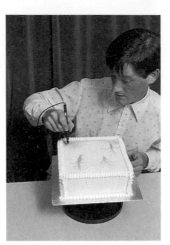

A background design is sprayed directly on to the top of the cake.

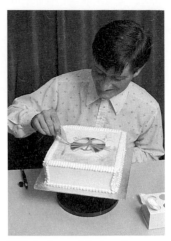

With the tiger mask in place, the whiskers are added using a forcing cone.

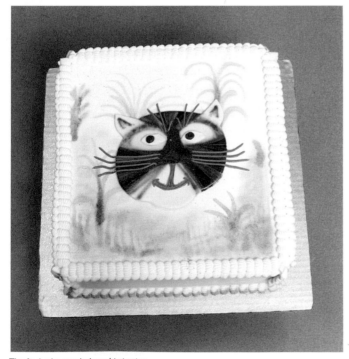

The final cake may lack sophistication, but it is undeniably fun, and most people would love it. This was the artist's first experience with an airbrush!

Cake decorating is one of those areas where you will get the best results if you combine airbrushing with a more traditional approach: airbrushing alone is too delicate, too subtle, for many applications. For fine lines, you will get much better intensity of color if you use either an icing pipe or a forcing cone.

The traditional syringe-style icing pipe is arguably easier for the novice to use, but it suffers from the major drawback that you have to clean it out every time you want to change colors. The forcing cone, formed from a piece of paper, takes a little more time to master but is capable of even finer work than the icing pipe once you have mastered it; also, of course, you can make up as many cones as you want to use colors.

For the icing itself, there is a slight difference between British and American practice. The normal British approach is to use a hard icing, which is applied soft but rapidly hardens; American 'frosting', on the other hand, usually remains soft. The advantage of the British type is that when it is hard, you can use simple card masks, which would of course mar and smear the American type.

Whichever you use, you will find it much easier if you make up a surplus of icing, and throw away what you don't need. This may seem extravagant, but icing ingredients are cheap and a little extravagance is preferable to a lot of frustration, which is

An experienced outfit like Bristol Sugarcraft Centre can produce a deceptively simple cake which is quite stunning. This design was created especially for them, and represents only a fraction of their repertoire.

what you will get if you run out in the middle! Not only can you use icing for fine lines and extra color intensity; you can also use it to build up three-dimensional effects, including the eyebrows on a portrait or the hub-caps on an automobile.

For coloring, a number of paste or crystalline confectioners' dyes are available; most are diluted with alcohol for use. You can use any of the usual spirits, though rum and brandy are the usual ones, or (if you can get it) you can use 190 proof grain spirit, which will dry considerably faster. Go to a confectioner for advice.

Begin by sketching the principal design with black icing from a forcing cone, or use a solid icing 'sculpture' like our tiger-face. If you are not confident of your sketching skills, begin first with a pencil and paper, and then practice with the forcing cone (or icing pipe) on a sheet of clean paper before you go near the cake itself. Don't worry if you cannot face fancy tricks of perspective: a simple, cartoon-like drawing will delight most people, and it will often be more effective than an excessively complicated picture.

Remember, though, not to draw in *too* much. Clouds and a blue sky, for example, will be added with the airbrush. So will the color in a cheek; use red over orange to create a rosy-cheeked look. Learning when to draw in a line, and when to

suggest shape with color, is largely a matter of experience.

Next, color in the drawing using the airbrush. Because you will be working freehand, it is often easier not to attempt to be too methodical, but to change colors as the drawing dictates and to go from one color to another and then back again. Just blow some water through the airbrush between colors, and test it on paper towels (or an old white towel) before returning to the fray. Build the color up slowly; there is very little you can do, short of re-frosting the cake, to reduce color!

If you feel the picture calls for it, build up any three-dimensional features with plain or colored icing. This adds a certain lushness to the cake, quite apart from any artistic advantage, and also makes it look more like a cake and less like a painting. If there are *large* three-dimensional features, such as flowers, either make them from colored icing and do not attempt to use the airbrush, or paint them *off* the cake (to avoid overspray) and attach them with a dab of icing. This is obviously only possible with hard ('run-in') icing, but it is a common professional approach.

Finally, add highlights with white icing from a forcing cone; this can be surprisingly effective, whether you are trying to suggest catchlights in eyes, drops of dew on a flower, or highlights on chrome. *Bon-appetit!*

Fish Taxidermy

Polytranspar AIRBRUSH SYSTEMS WARM WATER FISH PAINTING SCHEDULE BP160

The Black Crappie

The colors of the black crappie vary to some degree depending on where the fish is found, the time of year, type of habitat, and even the mood of the fish. This schedule is Tom Sexton's personal interpretation and should work well for most color variations.

Polytranspar Airbrush Paint Needed

FP or WA220	Fungicidal Sealer	FP or WA440	Shimmering Blue	FP or WA30	Black
FP or WA441	Shimmering Green	FP or WA10	Superhide White	FP or WA260	Bright Yellow
FP or WA402	Silver Pearl	FP or WA110	Bright Silver	FP or WA425	Yellow Gold Pearl
FP or WA300	Sailfish Blue	FP or WA442	Shimmering Gold	FP or WA444	Shimmering Violet
FP or WA443	Shimmering Red	FP1000	Polytranspar Thinner	FP or WA1001	Polytranspar Retarder
FP or WA240	Wet Look Gloss or FP241 Competition Wet Look Gloss				

"FP" denotes *Polytranspar*™ Polymer/Lacquer Airbrush Paint. "WA" denotes *Polytranspar*™ Water/Acrylic Airbrush Paint. Choose one system and use throughout entire schedule.

NOTE: For Skin Mounted Fish: Before painting begins, fish should be completely dust free, clean, and dry. Fins should be backed with FC101 *Polytranspar*™ *Fin Backing Cream* and allowed to dry clear. *Liquid Eye Protector* (FP1002), likewise, should be applied to glass eyes and allowed to dry before painting.

Painting Instructions

Step 1. FP or WA220 *Fungicidal Sealer*—Heavily spray the entire fish with one flash coat, then two or three wet coats, or until a definite sheen is obtained on the surface.

Step 2. FP or WA10 *Superhide White*—Lightly apply to the yellowed areas only. Areas such as the anal opening, the interior of the mouth, the gills and gill flaps, etc. Do not apply to the side of the body, just the "yellowed" areas.

Step 3. FP or WA110 *Bright Silver*—Very lightly apply this color to the upper two-thirds of the body including the opercle (gill cover) and cheek. Position the fish with the lighting so you can watch this color go on. Be careful not to apply too much, just enough to barely cover.

Step 3.

Step 4. FP or WA402 *Silver Pearl*—Apply a moderate to heavy coat to the entire body of the fish. Don't worry about overspray on the fins.

Step 5. FP or WA425 *Yellow Gold Pearl*—Apply a moderate coat on the upper one-half of the body of the fish.

Step 6. FP or WA240 *Wet Look Gloss*—Spray a light to moderate coat over the entire fish.

Step 7. FP or WA260 *Bright Yellow*—Mist a light spray to the upper two thirds of the body and head (watch for overspray) Now spray a lighter coat onto all of the fins. Be sure to mist the edges of the maxillary and mandibles (lips).

Step 8. FP or WA300 *Sailfish Blue*—Mist this color on the upper one-third of the body from the maxillary and mandibles (lips) to the base of the tail. Control overspray.

Step 9. FP or WA30 *Black*—Thin with 100 percent of FP1000 *Polytranspar Thinner* (or water if using Water/Acrylics) and 10 percent FP or WA1001 *Polytranspar Retarder*. Detail the fish by following the existing spot pattern. Do not forget the fins. Now darken the upper back, the dorsal fin, the tail and the anal fin to the desired value. Mist the edge of the "lips" and upper maxillary plate.

Step 9.

Step 10. FP or WA440 *Shimmering Blue Iridescent*—Position the fish with the lighting so that the color can be seen going on. Mist the entire fish with an even coat. Now spray a few small spots on the upper one-third of the fish, using no particular pattern.

Step 10.

Step 11. FP or WA442 *Shimmering Gold Iridescent*—Follow the procedures as in Step 10. Include the spots, but do not spray these spots directly on the previous spots.

Step 12. FP or WA441 *Shimmering Green Iridescent*—Mist the top one quarter of the fish from the "lips" to the base of the tail. Then "spot" the upper back of the fish as was done in Steps 10 and 11.

Step 13. FP or WA444 *Shimmering Violet Iridescent*—Spray a mist on the lower one-quarter of the body, then "spot" the upper back as in the previous steps.

Step 14. FP or WA443 *Shimmering Red Iridescent*—Mist an even coat on the lower one-half of the body.

Step 15. FP or WA240 *Wet Look Gloss*—Spray the entire fish with one flash coat and two or three wet coats until the desired gloss is achieved. The highest gloss obtainable may be achieved by using FP241 *Competition Wet Look Gloss* (one coat should be sufficient). A very low gloss may be obtained by using FP or WA225 *Satin Sheen Gloss*. Add FP or WA460 *Refracted Frost* to further subdue gloss if necessary to dead flat. Spray heavy.

The Black Crappie BP160

This fish painting schedule is from The Breakthrough Fish Painting Encyclopedia, available from Wildlife Artist Supply Company. To order, call toll free 1-800-334-8012. (In Georgia call 1-800-822-2392). ©1987 Breakthrough Publications. Reproduction in whole or in part by any means—graphic, electronic, or mechanical, including photocopying—is prohibited without the express written consent of Breakthrough Publications. P.O. Box 167, Monroe GA 30655. *Polytranspar*™ is a trademark of W.A.S. Inc.

Fish painting is a subject which is greeted by many with disbelief; but for the proud fisherman or the professional taxidermist, it is a matter of considerable importance.

The magical colors of many types of fish change within hours or often minutes of death; most fade, some darken, and in almost every case the delicate differentiation of tones is lost. Fish painting is the art of restoring lost colors, to provide a semblance of the trophy as it was caught.

The taxidermy part of the preparation is not something we can go into here; suffice it to say that the fish should be photographed as soon as possible after it is caught, and then wrapped in a wet towel and frozen in a plastic bag until it is required. Removing the skin in one piece is difficult, cleaning it (especially the skull) is messy and time-consuming, and carving the foam block to provide a lifelike form requires considerable artistry. There is in fact a growing trend, even among professionals, to use molded plastic fish which are close in size and shape to the original: these are painted with the same markings as the trophy fish, but they are not true 'skin' specimens. Molded fish are fine (though expensive), and would be ideal for the hobby painter or for someone who wants to decorate a restaurant, but anyone who commissions a taxidermist should be clear whether he is getting a skin mount or a replica.

In fish painting, perhaps more than anywhere else, the rule is to spray many thin coats rather than a few thick ones. There are two reasons for this. The first is that the new generation of fish lacquers, introduced in the 1980s, are transparent and show the original scale pattern and markings underneath: the airbrush is therefore used to enhance, rather than to reproduce, the markings, and too thick a coat gives an unnatural look. The second is that in order to reproduce the irridescent effects which give fish so much of their beauty, you will often need to lay transparent colors over pearl colors, or to lay 'mist' coats

For fish paints, check taxidermists' suppliers or (for mail order) Breakthrough Productions, PO Box 1320, Loganville Georgia 30247 or Van Dyke of South Dakota. Fish lacquers are hard on the lungs, so wear a respirator.

Books: *Encyclopaedia of Fish Painting*, by Jim Hall and Bob Williamson, published by Breakthrough Productions (above) and *How to Mount Fish for Profit and Fun*, written and published by Archie Phillips.

This superb piece of fish painting by Tom Sexton won 'Best of Show' at the 1987 World Taxidermy Championships. Photographed by Duncan A. Dobie; reproduced courtesy of Breakthrough Productions (see Acknowledgements).

which are so fine that they are almost invisible except at certain angles. In a somewhat macabre fashion, irridescent paints derive their iridescence from ground-up fish scales.

It is much easier to reproduce colors if you are a fisherman yourself, and if you can work with a color photograph (preferably a slide) taken as soon as possible after the fish was caught. You can, however, buy fish painting schedules, which give the recommended colors, patterns and spraying sequences for 'typical' specimens, though you will need to make adjustments for local and individual variations. North American readers will find these schedules much easier to come by than Europeans, and indeed European fish taxidermists may often have to improvise from a North American original.

The normal painting sequence is as follows. First, using a broad spray, lay the ground coat, which is typically a pearl white containing (for obvious reasons) a fungicide. This may need to be quite heavy if the fish has darkened since it was caught; if it

has faded, on the other hand, it is worth knowing that colors will frequently intensify under lacquer, so use a light touch.

Second, working with a medium spray, lay the horizontal colors – the colors, that is, which parallel the lateral line. This is where you may need to use multiple overlays including transparent, opalescent and even opaque paints. Thin the lacquer as far as you dare, but be aware that too-thin lacquer can dry before it lands (leading to a matt finish) or 'bloom' with a milky haze which is almost impossible to cure.

Third, with a fine spray, add details such as top-to-bottom stripes and spots. This is also the time to blow red into the gills.

Finally, with a broad spray again, add the surface lacquer which gives the fish its 'wet-look' finishing coat. The latest product is actually a *water*-soluble coating which is more realistic and less glittery than the older lacquers.

Fabric Painting, Body Painting and Nails

Screen Wren Loasby
This beautiful screen was created with stencils and sprayed with different colored paints. This technique works particularly well where the design is enhanced by the use of graduated tones. (JB)

Fabric painting is normally done in one of two ways: either as something approaching fine art, where individual one-off pieces are sprayed in the way that Japanese kimonos were once individually painted, or as a means of series-production work using stencils.

Ensuring compatibility of fabric and dye is not always easy, and cotton fabrics in particular should be well washed to remove any sizing. Cotton and silk accept dye very well; and so does linen, which is widely used as a furnishing fabric. Wool tends to give a very diffuse effect, and to 'wick' the color, though the finest wools and of course wool/silk mixtures are much better. Nylon and other synthetic fabrics are rather harder to dye permanently, though (for example) cotton/polyester mixes are fine. Before attempting to spray a design onto any fabric, whether one-off or series-production, it is as well to carry out exhaustive tests first on pieces of scrap material.

Suitable materials include true dyes, as formulated for different fabrics; latex-type paints, which are easy to use and will stick to virtually anything, but which if applied too thickly give a rubbery sort of finish that some people dislike and which can be clammy in hot weather; bleaches; and any paste-type dyes which can be thinned far enough to spray through an airbrush.

Remember that some fabrics can only be wet-dyed: trying to avoid dye-spread when working on these can be very difficult indeed. Many spray-on dyes are washable until they are 'fixed' by ironing, but they are unlikely to wash out completely, so do not bet on being able to correct your mistakes!

Airbrushing T-shirts on a one-off basis is fun if you do it for yourself, and can be lucrative if other people like your designs. Working out stencils for T-shirts is an interesting intellectual exercise, and you have the advantage over regular commercial sources that you can design and make very small runs for (say) a new band's tour or a book promotion, giving the 'million dollar promotion' look for a modest outlay.

Moving up-market, kimonos and similar loose, flowing garments look good when airbrushed, but getting the drape right is difficult; a store mannequin or dressmakers' dummy is useful at the design stage, but for spraying you really need a large, flat surface: a paperhanger's table is ideal.

An altogether more arcane possibility is body-painting, but it is important to realize that this does *not* necessarily mean the kind of 1960s psychedelic decoration of naked girls which the phrase seems to conjure up for most people. For example, it is perfectly possible to create 'tattoos' which are short-lived but which are surprisingly similar to the real thing unless you look very closely indeed. Most people are too polite to do this . . .

There is one small catch to 'tattoos'. They work much better on women and children; hairy men are harder to mask, and

Tablecloth Wren Loasby
The shading of the poppies on the
cushion and tablecloth helps to create
the illusion of delicate petals. (JB)

unless the hair is dark, the hairs themselves will also show the color. This is an interesting effect, but it does somewhat destroy the illusion of a tattoo.

An area of 'body-painting' which is growing in importance is airbrushing fingernails, which is now done in a number of beauty salons. Normally, the lacquer is applied to false nails *in-situ*; beauty salons recommend a 'retouch' every two or three weeks, when the lacquer is renewed and the inevitable gap between the base of the false nail and the cuticle is filled with a special gel which allows the nail to 'breathe' and avoids infection. All sorts of stencilled patterns are available, including diagonal color mixes, stars and stripes of various patterns. A leading company in the UK is Nailflair (their address is in the Acknowledgements section); in the USA, there are several companies in this line of business.

Finally, the airbrush has some uses in stage make-up. Its advantages in applying colors are questionable, when compared with the older techniques, but it is apparently used to spray on latex for ageing and for 'horror movie' effects. We have not tried this, and we cannot recommend it, but we can recommend Richard Corson's book *Stage Makeup* to anyone who wants to learn more about the subject.

Fabrics from 'Miracles' in the King's Road,
London in 1979 – a treasurehouse of
airbrushed work.

Ceramics, Glass and Metal

Miniature Porcelain Pot
Geoffrey Swindell
Individual pieces of pottery can be decorated with an airbrush after the glaze has been applied. Here, an airbrush was used to spray a fine mist of paraffin on to the wet freshly applied lustre liquid. The paraffin causes a break in the surface tension of the lustre, making it shrink and run rather like the effect created by mixing oil and water.

It is possible to spray fine slips and glazes onto leather-dry or bisque-fired ceramics, using a broad nozzle: a good starting-point is a 1-to-3 mixture of water and prepared underglaze. You can spray either freehand or masked: masking tape, library film, and even liquid masking material can be used, but you should be careful with the last as it can be hard to remove.

Be extremely careful to avoid finger-marks, and take great care not to spray too wet: if you do, the finish may not adhere properly, and you can get flaking during the firing.

Intriguingly, a major manufacturer of fine porcelain who quite clearly uses at least some airbrushing during series production refused to admit to the fact; we are therefore unable to show any of their work, which is very well known. Take a look in the china shops next time you are shopping, and see if you can work out who we mean.

Glass can be treated as a conventional ground, or it can be etched. Winsor & Newton used to make a range of transparent paints specifically for glass – the 'Vitrina' range but these are no longer available, and various substitutes have to be used, including Mameri and Lefranc & Bourgeois. Glass paints can also be used on metal, or automotive paints can be used for large-area work such as shop windows.

Metal offers even more possibilities. It can be treated as a regular ground, using a variety of paints including fusible enamels (these are normally fired in a potter's kiln), it can be etched, or it can be plated.

What you need here is some form of *resist*, something which you can spray out of the airbrush onto the metal (glass-workers use the term 'metal' for glass, interestingly enough) and which will then resist the etching action of the acid with which you treat the work, or which provides a non-conducting barrier in the plating bath.

Although it would be possible to apply liquid resists direct to the surface, and etch or plate around those, it is more usual to apply a mask; spray on the resist; remove the mask; and then use the chemical etching or plating bath. Film masking would

also be possible, but there is considerable danger of the corners lifting, to the detriment of the design.

One of the other advantages of spraying on the resist is that you can use stencils for series production work: this is how the airbrush is used in the production of cowboy belt-buckles. Regular latex-type resists are a possibility, but in commercial production lacquer-type resists are used which dry hard.

For metal etching, most of the regular school-lab acids are fine: nitric is good for copper or brass, and hydrochloric for zinc or aluminum. You can also use caustic soda (sodium hydroxide) for aluminum. Use the acids fairly weak – as weak as 10% of the full strength reagent is advisable – for two reasons. First, weak acids are obviously safer to use, and second, the slower the process is, the more controllable it is – though you may need to experiment to find the slowest process, as certain concentrations seem to work disproportionately fast. If you are diluting the strong acid yourself, remember the old advice: ALWAYS ADD ACID TO WATER. If you add water to strong acid, there is a danger that the water will boil and the acid will spit back at you, which is not much fun.

For glass etching, the only solution is hydrofluoric acid. This is a frightening chemical which can strip the flesh off your bones in no time, so treat it with the utmost respect. For obvious reasons, it is supplied in plastic (not glass) bottles.

For metal plating, you can use the various 'plate-it-at-home' kits which are advertised in the hobby magazines, although of course commercial platers use full-scale baths. You can also plate one metal on top of another, so that (for example) you could nickel-plate an item all over; silver-plate some areas; and then gold-plate the highlights. The resist is normally removed in a powerful organic solvent. Once you have plated the item, it is usually a good idea to protect it with a clear acrylic lacquer, which can also be applied with the airbrush. With any plating process, follow the de-greasing and chemical cleaning instructions *scrupulously* if you want anything like a decent finish.

Tiger
Part of a window-painting for a massage parlour; automotive paints on plate-glass. Using a chinagraph or wax pencil draw your design on the outside of the window. Then lay a single sheet of masking film over the inside of the window covering the entire area of the design. Cut ALL the mask lines before applying any paint so that they are not obscured by overspray. Starting with the darkest areas, use black (or your darkest color) and work in sequence finishing with the lightest areas and white (or your lightest color). Airbrushing the design in this sequence will enable light to shine through the image to the interior so that the finished work can be seen from both sides of the glass.

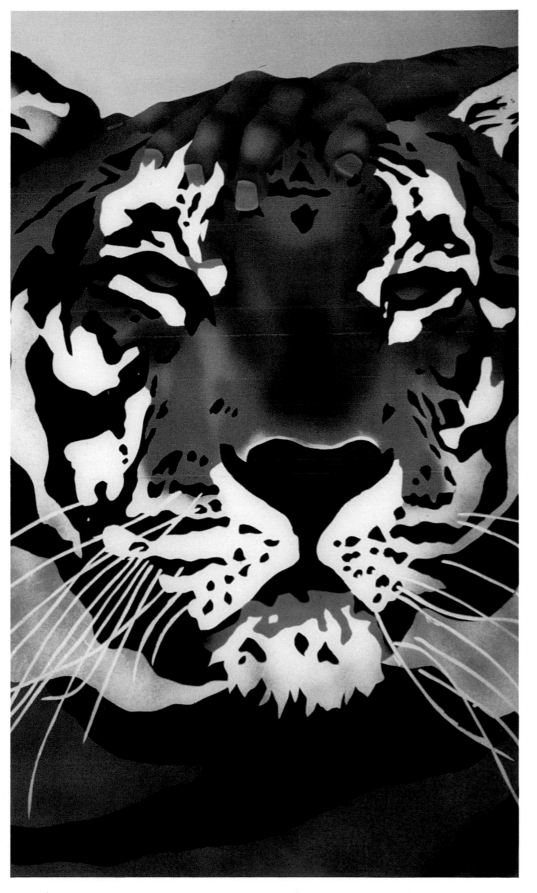

Engraved glass Adam Morrison
This glass was masked with film, then sand-blasted using a Paasche air-eraser. It could also have been etched with hydrofluoric acid, as described in the text. Both techniques are DANGEROUS: wear eye and lung protection when sand-blasting, and treat hydrofluoric acid with the utmost respect.

The Airbrush at School

Cartoon Dylan Glover
Dylan Glover was seven when he picked up an airbrush for the first time. He was initially disappointed that it did not squirt Ink like a water-pistol, but once it was explained to him, he said, 'Oh, you mean like this!'. This was the first thing he ever painted with an airbrush.

Microscopes, cameras, machine tools, dissection equipment, potters' wheels – the range of equipment provided by many modern schools is extraordinary. And yet, very few schools possess even a single airbrush. Why not?

The most basic objection is expense. There is no point in trying to learn with a too-limited airbrush, and not only is a traditional high-quality airbrush expensive to buy, but a few days' neglect can result in its being written off as a result of corrosion. Many schools have bought (say) half-a-dozen airbrushes, only to find that by the end of the school year they have perhaps one working model left.

The Aztek brush goes a long way towards answering this argument. It is not cheap, but it is less expensive than many competitors, and it is far less prone to corrosion. If it is left with color in it, and cannot be cleaned, replacing the nozzle/needle assembly is not outrageously expensive; the likelihood of the damage being any more extensive is not great. Ideally, enthusiastic students will buy their own airbrushes; at worst, they should be able to clean up a school brush and use that, even if it has been neglected.

The other main objection is that it is impractical to teach airbrushing to full-size classes of twenty or more children: airbrushes are too expensive, arranging an air supply is difficult (and high-pressure air can be dangerous anyway), and working in a paint-laden atmosphere is not conducive to good health.

This is quite unreasonable. As for class sizes, few schools can muster (say) twenty lathes or twenty potters' wheels, but they still teach turning and pot-throwing. And as for safety, it is something to be taught: there are many things in a school which are potentially more dangerous than an airbrush, from the lathes in the machine shop to the scalpels in the biology department to the chemicals in the chemistry department. Also, if you restrict pressures to 30 psi (2 bar) or lower, there is very little danger from the air supply.

In short, the airbrush can and should be made available to students at all levels, though one might fairly expect that the most senior pupils will benefit most. This information is concerned mainly with setting up airbrush teaching facilities for older school pupils – third formers and above in the UK, senior high school students in the United States – though teachers will see what modifications to make for other groups.

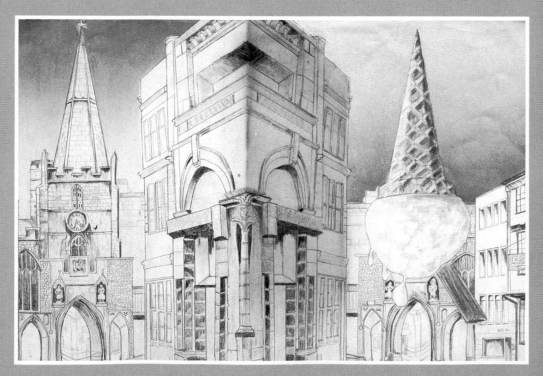

'Cones' Charlotte Pulfer
Charlotte was a schoolgirl when she painted this; it is basically a pencil drawing, but the airbrush was used to add tone to some areas – another example of combining established techniques with airbrushing.
Approximately 11x15 in, 27 x 38 cm.

A School Art Room

The first consideration in equipping a studio or art-room for airbrushing is ventilation. Unless the room can be ventilated, either by opening windows or by forced ventilation (or both) drifting paint can be a health hazard, and the room should not be used. The use of toxic pigments should of course be banned completely in a school context.

The second consideration must be the air supply, and there are three main possibilities. The first is 'tinned wind', which is likely to prove impractically expensive. The second is an air line, and the third is individual compressors.

Tinned wind is expensive, but the capital outlay is not great: each pupil can pay for his or her own canisters.

Line supplies are in many ways ideal, but they are rarely available in art areas. The best way to use a line supply is with individual regulators, and a line supply at say 80–90 psi (5–6 bar) regulated to a much lower pressure (say 30 psi) at the bench. There should also be a large reservoir or receiver between the compressor and the air-line, to keep air pressure in the line constant. Ideally, a big compressor in a shed outside can be shared with craft/engineering; the location makes for safety, and you get double the use for the outlay.

At present, individual miniature compressors are not really robust enough to stand up to the wear and tear of school use, and larger individual compressors (or compressors shared between two or more people) are expensive to buy. Even so, this is probably the best solution for most schools and colleges, as the compressors can be moved from room to room and can be locked away when they are not in use.

Now we come to the heart of the matter: the airbrush.

The best system is probably a two-tier approach, with 'class A' and 'class B' airbrushes. A 'class A' airbrush will normally be the responsibility of the senior pupil to whom it is issued: he or she will be responsible for cleaning it, and ideally he or she will be the only one to use it. Alternatively, the same brush may be issued to two or three students in different classes, each of whom is responsible for its maintenance and for reporting any defects. This sort of approach is normal with microscopes and dissection kits in biology classes, and can be made to work equally well in art classes. Half a dozen 'class A' airbrushes will probably be sufficient.

'Class B' airbrushes are for general use. There can be as few as two or three of them, because their main function is to introduce the airbrush to as many students as possible, under the close supervision of the teacher. The idea is to fire the

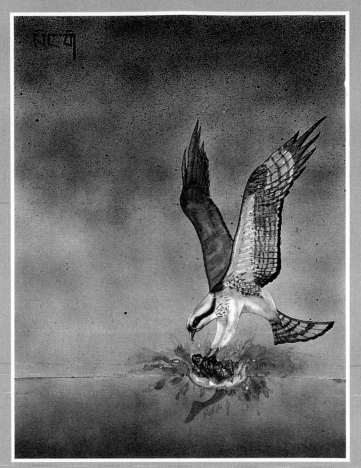

Osprey
Seng-gye's first piece of airbrush work. The osprey is not anatomically particularly accurate, but the picture has plenty of movement. Overleaf are further examples of early work by two other artists whose work appears here.

students' enthusiasm so that (with any luck) they buy their own; otherwise, they may graduate to 'class A' brushes if they are really keen.

This is where the advantages of the new design really come into their own. The choice is basically between buying very cheap brushes, which are difficult to use and not very versatile, so that the students learn very little, or to buy decent brushes which will stand up to the hurly-burly of the school environment. The former is not worth doing, and at present the *only* high quality brush which can reasonably be expected to survive is the Aztek design.

Each individual work-station should also be provided with the basic equipment reproduced here in check-list form for convenience (see panel).

All pupils must understand the safety aspects of the airbrush (see pages 12–13), and they must also realize that any transgression of safety rules may result in loss of airbrush privileges.

Checklist for Airbrush Work Station	
Porcelain or similar mixing-bowls	Rags
Eye-droppers	Paper towels
Tea strainer	Mask or respirator
Clean water bottle	

Gun Adam Morrison
Among Adam Morrison's earliest work was this strip-down of a Colt .45. Like Seng-gye's osprey, there are certain technical inaccuracies, but it still shows what impressive work can be turned out by a relatively inexperienced artist. There is actually an intermediate stage to this strip-down, but it has been omitted in the interests of saving space. Compare this with Adam's other work in this book.

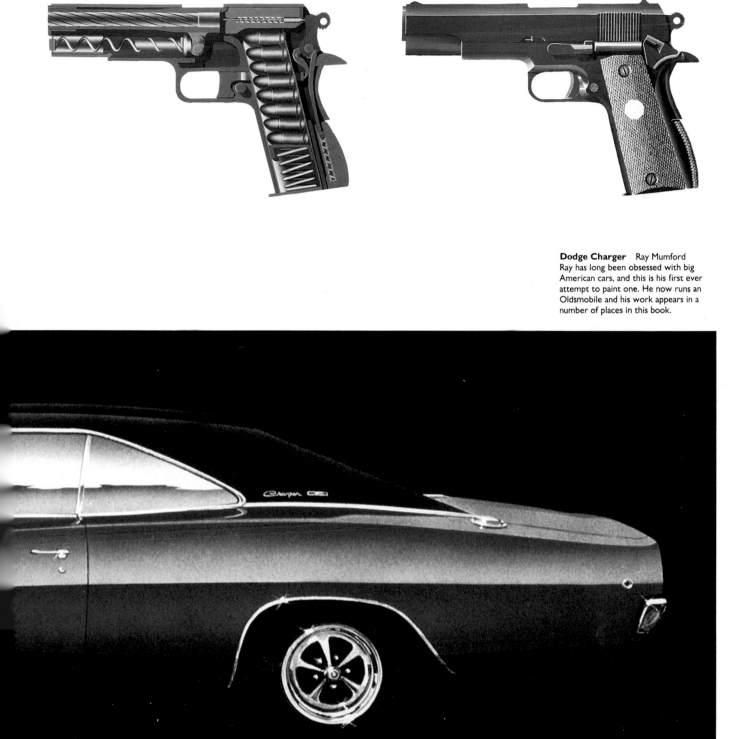

Dodge Charger Ray Mumford
Ray has long been obsessed with big
American cars, and this is his first ever
attempt to paint one. He now runs an
Oldsmobile and his work appears in a
number of places in this book.

APPENDIX
Care and Maintenance

Because of the straightforward, modular, corrosion-resistant design of the Aztek brush, there is far less need to be an expert airbrush-rebuilder than there used to be. Ultimately, there is only one thing you really need to do to keep your airbrush in good working order, and that is to keep it clean. After using it, run an appropriate solvent through it, and put it away clean.

For water-soluble media, use just water – though for acrylics, it is also advisable to blow alcohol through afterwards, in case any paint has solidified in the brush. Liquid acrylic is water-soluble, but dry acrylic is not. Also, if you have been using old-fashioned drawing inks, you should again use water followed by alcohol. This is because they contain shellac, which will not be removed by water. For oils and alkyds, use white spirit.

From time to time, it is a good idea to use a proprietary airbrush cleaner, but note that some formulations are much safer than others; one well-known brand (not Aztek) has been described as 'a quick route to a white stick' if you get it in your eyes. Spray onto a wet towel or into some other form of trap.

Replacing nozzles is simply a matter of unscrewing one and screwing in another, using finger pressure only – but make sure that the unit is screwed fully home, or you may find that the brush refuses to work, and air bubbles back through the paint cup. To clean the nozzle, all you usually need to do is to immerse the entire unit in cleanser. As well as proprietary cleaners, you can use a wide range of other solvents including ethanol, methanol, brake fluid (!), and even acetone – though you should not leave the nozzle soaking in brake fluid or acetone for more than a few days, which should be more than long enough to remove dirt and debris.

If the nozzle is clogged, and you cannot clean it on the brush by running solvent through it and working the action (with as much air pressure as you can muster), remove the nozzle and, if need be, remove the needle itself by twisting it anticlockwise. Tissue paper may then be used to help clear some of the mud out of the nozzle.

DO NOT attempt to clean the nozzle (or any other part of

the airbrush) with a screwdriver, piece of fuse-wire, or even a sharpened toothpick or matchstick. You may be lucky, but you may equally well damage the nozzle beyond repair. The only part you can safely clean out with a matchstick is the inner paint cup, which is a snap-fit in the outer paint-cup.

Needless to say, because additional nozzle units are not expensive, it is always a good idea to keep a spare handy. When you take out a dirty nozzle, put it to soak IMMEDIATELY, and use the spare; that way, you can reassure yourself that it is working, as well as checking where it is!

You should not need to do any more work on the brush, and indeed, if you disassemble it yourself, it will invalidate your guarantee. Nevertheless, there are occasions when it is a question of trying to repair the brush yourself, or nothing: as one artist put it, 'When it's a Sunday afternoon, and your brush packs up, and you have to deliver the work at 9 o'clock Monday morning, you take the thing apart!' There are also people who take things apart out of sheer curiosity.

Of course, we strongly suggest that you keep a spare brush if your livelihood depends on it; indeed, we would go so far as to suggest that it would be foolish not to – no photographer ever relies on a single camera, for example. At the very least, keep a spare nozzle. But if you insist on taking the brush apart yourself, the following information is FOR EMERGENCY USE ONLY, and no responsibility is accepted by the designer, the author, the publishers, the manufacturers or anyone else if you cannot repair the brush yourself. It is worth stressing that the design of the brush is very strong, and nothing should go wrong; but even a one-in-a-million chance is likely to happen (by definition) once in a million airbrushes. Also, a cynic might add that the way that some airbrushers treat their tools has to be seen to be believed.

These instructions are for guidance only, and the latest version will be in the instruction book which came with your airbrush; you may care to tape your instruction booklet inside the back cover of this book.

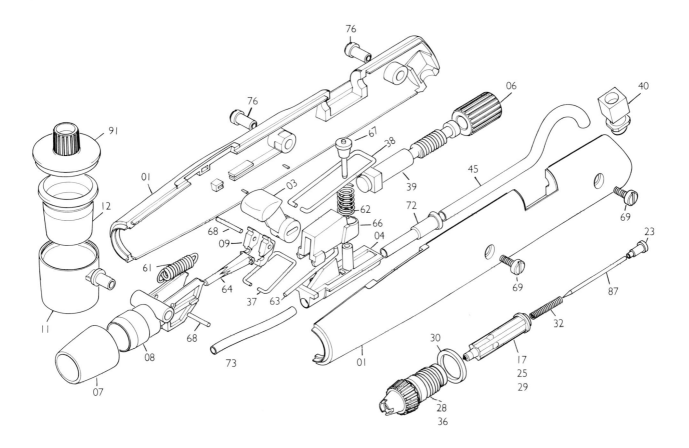

Key to exploded diagram of Aztek airbrush: *When prefixed by the number 47 the key numbers listed form the product number for the parts shown.*

01	Handpiece Shell Set	29	Highflow Nozzle (Green Ident Ring)	62	Compression Spring
03	Control Lever		Spatter Nozzle (Red Ident Ring)	63	Lever
04	Air Valve Body	30	Ident Ring (Blue, White, Green and Red for	64	Plunger
06	Roller		different nozzles)	66	Rocker
07	Cowl	32	Needle Spring	67	Air Valve Spring Retainer
08	Nozzle Housing	36	Air Cap (Standard – all nozzles except Spatter)	68	Anchor Pin
09	Swing Arm	37	Forward Link	69	M2 Screw 6mm long
11	Paint Cup Base (various sizes)	38	Rear Link	72	Air Valve Tube
12	Paint Cup Insert (various sizes)	39	Roller Connector	73	Front Internal Hose
17	General Purpose Nozzle (Blue Ident Ring)	40	Hose Connector	76	M2 Tube Nut
23	Needle Head	45	Rear Internal Hose	87	Needle
25	Fineline Nozzle (White Ident Ring)	61	Tension Spring	91	Paint Cup Lid (various sizes)
28	Air Cap (Spatter nozzle only)				

Disassembly Procedure

1. Remove the nozzle, the paint cup and the blanking plug.

2. With a suitable screwdriver, undo the two screws which hold the brush together.

3. Place the brush with the nozzle to your LEFT, and lift up the side-cover. To remove it, lift the rear end away from you slightly in order to unhook it from the nozzle receiver.

4. If you can see anything that has obviously come adrift – one of the stirrup linkages, or the main air line – put it back together again using a mixture of common sense, the exploded diagram above, and the cutaway drawing on page 20. The tubes are all push-fit; the air-valve can be pulled out without tools.

5. DO NOT poke about in the nozzle receiver with a screwdriver or anything else except perhaps tissue paper, as you will probably damage the seal. The nozzle receiver is one of the most expensive parts of the airbrush to replace. The other is the roller assembly.

6. If you have spilled paint in a way that has allowed it to get inside the brush, clean it out as best you can. Paint will NOT get inside the brush in normal use.

7. Reassemble the brush, remembering the point made in 3 above: hook the end under the nozzle receiver, with the other end away from you, and work it inwards and downwards.

'Left hand' and 'right hand' refer to the orientation with the nozzle pointing upwards and away from you.

The following parts are available as user-fitted spares without affecting the guarantee:

Nozzle (complete with needle)
Airbrush body, without nozzle
Feeder funnel
Paint cups: I cc 2.5 cc 8 cc
Blanking plug (supplied with paint cup)
Hose (air supply line)

Obviously Aztek cannot guarantee any components if you disassemble or strip down the airbrush or nozzle. However, if you are careful it is unlikely that you will damage any of the parts.

Street Hideaki Kodama

154

Glossary

Acrylics Group of paints which 'cure' to form a tough plastic skin on the ground. Fine-art acrylics are all water-based; automobile acrylics are akin to alkyds (see below). See pages 104–105.

Acrylizer Acrylic medium (see Medium, below).

Alkyd Alcohol-based resin paints, similar to acrylics. The most durable alternative to oil paints. See pages 104–5.

Bar Unit of pressure, equivalent to one atmosphere (15 psi).

Color Anything that you can spray through an airbrush, including dyes, inks and paints. See pages 22–5.

Contact mask Mask (see below) which adheres to the ground. See pages 50–1.

Control roller Unique feature of Aztek design. See pages 14–17.

Double-action An airbrush in which the vertical movement of the control lever affects air supply, and the to-and-fro movement affects color supply. See pages 10–11, 16–17.

Dye Color in which the coloring agent dissolves in the medium (see below). See pages 22–5.

Feeder funnel Small funnel, designed to be filled with an eye-dropper, which fills the internal reservoir of the airbrush. See pages 18–19.

Frisket Now, generic term for contact masking made of thin plastic film. See also pages 32–3.

Gouache Fast-drying water-based paint commonly used in illustration.

Ground Any surface onto which you spray. See pages 28–31.

Loose mask Mask (see below) which is not stuck to the ground, and can often be re-used. A stencil (pages 46–7) is an example of a loose mask. See pages 48–9.

Mask Anything which comes between the spray and the ground. The mask leaves a 'shadow' of its own shape. See pages 44–5.
Also: most basic form of breathing protection. See pages 12–13.

Medium Liquid in which dyes (above) are dissolved, or pigments (see below) are suspended. Media include water, oil, various organic solvents, acrylic medium ('acrylizer'), and so forth. See pages 22–5 also 102–5.

'Orange peel' A particularly unattractive pitted effect, usually obtained with automotive paints, resulting from trying to use a few thick coats rather than many thin ones.

Overspray Any spray which does not end up on the ground, where you want it. It can drift a surprisingly long way. See pages 12–13.

Pigment Finely-ground solid colors. Pigments do not dissolve in media (see above) but are held in suspension, and can therefore settle in thin media, which need to be shaken well. See pages 22–5.

PMT Short for 'Photo-Mechanical Transfer', and a Kodak trade mark. A 'PMT Machine', also known as a 'reprographic camera', can be used for enlarging and reducing artwork onto a variety of photographic grounds. See pages 32–3, 72–3.

Priming Preparing a ground (see above) so that it will accept a given medium. See pages 28–31.

Propellant Usually, air. Also includes any other gas used to propel the spray. See pages 26–7.

Receiver Air container attached to compressor. Acts as a reservoir, and also smooths out 'pulsing' due to compressor action. See pages 26–7.

Reservoir Another name for Receiver. See above.

Resist Lacquer or similar material used to protect a ground from the action of etching or plating baths. See pages 22–4 and 146.

Respirator Breathing protection, either with an independent air supply or with an activated charcoal filter. See pages 12–13.

Roller See Control Roller, above.

Single-action Strictly, an airbrush in which the lever controls *only* color (see above) *or* propellant (see above). See pages 10–11.

Spidering Line fault where ink 'spiders' out from the line like a half-centipede. See pages 38–39.

Tinned wlnd Facetious but common name for pressurized canisters of propellant (see above).

Anglo-American Dictionary

There are a number of terms which differ significantly between American and English usage. Most people are probably familiar with both, but the list below may be useful.

American	English
aluminum	aluminium
fender	wing (on car)
frosting	icing (as on cake)
hood	bonnet (on car)
Lucite	Perspex
Masonite	hardboard
trunk	boot (on car)
X-Acto (US)	Interchangeable-blade craft knife. There are various sizes of X-Acto, from delicate to heavy-duty

Many of these terms, for example Lucite, Masonite, Perspex and X-Acto are trade marks which are often used (incorrectly) as generic terms.

Acknowledgements

If this is a somewhat expansive 'Thanks and Acknowledgements', so be it. Many people helped a great deal in the production of the book and (especially) in securing pictures.

The acknowledgements are divided into two parts, 'Businesses' and 'Individuals', but this *only* reflects commercial availability of their work. I have abandoned the editorial 'we' here, and just spoken for myself; many of these people went far beyond mere business, and were genuinely friendly. If you like their work, I can recommend them as people to work with!

Businesses and Commercial Artists

Archer Art
Andy Archer of Archer Art, 5 Park Road, London NW1, and his brother Eddie of Archer Art, Hoffdweg 50, Amsterdam 1058 BD, Netherlands run a superb art agency. They are both very nice guys, with whom it is a pleasure to work and they secured for us the work of the following artists who they represent: Phil Evans, Keith Harmer, Jens Holt, Tom Liddell, Erno Tromp, and Jurgen Wiersma.

Aztek
The illustrations of the Aztek airbrush which appear on the title page (drawn and airbrushed by Adam Morrison), page 20 (drawn by Adam Morrison and airbrushed by Ray Mumford) and pages 152–3 (drawn by Adam Morrison), are reproduced with the permission of Aztek.

Robert Beer
Robert's *Thangkas* appear on pages 31 and 93: he has illustrated several books, and his work has appeared on a number of covers. The originals are utterly stunning.

Boaze Massimi Politt
For permission to use the British Rail advertisement on page 63.

Jonathan Bosley
For photographs on page 144 and in Chapter 10.

Terence Brace
I learned a great deal watching Terry.

Breakthrough Publications
For fish painting schedules, the illustration on page 143. Their address is on pages 142–3.

Bristol Fine Art
Sue at Bristol Fine Art runs a truly professional art shop, and I owe her a great debt of thanks for the loan of equipment (she seems to keep most things in stock) and for advice on many topics.

Bristol Sugarcraft Centre
Bristol Sugarcraft Centre produce truly spectacular custom-made cakes, often using exclusively commissioned patterns. An example of their work appears on page 141.

British Rail
For permission to use the advertisement on page 63.

Crime Incorporated Crew
CIC began working illegally in 1983, and comprises three people: Felix Braun, Tom Bingle and Joe Braun. They now work on legitimate commissioned projects; for example, they painted the mural in the canteen at Filton Technical College, Bristol, where Felix and Tom were students.

Don Eddy, represented by The Nancy Hoffman Gallery, New York
Don's agent very kindly sent an excellent selection of his intriguing work, an example appears on page 106.

Michael English
Michael is one of the best-known British fine artists; the illustration on pages 98 and 99 is reproduced by his kind permission.

Dylan Glover
Dylan's work appears on page 148.

Toby Glover
An example of Toby's cartoon style appears on page 17.

Glen and Peter Hewett
Glen and Peter are a pair of really original Australian artists; their work appears on pages 59 and 101.

Jeff's Taxidermy, Visalia
Jeff is a very fine fish taxidermist, and was extremely helpful when I asked him for information. He is brilliant with other animals, too. His phone number is in the Yellow Pages for Visalia, California.

Japan Creators' Association
The Japanese Art Agency for securing permission to use pictures by the artists listed below, or for commissioning their new work. JCA as it is generally known, is the headquarters of the International Creators Organization which is represented in most major countries of the world. Any enquiries should be directed to ICO Headquarters, c/- JCA Press Inc., 5-12-3 Higashikaigan Kita, Chigasaki, Kanagawa, Japan. Telephone: 81 (Japan) 467 85 2725. Fax: 81 (Japan) 467 86 1501. Kazuaki Iwasaki 100: Hideaki Kodama 103 and 154: Susumu Matsushita 33: Keiichi Murakami 24: Seiji Nakamura 90: Toshikuni Ohkubo 92: Ryo Ohshita 8 and 61: Mikio Okamoto 68: Otto & Chris Contents and 94: Hideaki Shioya 69: Ramon Gonzalez Teja 56: Yip Kam Tim 95 and 107: Ichiro Tsuruta 27: Vision Graphics 97.

Kopy Kake
Kopy Kake of Los Angeles supply complete cake-painting kits; they provided the illustration on page 72 and a good deal of information.

Churchill Livingstone
The illustration on page 136 was reproduced from Williams & Warwick: *Gray's Anatomy* 37th Edition, by courtesy of Churchill Livingstone, illustrator: Kevin Marks.

The Modelmaking Business
The Modelmaking Business kindly supplied the illustration on

page 138. For further information about architectural models write to: Mill Street Studios, Bridgnorth, Shropshire, England WV15 5AG.

Motif Editions
Motif Editions in London for letting us use the Coca-cola illustration by Michael English.

Ray Mumford
Ray's work appears in Chapter 7 and in Chapter 9, and there are individual pictures on pages 10, 77 and 150. I am indebted to him for his help and expertise.

Nailflair
Nailflair of 62 Triton Road, London SE21 8DE provide complete nail-painting kits. They were a mine of information on this arcane but growing field of beauty care.

Sim-Air
Sim-Air are manufacturers of the booth shown on page 13.

Stencillitis
Michael Flinn kindly supplied stencils, ideas and advice; stencilling and Stencillitis are covered in Chapter 10.

Street Machine
Street Machine magazine allowed Ray Mumford and me to go through their picture files; many of the pictures in Chapter 9 are from Street Machine.

Studio Two
Studio Two of 104 Great Portland Street, London W1 supplied the illustration of the Security Switch on pages 126–7 which was retouched by Alan Watkinson.

Top Hat Cakes
Dominic Vyvyan-Jones makes excellent cakes using only organically-grown ingredients; his 'Tiger' cake on page 141 was his first attempt at using the airbrush, and is a remarkable success.

Walser's
Tim O'Brien of Walser's in Torrance, CA, probably did more to focus my attention on the content and layout of this book than anyone else. Walser's is an excellent art store, too.

Wren Loasby
Jenny Loasby provided examples of her stencil work which appear in Chapter 10 and on pages 144–5. Stencilled embroidery canvases can be obtained from her at the following address: Brennels Mead, Highweek Village, Newton Abbot, Devon TQ12 1QQ.

Individuals

Antonia Blake, for advice on nail painting.
Val and Tony Blake, for shelter while we were finally getting the book sorted, and for many hours of lively and entertaining discussion.
John Clifford, for the use of his flat and for several pleasant evenings in his company.
Frank Drake, for use of studio space.
Talia Benz Fisher, for pictures on pages 36 and 94.
Colin Glanfield, for use of studio space.
Julia and Tim Glover, for the loan of an extremely comfortable garret with en-suite color darkroom, and for proving such good friends.
Herb Hayday, for ideas and meticulous notes in very fine handwriting.
Jan Ilott, for inventing the airbrush and for being a delightful guy to spend an evening with at the pub.
Julie Lewis, for checking out applications of the airbrush in both hairdressing and nail-painting. Julie owns JJ's Hair Salon in Bristol.
Mark Llewellin, for hospitality in London.
Adam Morrison, for many useful comments and ideas, as well as for checking the text; also for illustrations on pages 10, 152 and in Chapter 5.
Laura Sanderson, one of the best editors with whom I have ever worked.
Frances Schultz, my wife, for artwork, proofreading, picture-chasing, fact-checking and generally saving what remains of my sanity. As is so often the case, her name could fairly appear as co-author.
Rose Tombs Curtis, for help of many kinds and remembering things for Seng-gye and me.
Seng-gye Tombs Curtis, for endless help, ideas, and a considerable amount of artwork.
Dave Wells, for many useful comments and for checking the text.

Index

New York Skyline with Bulb (Wrangler) Terry Pastor
Although executed with tremendous skill, this advertisement actually uses fairly simple techniques, all of which are described in this book.

© Roger W. Hicks 1988

Illustrations of the Aztek airbrush
© Kodak Ltd 1988
(see acknowledgements)

First published in 1988 by
Broadcast Books Ltd
a subsidiary of
Element Books Ltd
Longmead, Shaftesbury, Dorset

Set by Typesetters (Birmingham) Ltd.
Origination by Peninsular Repro Services Ltd
Exeter, Devon
Printed in Great Britain by
Purnell Book Production Ltd
Paulton, Bristol
Design and production by
David Porteous Associates, Chudleigh, Devon

British Cataloguing in Publication Data:
Hicks, Roger, 1950–
 The airbrushing book : the handbook for
 all airbrush users.
 1. Airbrushing – Manuals
 I. Titles
 751.4'94

ISBN 1-85404-000-6